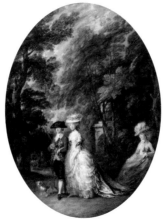

The Conversation Piece
Scenes of fashionable life

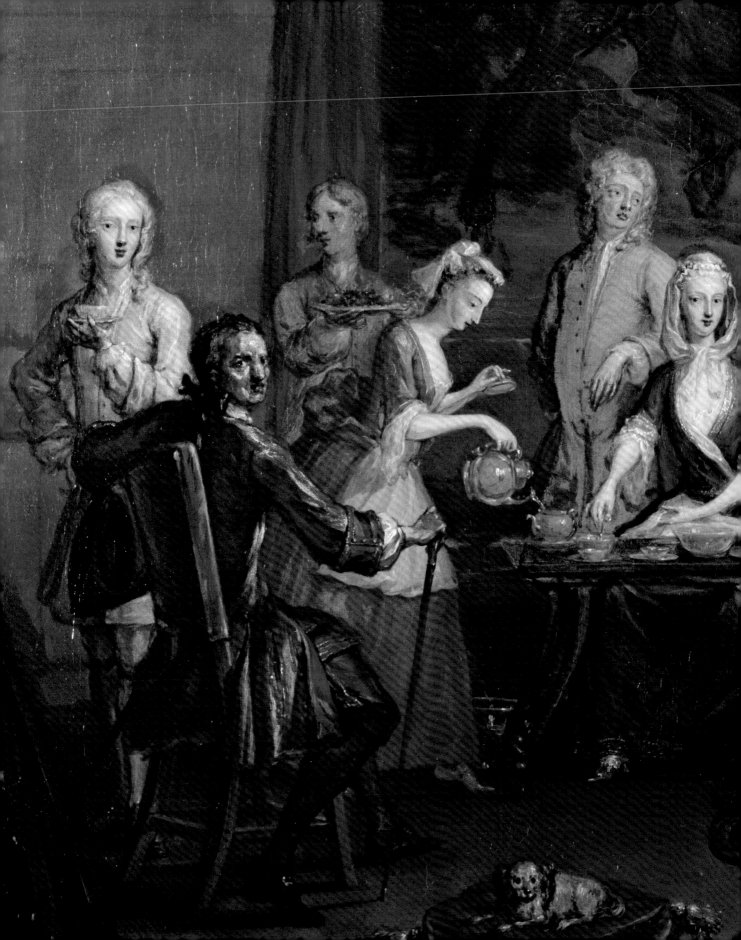

The Conversation Piece

Scenes of fashionable life

Desmond Shawe-Taylor

Royal Collection Publications

Published by Royal Collection Enterprises Ltd
St James's Palace, London SW1A 1JR

For a complete catalogue of current publications, please write to the address above,
or visit our website at www.royalcollection.org.uk

012799

ISBN 978 1 905686 07 0

British Library Cataloguing in Publication Data:
A catalogue record for this book is available from the British Library.

Design: Price Watkins
Editorial project management: Johanna Stephenson
Production: Debbie Wayment
Printed and bound by ContiTipocolor, Italy
Typeset in Didot, Plantin and Bliss and printed on R400 Matt

Cover: Johan Zoffany, *The Tribuna of the Uffizi* (no. 25, detail)

Contents

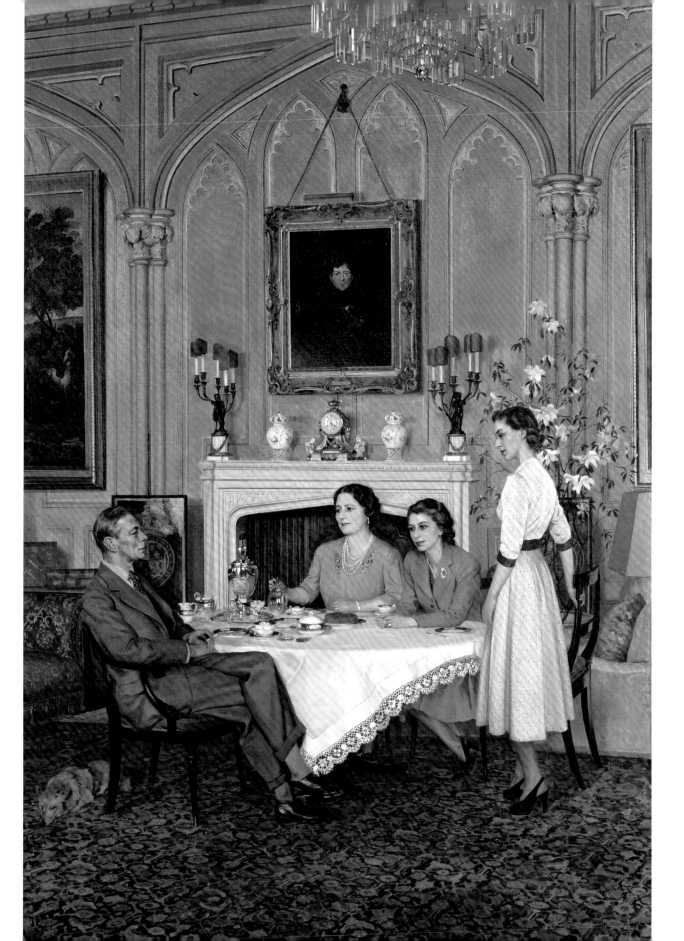

In Custom and in Ceremony
The Meaning of the Conversation Piece

And may her bridegroom bring her to a house
Where all's accustomed, ceremonious;
For arrogance and hatred are the wares
Peddled in the thoroughfares.
How but in custom and in ceremony
Are innocence and beauty born?
 (William Butler Yeats, *A Prayer for my Daughter*, 1919)

onversation Piece at the Royal Lodge, Windsor
by Sir James Gunn (1887–1953; fig. 1) was
commissioned in 1950 by the Trustees of the
National Portrait Gallery; the artist and the
setting were chosen by Queen Elizabeth, who
herself owned the charcoal sketch (fig. 2). This is an unusual
image of a reigning monarch in having nothing to distin-
guish King George VI from any other English gentleman
sitting down to tea with his family (unless it be the strict
profile view, reminding viewers of the coin of the realm,
or the ancestral portrait of George IV on the wall). Although
unusual, it was obviously appropriate: after a decade in
which some foreign heads of state had been power-hungry,
destructive and mad, how reassuring to see a British one
so unassuming, kindly and obviously sane. The King appears
to be discussing some matter with his family, with a cheer-
ful seriousness. A beautiful historic interior is filled with
light and fine things, without ostentation of wealth. This is
a scene as English as rain.

 This type of painting is also peculiarly English; Gunn
seeks deliberately to recreate the character of a conversa-
tion piece from the eighteenth century, like Johan Zoffany's

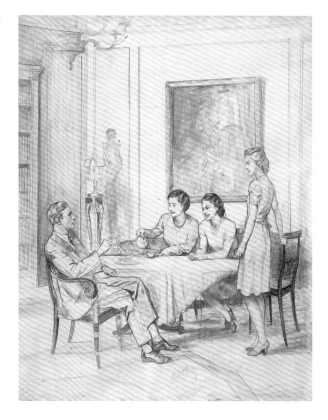

FIG. 1 Sir James Gunn, *Conversation Piece at the Royal Lodge, Windsor*,
1950; oil on canvas (National Portrait Gallery, London)

FIG. 2 Sir James Gunn, *Study for Conversation Piece at the Royal Lodge*,
1950; charcoal on paper (Royal Collection, RCIN 453397)

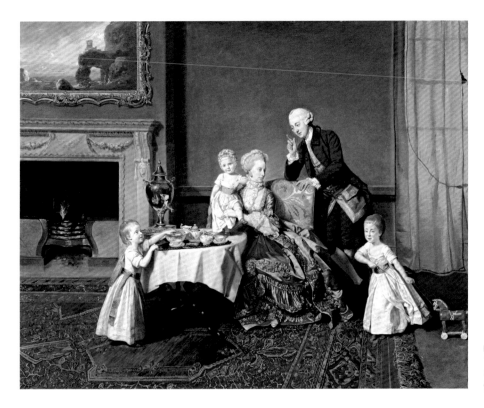

FIG. 3 Johan Zoffany, *John Verney, 14th Baron Willoughby de Broke, and his Family*, c.1766; oil on canvas (The J. Paul Getty Museum, Los Angeles)

group portrait of the Willoughby de Broke family (fig. 3) of *c*.1766, then still in the possession of the sitter's descendants. Here is the same teatime ritual set in a similarly elegant and light-filled interior, with another indulgent father this time telling his younger son not to steal food from the table (or possibly to do it quickly before his mother turns her head). The reference is clearly intended to remind viewers of the prosperity and exquisite taste of Georgian England, the products of which were still admired in 1950, but also of the civilised ideals of the Age of Enlightenment.

The idea that the domestic circle, even when at play, has a sacred value can be traced back another hundred years. Godfried Schalcken's *Family Concert* of the late 1660s (fig. 4) has a symbolic formality of composition: the first, third and fourth figures from the left remind us of the Three Ages of Man and suggest that within a harmonious family these stages proceed in a measured progression. A print of 1656 (fig. 5) depicts William and Margaret Cavendish, monarchists living in exile in Antwerp in the house built by the painter Peter Paul Rubens (1577–1640). They sit in armchairs crowned with laurel wreaths and surrounded by their children and in-laws, like benign

monarchs presiding over a council. The poem beneath makes the moral explicit:

> Thus in this Semy-Circle, wher they Sitt,
> Telling of Tales of pleasure and of witt,
> Heer you may read without a Sinn or Crime.
> And how more innocently pass your tyme.

Visscher's *Grace before Meat* of 1609 (fig. 6) depicts the most obvious manifestation of family virtue – prayer. Later in the century this subject is repeated showing peasant families blessing simple fare. Visscher's family is demonstrably prosperous, but the potential worldliness of the scene is neutralised by the act of thanking God for his generosity. The other examples in this sequence (figs. 1–5) would seem to suggest that piety does not need to be so explicitly revealed: that gratitude may also be shown through the gaiety of an innocent gathering, 'telling tales of pleasure and of witt'.

In general, seventeenth-century Netherlandish viewers read images of wealth and pleasure with a great deal of suspicion, as reminders of the worldliness and vanity of

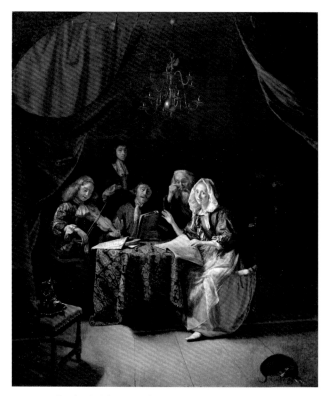

FIG. 4 Godfried Schalcken, *Family Concert*, late 1660s; oil on panel. Published as an engraving in 1769 by the German printmaker Johann Georg Wille; acquired in 1810 by George IV (Royal Collection, RCIN 405337)

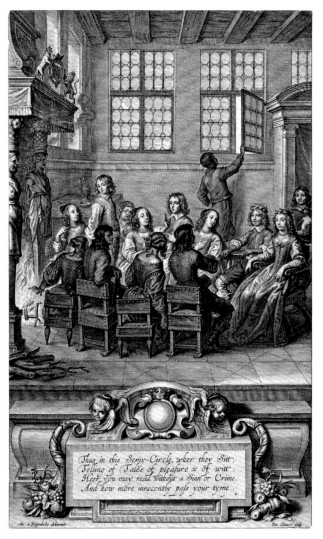

FIG. 5 Peter Clouet after Abraham van Diepenbeeck, *William and Margaret Cavendish with their Family*, engraving published in Margaret's *Natures Pictures drawn by Fancies Pencil to the Life*, London, 1656 (British Museum)

men, particularly young men (see figs. 22 and 24). In art it is sometimes difficult to say whether a fine interior is showing us the good life in this world or urging us to a better one in the next. A glance at the images in this exhibition reveals that the former message gains ground over the latter as the seventeenth century progresses, and almost wholly displaces it during the eighteenth. An important landmark in this respect is the appearance in 1664 of Molière's play *Le Tartuffe*, which shows a pious hypocrite nestling in the bosom of a fun-loving but essentially virtuous family. Voltaire (1694–1778) called the play a masterpiece which had rendered mankind the great service of showing hypocrisy in all its ugliness (letter to Frederick the Great, 20 January 1740). Joseph Addison (1672–1719) wrote in a similar vein in the *Spectator* (no. 494, 26 September 1712) attacking those whose 'Superstitious Fears, and groundless Scruples, cut them off from the Pleasures of Conversation, and all those social Entertainments which are not only innocent but laudable; as if Mirth was made for Reprobates,

and Chearfulness of Heart denied those who are the only Persons that have a proper Title to it'.

One ingredient which distinguishes laudable 'social entertainments' from the activities of reprobates is ceremony. This is the blessing for which Yeats prays in the lines from *Prayer for my Daughter* quoted above. Each of the works discussed so far has depicted a ceremony: afternoon tea (figs. 1–3), a family concert (fig. 4), a family circle (figs. 4–5), and family prayers (fig. 6); every scene has a quiet ceremonial dignity, even if partially disrupted by innocent mischief

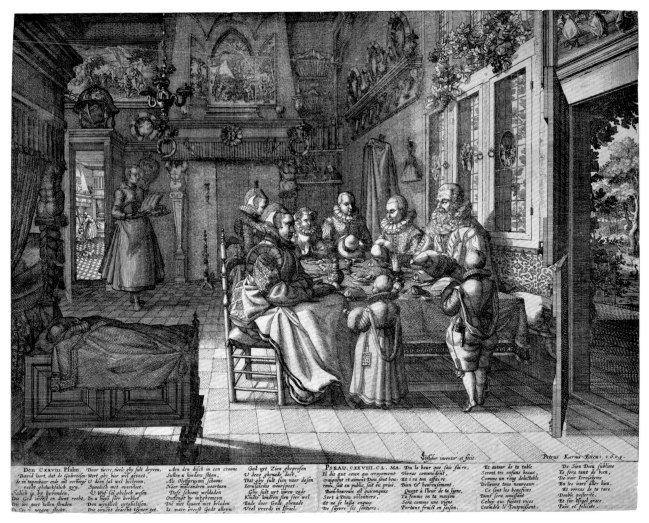

FIG. 6 Claes Jansz. Visscher, *Grace before Meat*, 1609; engraving. Beneath the image is a paraphrase in Dutch and French of Psalm 128 telling of the happiness of the righteous (Rijksprentenkabinet, Amsterdam)

(fig. 3). This quality is most valued when most at risk from strife or social change, which is why so many examples cited above, including Yeats's poem, have come from times of war or its aftermath.

It may seem strange to describe Gunn's *Conversation Piece* as a ceremony when we consider that the artist could have depicted King George VI performing any number of 'real' ceremonies – investitures, Garter processions and the like – in full robes of state, rather than relaxing in civilian attire. Clearly there are two distinct types of ceremony: the domestic event illustrated above, and the 'idol ceremony' described by Shakespeare's Henry V (Act VI, scene I) as

'thrice gorgeous' but a delusion, a 'proud dream', which cannot guarantee its owner a night's sleep.

Throughout the period covered in these pages the monarch performed an astonishing number of official ceremonies. They can be arranged in order of ascending regularity and descending significance: from the one-off christenings, marriages, coronations and funerals, through annual processions (Garter Day, Opening of Parliament) and birthday celebrations to regular investitures and, indeed, the routines of daily life. The arising of the King was called the *levée*, a ceremony invented by Louis XIV and widely imitated, though the word soon came to mean no more than

a morning audience. George III, for example, held a *levée* at midday every Wednesday and Friday, to which gentlemen only were admitted. Monarchs in the seventeenth century regularly ate in public, a ceremony recreated in the interiors of Bartholomeus van Bassen and Gerrit Houckgeest (1600–61), depicting Charles I and his brother-in-law, Frederick, the exiled King of Bohemia (fig. 23 and no. 3). Though painted from the imagination, these scenes provide valuable insight into the ritual. In both the King, Queen and Crown Prince are the only seated figures and the only ones wearing their hats. They are served by a procession of gentlemen wearing swords, rather than mere servants, while other courtiers form an attentive ring behind their chairs. The members of the greater kingdom appear in a public viewing gallery, kept back by pikemen.

Neither of these paintings accurately depicts the interior of an English palace, but Houckgeest's does provide some hint as to their layout (fig. 23). Beyond the public gallery he depicts a sequence of aligned doors, called an 'enfilade', something which can also be seen in the contemporary (also imaginary) interior painted by an unknown artist (fig. 10). In the State Apartments of European palaces rooms aligned in this way were designed to allow ceremonies to be performed in front of an appropriate audience: the subject approached from one end, the monarch emerged from the other; where they met was determined by the importance of the former and the condescension of the latter. This sequence of mounting intimacy is conveyed by the names of the rooms, which might be chosen from the following list (not necessarily in this precise order): Guard Chamber, Presence Chamber, Public Dining Room, Audience Chamber (sometimes Throne Room), Privy Chamber, Withdrawing Room (sometimes called 'Entrée Room'), Gallery, Bedchamber, Dressing Room and Closet.

At the outer end of the sequence a regular public audience was given. Queen Charlotte's companion, Mrs Papendiek, wrote in 1761 explaining the conventions of access: 'many who could not obtain tickets of admission went in Court dresses, which franked them through the rooms as far as the *entrée*.' A comic watercolour by Thomas Rowlandson (1756–1827; fig. 7) shows the Guard Chamber (the outermost room) on such an occasion: courtiers advance while pikemen hold back the less favoured majority. At the inner end of an enfilade a courtier might be granted a private audience in the King's Closet or Dressing Room. A visitor might be stopped at some stage in their approach to the King, but essentially the palace was a place of fashionable resort: according to Pierre-Jean Grosley, who visited London in 1765, the King's palace 'is open to every Englishman'. The King led his life in front of an audience.

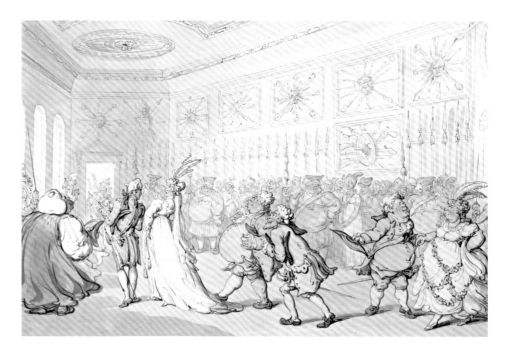

FIG. 7 Thomas Rowlandson, *A Drawing Room at St James's Palace*, nineteenth century; watercolour (Museum of London)

These ceremonies required complex rules of precedence which a magnanimous monarch might waive. Everyone but the man of highest rank must be bare-headed (see no. 3); if two rivals for that title were in the same room, etiquette might require both to leave their hats behind out of politeness rather than deference, as Charles II and Cosimo de' Medici, Grand Duke of Tuscany, did when they met in the King's Closet during the latter's visit of 1669. A petty-minded member of the royal family, on the other hand, might invent new rules, as Frederick, Prince of Wales, did on the occasion of his marriage in 1736.

The King and Queen dined this day as usual in their own apartment, but the Duke and the Princesses were ordered to dine with the Prince and his bride in the Prince's apartment, where the King, to avoid all difficulties about ceremony, had ordered them to go undressed. Notwithstanding which the Prince wisely contrived to raise a thousand disputes, pretending first that his brother and sisters should sit upon stools whilst he and his bride sat in armed chairs at the head of the table; next, that they should not be served on the knee, though neither of these things had ever entered before into his head since he came into England, and that he had ate with them constantly every day.

(Lord Hervey, *Memoirs of the Reign of King George II*, 1736)

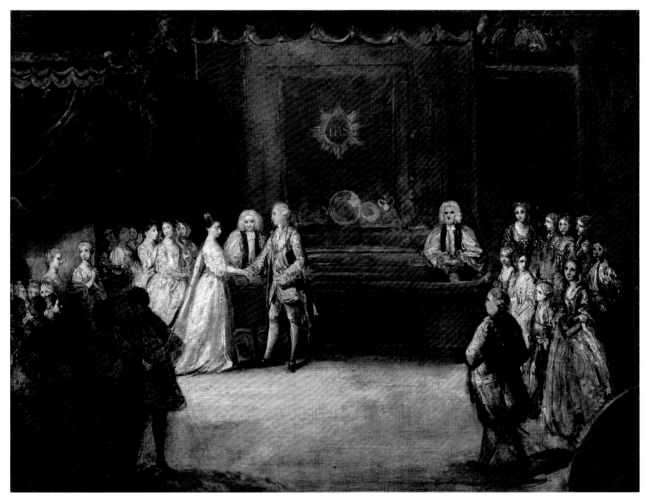

FIG. 8 Sir Joshua Reynolds, *Sketch for the Marriage of George III and Queen Charlotte*, 1762; oil on canvas. This unsuccessful attempt to catch the eye of George III remained in Reynolds's possession until his death; it was acquired by Queen Victoria (Royal Collection, RCIN 404353)

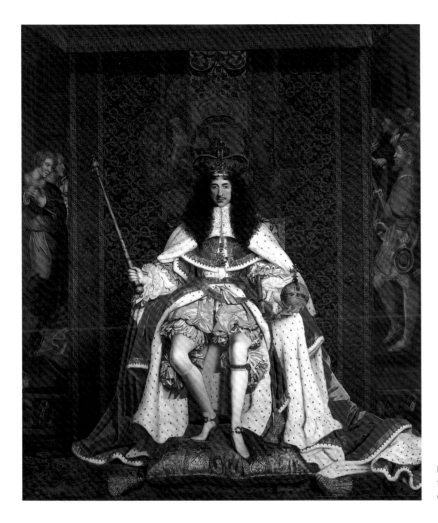

FIG. 9 John Michael Wright, *Charles II*, painted for the King after the Restoration, *c.*1661; oil on canvas (Royal Collection, RCIN 404951)

Royal ceremonies were occasionally recorded in prints, such as that of the marriage of Princess Anne (fig. 47), or even in satires like Rowlandson's (fig. 7). They were, however, surprisingly rarely painted. The history of royal ceremonial painting before 1800 is a short one. Van Dyck planned a series of tapestries depicting Charles I with his Garter Knights, which did not proceed beyond the stage recorded by an oil sketch in a private collection. Reynolds made a bid to depict the marriage of George III and Queen Charlotte, possibly planned as a huge canvas with life-size figures; however, his oil sketch (fig. 8) clearly failed to impress the King. George III's state coach setting off for the Opening of Parliament in 1762 is recorded in John Wootton's charming but hardly ambitious crowd scene (fig. 53). The ceremonies of the reigns of George IV (1820–30) and William IV (1830–37) begin to be

irregularly recorded, but it was Queen Victoria who saw the propaganda value of such images and supervised their creation in large numbers (see pp.163–4).

English monarchs clearly appreciated the contribution that painting could make to the theatre of ceremony, but this was through formal portraiture decorating public spaces rather than through any record of the events that took place there. The life-sized royal portraits by Hans Holbein and John Michael Wright (figs. 15 and 9) provide an image of time-honoured authority to match the venerable rituals of coronation and other formal royal events: they show the paraphernalia of ceremony – the crown, orb, sceptre and robes – even if all these things had had to be re-created for the coronation of Charles II at the Restoration.

The supporting cast in any ceremony is made up of the King's household; these are the men in attendance in

FIG. 10 British School, *Interior with Charles I, Henrietta Maria, the 3rd Earl of Pembroke, the Earl of Montgomery (later 4th Earl of Pembroke), and Jeffery Hudson, c.*1635; oil on canvas. Acquired in 1888 (Royal Collection, RCIN 405296)

van Bassen's *King and Queen of Bohemia Dining in Public* (no. 3). Why did these people not choose to record the honour bestowed upon them by commissioning paintings? An exception to this rule would seem to be the anonymous depiction of Charles I and his queen accompanied by their dwarf and two senior courtiers (fig. 10). These are the 'incomparable pair of brethren' to whom Shakespeare's first folio was dedicated: William Herbert, 3rd Earl of Pembroke (1590–1630) was Lord Chamberlain in 1615 and Lord Steward in 1626, and here appears posthumously; Philip Herbert, 4th Earl of Pembroke (1584–1650) took over from his brother as Lord Chamberlain in 1626. This painting celebrates the family's double distinction. Even in this case, however, the eccentric composition suggests a desire to

demonstrate the power of perspective, playing games on the viewer by placing a dwarf (an unreliable gauge of scale) in the centre of our vision and the royal couple at its periphery. The painting looks like a ceremonial painting that manages to 'just miss' its subject.

The conversation piece in general is the inverse of ceremonial painting and it similarly contrives to miss the formal event. If it is a dinner, then it depicts the dressing and gathering beforehand (nos. 20 and 34), or the moment when the guests proceed to a less formal place for sweets, fruit and wine (nos. 4, 11). It depicts the off-duty part of a normal day – the strolls (nos. 2, 7, 18, 22 and 27), the rides (nos. 8, 28 and 31) and the informal gatherings (nos. 5–6, 12–17). It generally depicts clubs rather than august bodies

(no. 16), but if it does depict the latter, it shows them preparing rather than performing (no. 24).

It may be difficult to explain the paucity of formal ceremonial painting but it is easy to see the value of this more informal type. Throughout history there has been a vein of anti-court literature, whether pastoral poetry advising retirement from court or satire inciting hatred of court. In the eighteenth century there was a fashion throughout Europe for regarding courts and their ceremonies as stiff and dull as well as corrupt. This was a period during which manners were redefined accordingly. Joseph Addison provides a brief history of what happened to the 'various deferencies, condescensions and submissions' that grew up in cities in order to distinguish their inhabitants from rustics:

These Forms of Conversation by degrees multiplied and grew troublesome; the Modish World found too great a Constraint in them, and have therefore thrown most of them aside. Conversation, like the *Romish* Religion, was so encumbered with Show and Ceremony, that it stood in need of a Reformation to retrench its Superfluities, and restore it to its natural good Sense and Beauty. At present therefore an unconstrained Carriage, and a certain Openness of Behaviour, are the height of Good Breeding. The Fashionable World is grown free and easy; our Manners sit more loose upon us: Nothing is so modish as an agreeable Negligence. In a word, Good Breeding shows it self most, where to an ordinary Eye it appears the least.

(*Spectator*, no. 119, 17 July 1711)

This reformation affected monarchs and their courts: Voltaire praised Frederick the Great of Prussia (1712–86) for speaking like a man and shunning that 'gravity which invariably conceals pettiness and ignorance' (letter to Frederick the Great, 20 January 1740).

Perhaps because it is not ceremonial or courtly, the conversation piece has been described as a middle-class form. The introduction to Mario Praz's *Conversation Pieces* (1971) is entitled 'The Art of the Bourgeoisie', although this denomination cannot be strictly accurate or a royal conversation piece would be a contradiction in terms. The form does, however, seem to thrive in societies with a large and powerful middle class: the Low Countries in the seventeenth century, Britain in the eighteenth century, and most of the rest of Europe by the nineteenth century. But it is by no means exclusively bourgeois; rather, it represents common ground occupied by aristocrats as much as by merchants. The genre has recently been described by Christine Lerche as 'a manifestation of a prosperous class, becoming ever more homogeneous'. Put simply, there is no way of telling, had the identification been lost, that Zoffany's painting of John Verney (fig. 3) depicts a 14th Baron rather than a first-generation banker.

Society in eighteenth-century England was becoming more homogeneous in part because aristocrats were prepared to trade: Voltaire contrasted the English peer who becomes a rich and powerful *bourgeois* with the proud but poor prince in Germany. Voltaire was one of many who welcomed the development:

I don't know who is the more useful to a State, the powdered seigneur who knows precisely at what hour the King rises and at what hour he goes to bed and who gives himself airs while acting like a slave in the antechamber of a minister, or a merchant who enriches his country, issues orders from his office to Surat and Cairo, and contributes to the happiness of the world

(Voltaire, *Lettres Philosophiques*, no. 10, 1734)

If 'getting money' is an innocent employment (as Dr Johnson claimed), so, too, is the conspicuous display of those good things that money can buy. The economist and Dean of Gloucester, Josiah Tucker (1713–99), described England as 'a free Country, where Riches got by Trade are no Disgrace, and where Property is also safe against the Prerogative either of Prince or Nobles, and where every Person may make what Display he pleases of his Wealth, without incurring a higher *Taille*, Poll or Capitation the next Year for so doing' (*Instructions for Travellers*, 1757). In 'free countries' (such as Britain and the Netherlands) no sumptuary laws limited the display of fine things, the ownership of which was common to all prosperous classes. Fine things are also the unacknowledged subject of conversation pieces. In these paintings there is little that is specifically aristocratic: princes and peers generally do not wear their robes, though the

sashes or badges of an order (Garter or Bath) appear, even if concealed under hunting costume (see no. 34). It is difficult to define what could be specifically middle-class in societies where the fashion was always to ape one's superiors. In seventeenth-century Holland, however, there were some strikingly modern definitions of the family (in this case, of course, the middle-class family) highlighted by Simon Schama in his *Embarrassment of Riches* (1987). For the moralists of the Dutch Republic the family was a microcosm of that *republican* state: for Jacob Cats (1577–1660) it was a 'community' (*gemeenschap*); Johan van Beverwijck (1594–1647) writes that the 'first community is that of marriage itself; thereafter in a family household with children, in which all things are common' (*On the Excellence of the Female Sex*, 1643). This is not a monarchist's idea of a community, but the Dutch maintained the analogy consistently: the father was to be obeyed *conditionally* upon his rule being just; the wife should respect his authority (and certainly not try to lord it over him), but she was no slave. According to Jacob Cats, 'in our Netherlands, God be praised, there are no yokes for the wife, nor slaves' shackles or fetters on her legs'. To some visitors this freedom looked like anarchy: the sustained attack by the poet and essayist Owen Feltham (?1604–68) on the Dutch included the complaint 'in their families they are all equals and you have no way to know the Master and the Mistress but by taking them in bed together' (*Brief Character of the Low Countries*, 1652). One might imagine such a complaint made by someone used to the sort of deference seen in van Bassen's grand dining scene (no. 3) and then encountering the families depicted by Barent Graat (no. 4) and Godfried Schalcken (no. 6). No English conversation piece depicts this degree of familial anarchy, but there is some levelling nonetheless. Within a royal or aristocratic family the eldest son is incomparably more important than any other child, as he alone will inherit title, power and land. This is what Frederick, Prince of Wales, was insisting upon with his armed chairs and kneeling cup-bearers (pp. 12–13). Within a middle-class mercantile family there is no such limitation, as testified by the number of businesses with the plural 'sons' or 'brothers' in their title. Gunn's family group (fig. 1) is typical of the entire history of the conversation piece in the equal prominence given to the children. Needless to say, in some cases the heir is distinguished, either by stage-management

No. 21 (detail)

(as in nos. 14 and 21) or through some discreet visual contrivances, like the toy horses with which the eldest sons play in figs. 3 and 36 to remind us of their status as the 'cavalier' or knight of the younger generation.

If childish equality is a middle-class characteristic then the formal garden, which appears in so many conversation pieces, is certainly aristocratic. Aristocrats own land and impose order upon it. As early as 1545, in the anonymous allegory of Henry VIII's reign (fig. 16), the glimpse of formal garden in the background derives from depictions of the Virgin but is here suggestive of the orderly realm over which the King presides, peopled by his loyal subjects. This idea of a formal garden as metaphor for the benefits of good government is known to us through a gardener's words in Shakespeare's *Richard II*:

Why should we, in the compass of a pale,
Keep law and form and due proportion,
Showing, as in a model, our firm estate,
When our sea-walled garden, the whole land,
Is full of weeds; her fairest flowers chok'd up,

Her fruit-trees all unprun'd, her hedges ruin'd,
Her knots disordered, and her wholesome herbs
Swarming with caterpillars?

(*Richard II*, Act III, scene IV)

The same idea informs Andrew Marvell's famous description of a republican aristocrat's house and garden:

Unhappy! Shall we never more
That sweet militia restore,
When gardens only had their towers,
And all the garrisons were flowers,
When roses only arms might bear,
And men did rosy garlands wear?
Tulips, in several colours barred,
Were then the Switzers of our Guard.

(*Upon Appleton House*, stanza 42)

The persistence of the image of the formal garden within the conversation piece is confirmed by a glance at the images reproduced in these pages. The passages quoted above provide two related virtues associated with the garden: orderly governance and a well-protected haven of peace. Marvell's device of imitating arms and fortifications in flowers and hedges can also be seen in the fort-garden of De Jongh's courtly conversation piece, *A Formal Garden* (no. 7). Even in depictions of interiors a surprising number of houses leave their doors open (nos. 5, 11, 20; figs. 4, 6, 36, 86) or offer views through large windows (nos. 15, 34; fig. 57), as if to convey the idea that the just rule of the house extends out to the garden and beyond.

When the formal garden became unfashionable during the eighteenth century it was replaced in conversation pieces by the landscape garden (as in nos. 13, 14, 21–2 and 27–8), suggesting especially the sort of philosophical parks with symbolic temples and altars created at Twickenham by Alexander Pope (1688–1744) or at Stowe by his friend Lord Cobham (1669–1749). By the end of the eighteenth century the idea of the English garden had been exported to most European countries. The grandson of George II, Wilhelm IX, Landgrave of Hesse-Cassel (1743–1821), created a huge one at Wilhelmshöhe, his country palace near Cassel. His court painter, Wilhelm Böttner (1752–1805), depicted the Landgrave with his family in a recently completed section of the park (fig. 11). The mythological presiding genius of Wilhelmshöhe is Hercules, represented in a giant statue at the summit of the hillside; Böttner's painting is a re-telling of the story of Hercules choosing between Virtue

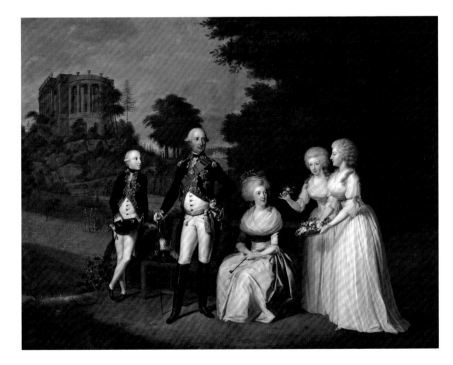

FIG. 11 Wilhelm Böttner, *Wilhelm IX of Hesse-Cassel with his Family*, signed and dated 1791; oil on canvas. Behind the figures appears the right-hand block of Wilhelmshöhe Palace, then under construction
(Royal Collection, RCIN 401351)

and Pleasure. The composition is divided into two equal halves; to the left is a rocky path leading up to a temple-like structure (in fact a wing of the palace), suggesting the reward for strenuous and virtuous aspiration, against which are set the men of the house, the Landgrave and his heir, the future Elector Wilhelm II of Hesse (1777–1847). To the right the realm of pleasure is suggested by the women, the Landgravine, Wilhelmine Caroline (1747–1820), and her two daughters, Frederika (1768–1839) and Caroline (1771–1848), gathering flowers against a background of woodland. The scene looks like a choice of Hercules, but requires no choice: it is a celebration of both principles and a reminder that, in the opinion of the time, it is a man's duty to strive and a woman's to please.

Even in the age of landscaped parkland glimpses of unfashionable formal gardens survive, such as that seen through the open door behind Queen Charlotte's dressing table (no. 20). When the formal garden enjoyed a partial resurgence in the early nineteenth century it took centre stage in Landseer's image of 'modern' Windsor Castle (no. 34). In Landseer's painting Prince Albert has clearly been hunting amongst the wilder oaks beyond the protected confines of the formal garden. Royal and aristocratic conversation pieces often allude to the extent of land ownership

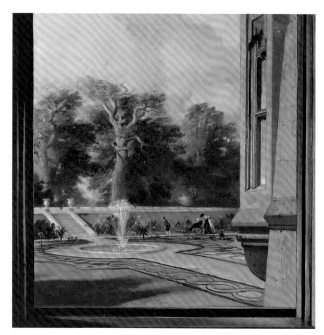

No. 34 (detail)

by setting the scene away from the house, as in the intrepid hunters straying into the dark forest in Wootton's *Shooting Party* (no. 17). In the later eighteenth century this became part of the cult of Jean-Jacques Rousseau (1712–78), who considered that Nature was a child's best moral tutor. Zoffany depicted the sons and daughters of the Earl of Bute having an improving nature ramble, though it is significant that the boys have ventured further than the girls (figs. 55–6). Rousseau did not of course invent these ideas in a vacuum: children were encouraged to get out of doors, especially in England, even before the publication of *Emile* in 1762. The princes and princesses in Du Pan's group portrait (fig. 44) seem to have strayed beyond the confines of the park to set up their country sports competition. However, the persistence in this type of painting of formal gardens, 'landscaped' nature and (occasionally) privately owned wildernesses, like the Great Park (no. 17), must have made a contemporary audience start with surprise to see Queen Victoria in Landseer's *Loch Laggan* (no. 35) drawing a magnificently inhospitable landscape at the side of a public road, miles from anywhere.

Unlike other works in this selection, Gunn's painting (fig. 1) has the words 'Conversation Piece' in its title. By the 1950s the conversation piece was regarded as a distinct genre of painting and its exponents thought to represent a great tradition within English art. Sacheverell Sitwell's classic study of 1936, *Conversation Pieces: a Survey of English Domestic Portraits and their Painters*, opens with the words: 'There are certain qualities of the English genius which find their expression in the English Conversation Piece.' Sitwell and others in the last century (Ralph Edwards and Mario Praz) define the type quite precisely and consistently. Edwards provides the best summary: 'if a picture is to pass as a "Conversation" the figurers should be considerably smaller than life, represent real people, and be associated in an informal portrait group; from which it follows (though this is not essential) that some incident or domestic occupation may be introduced' (*Early Conversation Pictures from the Middle Ages to about 1730*, 1954). The majority of works included here meet this description; all but a few were produced in Britain or for British patrons, and most in the Georgian or early Victorian period. However, the selection has been extended to include seventeenth-century Netherlandish works, some but by no means all painted in England,

and several works which in other ways lie outside Sitwell's definition. To what extent can they be called 'conversation pieces'?

In general usage during the seventeenth and eighteenth centuries the word 'conversation' meant firstly 'social gathering' and to a lesser extent, as now, the chat which takes place at such occasions. The family in Molière's *Le Tartuffe* are accused of excessive socialising (Act I, scene I):

Ces visites, ces bals, ces conversations
Sont du malin esprit toutes inventions
Là jamais on n'entend de pieuses paroles:
Ce sont propos oisifs, chansons et fariboles;

(These visits, balls and 'conversations' are all
inventions of an evil spirit; you never hear pious
words there; they are full of idle chat, songs
and flimflam)

This fashionable French word entered every European language, spelled *Conversation* in German, *conversazione* in Italian and *conversatie* in Dutch. It was also used to describe paintings of such events, but not so as to distinguish between group portraits and imaginary scenes, which we would now call 'genre' paintings. A version of Rubens's *Garden of Love* (fig. 35), for example, was described in the inventory of his estate as '*Een conversatie à la mode*'. English sale catalogues up to 1760 continued describing high-life Netherlandish and French genre paintings as 'conversations' (in English 'conversation' and 'conversation piece' are used interchangeably). The word '*conversatie*' was also used to describe group portraits, usually depicting prosperous families, by such artists as Gonzales Coques (see fig. 36). It was this definition that began to be used more systematically in England during the eighteenth century. George Vertue wrote in 1729 of his friend Hogarth: 'The daily success of Mr Hogarth in painting small family peices [*sic*] & Conversations with so much Air & agreeableness Causes him to be much followd, & esteemd. whereby he has much imployment & like to be a master of great reputation in that way.' Vertue clearly here refers to group portraits, though elsewhere he uses the word 'conversation' to describe genre paintings. This distinction was presumably made more easily by the original patron: it is now impossible to determine whether the works of Marcellus Laroon (nos. 11–12), for example, are peopled with portraits or types. In general it can be said that the Dutch and the English had the same word to describe substantially the same thing.

Most of the works included here could have been called 'conversations' by their creators. The exceptions may be the hunting and 'mews' scenes, by de Hondecoeter (nos. 8–10), Wootton (no. 17), Gilpin and Marlow (no. 26), and Stubbs (nos. 28–30), which do not show a social gathering but are closely related to the conversation pieces through the common theme of fashionable life. They depict the pleasures, the prosperity and the orderly wellbeing of a gentleman. It is a further justification of the connection that Stubbs did paint works, such as his portrait of the Milbanke and Melbourne families (fig. 76), described then and now as 'conversations'. The works included here have been selected to explore the fluid margins of this type of painting in the visual cultures of Britain and the Low Countries, where genres were adapted and combined with opportunism and innovation.

In the early eighteenth century the word 'conversation' came increasingly to mean 'intellectual exchange' as well as 'social gathering'. The freedom to consort, without being accused of having a '*malin esprit*', tends to accompany a freedom to exchange other than '*pieuses paroles*'. This was not altogether a new invention: one of the first classics of European philosophy, Plato's *Symposium*, describes an Athenian conversation, a drunken party at which Socrates expounds (in the form of a dialogue) his exalted ideas of heavenly beauty and spiritual love; this disreputable party is the nearest the pagans get to the Sermon on the Mount. Joseph Addison wanted to achieve something similar: 'It was said of *Socrates*, that he brought Philosophy down from Heaven, to inhabit among Men; and I shall be ambitious to have it said of me, that I have brought Philosophy out of Closets and Libraries, Schools and Colleges, to dwell in Clubs and Assemblies, at Tea-Tables and in Coffee-Houses' (*Spectator*, no. 10, 12 March 1711). It is no accident that philosophical ideas were expressed at this time in the form of the dialogue, which, according to David Hume, 'unites the two greatest and purest pleasures of human life – study and society' (*Dialogues Concerning Natural Religion*, written *c*.1751 and published in 1779). Addison's reference to the 'tea-table' above probably means something equivalent to the French *salon*; his other places of philosophical conversation are peculiarly English, the coffee-house, the assembly

and, above all, the club. The conversation piece celebrates the jocularity as well as the intellectual exchange of clubs, but also draws attention to the fact, frequently remarked upon by French visitors, that women were absent from so many English gatherings. According to the Abbé le Blanc, the English 'think the fair sex are made only to take possession of their hearts, and seldom or never to afford any amusement to their minds. They prefer the pleasure of toasting their healths in a tavern, to that of chatting with them in a circle' (*Letters on the English and French Nations*, 1747, no. 7). Several images within this exhibition (nos. 16, 24 and 25) admit women only in the form of paintings. On the positive side of the balance there is a warmth in the celebration of friendship (not necessarily though predominantly all-male), which suggests an appealing ideal of philosophical conviviality. It is interesting that this is seen as part of the 'counter-court' culture. For Addison, 'True Happiness is of a retired Nature, and an Enemy to Pomp and Noise; it arises, in the first place, from the Enjoyment of one's self; and, in the next, from the Friendship and Conversation of a few select Companions' (*Spectator*, no. 15, 17 March 1711). This is the blend that Pope seeks to capture when he describes entertaining agreeable has-beens at his Villa in Twickenham:

> There, my retreat the best companions grace,
> Chiefs out of war, and statesmen out of place.
> There ST JOHN mingles with my friendly bowl
> The feast of reason and the flow of soul:
> (*Horace Imitated: Satire I of Book II*, ll. 125–8)

Zoffany captures this spirit in his improbably affectionate group of academicians (no. 24). At this time portrait painting was believed to be a social art and not necessarily to be despised for depicting the domestic rather than the heroic. Samuel Johnson claimed that he should 'grieve to see Reynolds transfer to heroes and to goddesses, to empty splendor and to airy fiction, that art which is now employed in diffusing friendship, in reviving tenderness, in quickening the affections of the absent, and continuing the presence of the dead' (*The Idler*, no. 45, 24 February 1759).

Johnson is thinking of portraiture in general as an art which celebrates familiar and loved *people*; as we have seen, the conversation piece also celebrates familiar and loved *things*. Other branches of painting deal with ownership,

No. 24 (detail)

many closely related to the conversation piece and popular in England during the eighteenth century: the country house portrait, horse painting, and conventional life-sized portraiture, though this genre almost never shows the sitter's possessions beyond the clothes he wears. Conversation pieces are full of beautiful things, conveying the elegance and opulence either of a milieu (if genre paintings) or an individual (if portraits). Zoffany's *Tribuna* (no. 25) depicts the greatest concentration of beautiful things in the world (in the opinion of contemporaries). This painting also demonstrates the way in which the enjoyment of beautiful things was considered to be part of the education of a gentleman and a mark of civilisation. Throughout history beautiful things have been considered morally suspect: in the seventeenth century they might be described as 'worldly ostentation', today the same idea is conveyed by the phrase 'conspicuous consumption'. In the majority of images in this catalogue the fine things would have been considered as demonstrating the fine taste of the patron and of the age in which he lived.

The centrality of 'material culture' to the conversation piece means that there is a particular benefit in exploring the genre within a specific collection. Almost every royal conversation piece contains some reference to the accumulation of beautiful things within the Royal Collection as well as adding to that stock. The interior with Charles I of the

1630s (fig. 10) shows the King's recently acquired Titians, the *Entombment* and *Supper at Emmaus* (both now in the Louvre), as well as his courtiers; Royal Collection paintings, by John Wootton and Thomas Lawrence, feature on the walls of the Royal Lodge in James Gunn's *Conversation* of 1950 (fig. 1). The palace interiors and their furnishings similarly play an important part in these works, whether they are brilliantly new, as in Zoffany's interior of the 'Queen's House' (no. 19), or reassuringly old, as in Landseer's Windsor Castle (no. 34) or Gunn's Royal Lodge (fig. 1). The influence of the royal collection of paintings can be seen operating in a remarkable number of the works included here. It is most effectively exploited when an Old Master is brought to life again in a modern context, as Zoffany does with Van Dyck, Rubens and Formentrou (nos. 19, 21, 22 and 25), or as Landseer does with Ter Borch and Vermeer (nos. 33–4).

After the lapse of a century or more, paintings can be admired for characteristics which would have surprised their original creators. The most remarkable case of this creative misinterpretation concerns a Ter Borch painting published in 1765 as a print by Johann Georg Wille (1715–1808), entitled *L'Instruction Paternelle* (fig. 12). The characters in Goethe's *Elective Affinities* (*Die Wahlverwandtschaften*) of 1809 create a *tableau vivant* of this print (Book II, chapter 5), drawing attention to its subtle reading of the dynamics of a bourgeois family:

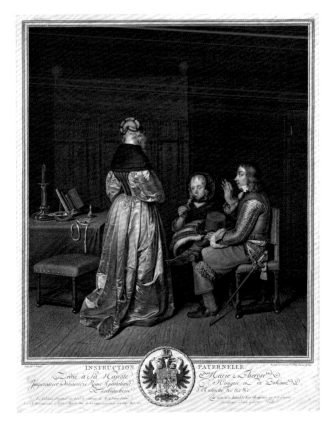

FIG. 12 Johann Georg Wille after Gerard Ter Borch, *L'Instruction Paternelle*, 1765; etching with engraving (British Museum)

> One foot thrown over the other, sits a noble knightly-looking father; his daughter stands before him, to whose conscience he seems to be addressing himself. She, a fine striking figure, in a folding drapery of white satin, is only to be seen from behind, but her whole bearing appears to signify that she is collecting herself. That the admonition is not too severe, that she is not being utterly put to shame, is to be gathered from the air and attitude of the father, while the mother seems as if she were trying to conceal some slight embarrassment – she is looking into a glass of wine, which she is on the point of drinking.

Recent cleaning has revealed a coin held in the 'father's' hand with which he is paying for the girl in what is now recognised as a brothel scene. Zoffany has not misread Ter Borch's *Lady at her Toilet* (fig. 60) or Landseer his *Letter* (fig. 92) as dramatically as this, but in both cases the meaning of the original has changed. Dutch art was admired in the eighteenth and nineteenth centuries for its uncomplicated depiction of everyday life, not for its abstract moralising: Ter Borch's general meditation upon vanity (fig. 60) becomes a portrait of a specific and virtuous mother (no. 20); his scene of intrigue (fig. 92) becomes an image of marital bliss. The story of the conversation piece within a specific collection allows an insight into the way in which architecture, painting and the decorative arts are enjoyed over the centuries, riding the waves of fashion and neglect, through a process of rediscovery and reinterpretation.

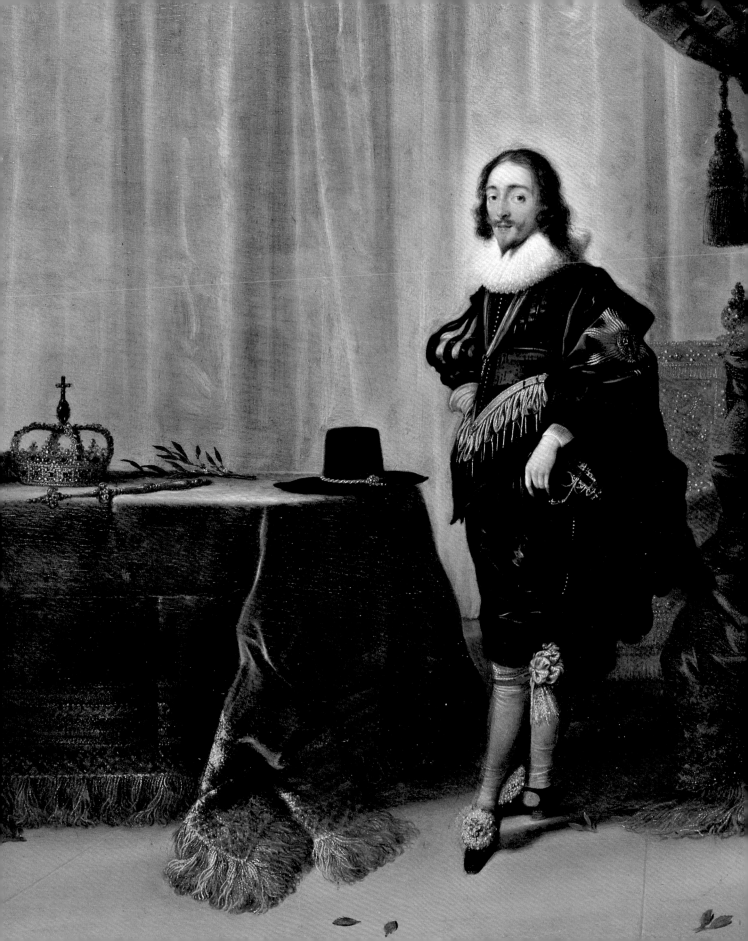

1

Charles I (1600–1649)

1 Charles I (1600–1649)

WHAT are the roots of the conversation piece? The type of painting in the sixteenth century which most anticipates the classic seventeenth-century 'conversatie' is the family group portrait, such as the lost painting of the family of Sir Thomas More by Hans Holbein the Younger (known through a drawing in Basle) and the portrait of the unknown family, signed and dated 1524, by Bernardino Licinio (fig. 13). This group, acquired by Charles I in 1627, shows a father dispensing justice in the matter of an apple (to nobody's apparent satisfaction) in a very jostling family-republic. It is possible that the portrait of the family of the Duke of Buckingham commissioned by Charles I in 1628 (fig. 14) shows some influence of the recently arrived Venetian painting, but the comparison only serves to point up the patriarchal order and subordination of the later

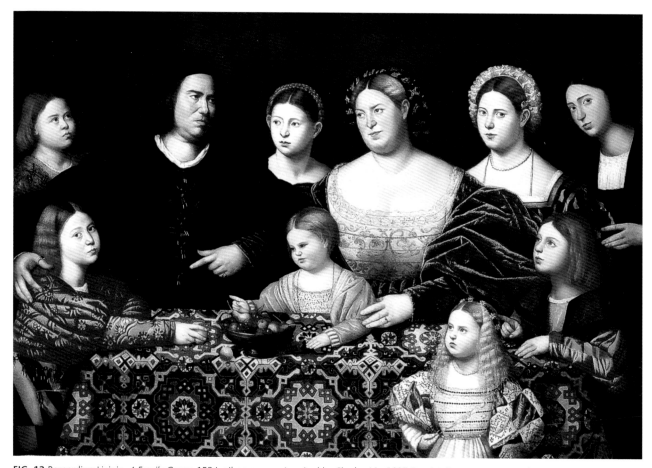

FIG. 13 Bernardino Licinio, *A Family Group*, 1524; oil on canvas. Acquired by Charles I in 1627 (Royal Collection, RCIN 402586)

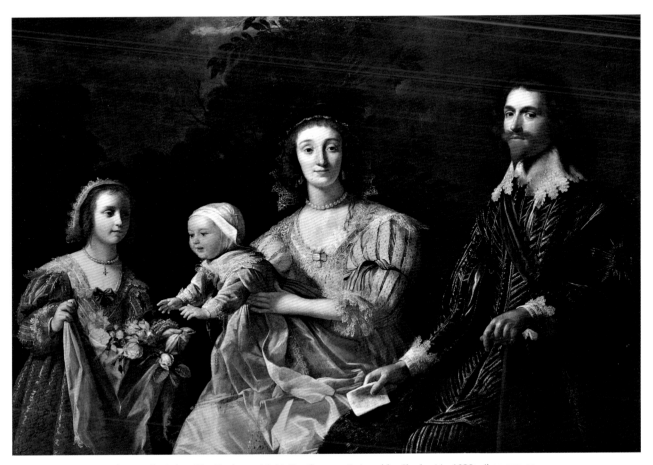

FIG. 14 Gerrit van Honthorst, *The Duke of Buckingham with his Family*, commissioned by Charles I in 1628; oil on canvas (Royal Collection, RCIN 406553)

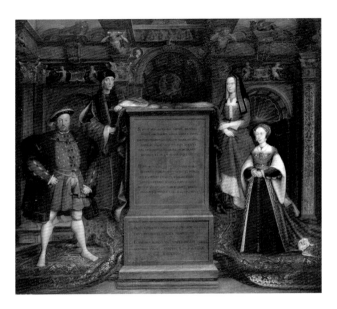

FIG. 15 Remigius van Leemput after Hans Holbein the Younger, *Henry VII, Elizabeth of York, Henry VIII and Jane Seymour*, inscribed with the date 1667, after an original of 1537; oil on canvas. Holbein's mural covered the end wall of the Privy Chamber at Whitehall Palace (Royal Collection, RCIN 405750)

work. The Duke placed in the foreground seems to present his wife who sits centrally, facing directly out of the picture and 'crowned' by the laurel tree behind, like the queen of the family.

If it plays a part in this context, how much more should this respect for 'degree' impose itself on Royal portraiture? In 1537 Hans Holbein the Younger painted a mural to cover the entire wall of the Privy Chamber at Whitehall Palace, creating the effect of the east end of a chapel. It was lost when the palace burned in 1698 and is known today through the reduced copy by Remigius van Leemput (fig. 15). This

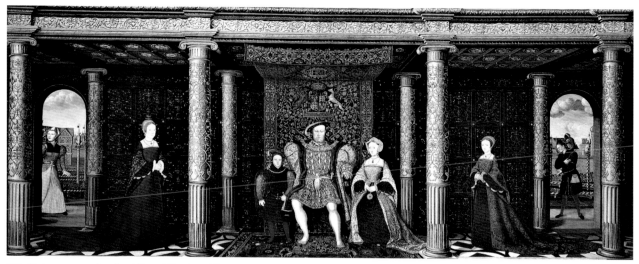

FIG. 16 Anonymous, *Family of Henry VIII*, painted for Henry VIII in 1545; oil on canvas (Royal Collection, RCIN 405796)

is the opposite of the conversation: the life-sized figures are hieratic, with a frontal stare directed at the viewer, and an iconic, uncommunicative and impassive immobility; they are canopied by niches, and are placed, like chesspieces, according to the rules of a dynastic game. The four figures (Henry VII and his queen, Elizabeth of York, behind Henry VIII and his third wife, Jane Seymour) appear like four saints within an Italian altarpiece, with the central Virgin and Child replaced by eulogistic Latin inscription. The anonymous *Family of Henry VIII* (fig. 16) of 1545 creates the same effect on a smaller scale, with Henry VIII himself occupying the central throne, flanked immediately by Jane Seymour and her son, Edward VI; his daughters, Princesses Mary and Elizabeth, occupy the outer bays.

Charles I appreciated imagery of this type and sought to embody in his reign the character of royal solemnity that it projects. According to Lucy Hutchinson, he was 'temperate, chaste, and serious; so that the fools and bawds, mimics and catamites, of the former court [that of James I], grew out of fashion' (*Memoirs of the Life of Colonel Hutchinson*). He reversed the trend towards informality of manners at court and reintroduced Elizabeth I's cult of the monarch as a sacred and separate being, a cult maintained through ceremony. Access to the royal presence was restricted; dress at court was more closely regulated; public functions, such as dining in state (see fig. 23), were more stage-managed. Charles admired Tudor manners and added considerably to the collection of Holbein portraits he had inherited. On

the other hand, his interest in Italian Old Masters exposed him to inventively informal images such as Licinio's family portrait (fig. 13), and to individual portraits such as Bronzino's *Portrait of a Lady in Green* (*c*.1528–32; Royal Collection, RCIN 405754), which must have made Tudor imagery seem stiff and old-fashioned. The portrait painters he attracted to England brought with them some of the same Italian warmth and *disinvoltura*. Rubens visited London in 1629, having been well known to English patrons within Charles's circle for at least a decade. He painted few group portraits, but they all have an easy physical spontaneity, especially in the depiction of children, which is crucial to the development of the conversation piece. His portrait of the Gerbier family (fig. 46) was not acquired for the Royal Collection until 1749, but he presented the King in 1630 with his *Allegory of Peace* (1629–30; National Gallery, London), which included portraits of some of the same children. Rubens's *Garden of Love* (fig. 35) of *c*.1630 was widely disseminated through Christoffel Jegher's woodcut of the mid-1630s and is probably the single most important image in the history of the conversation piece (see p. 63 below).

Charles I commissioned an allegorical ceiling from Rubens, but no royal portraits; perhaps he found his work too direct or 'familiar' in comparison to the idealising refinement of his pupil, Van Dyck. But Van Dyck is not all aristocratic hauteur; he could on occasion draw upon Rubens's vein of tender humanity and comedy. His

group portrait of the King's children (fig. 17) shows an awareness of Holbein: the Prince of Wales stares out boldly and directly, with a hint of the icon, like his Tudor ancestor (fig. 15), flanked by symmetrically arranged siblings. In other respects it is the opposite of dynastic: it depicts a single moment; it suggests a dialogue amongst the sitters and between them and the viewer. This painting hung over the fireplace in Charles I's breakfast room at Whitehall; it is probable that it was conceived imagining the King and Queen as its viewers, which explains the intimate immediacy and banter of the scene.

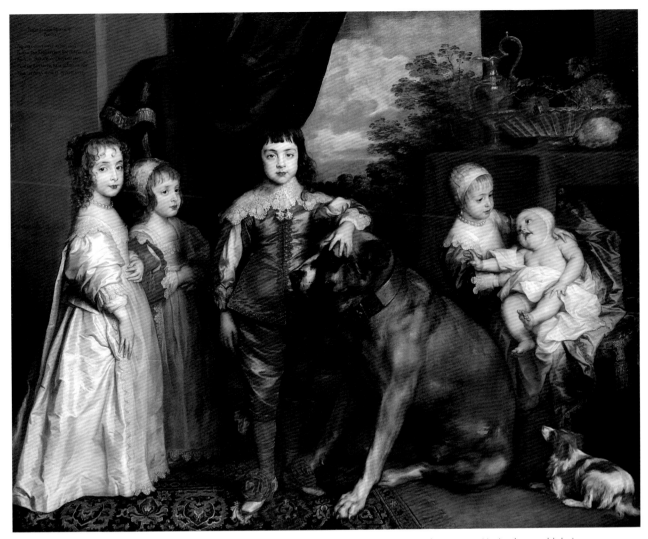

FIG. 17 Sir Anthony van Dyck, *The Five Eldest Children of Charles I*, painted for the King in 1637; oil on canvas. Having been sold during the Commonwealth, this painting was re-acquired by George III in 1765 for 500 guineas (Royal Collection, RCIN 404405)

| HENDRICK POT (1585–1657)

Charles I, Henrietta Maria and Charles, Prince of Wales (later Charles II)

Oil on panel
47.3 x 59.7 cm
Probably painted in 1632
Seen by Reynolds in a private collection in The Hague in 1781; acquired by George IV from the Baring collection in 1814
RCIN 405541
White 1982, no. 152

HENDRICK Pot was a native of Haarlem but his precise and polished manner of painting high-life genre and small-scale portraits resembles the work of his Amsterdam contemporaries, in particular Hendrick de Keyser (1596–1667). Charles I may have become interested in this relatively minor artist through his allegorical triumphal procession, *The Glorification of William the Silent*, commissioned by the city of Haarlem in 1620, or his group portrait, *Officers of the Civic Guard of St Adrian* of 1630 (both Frans Hals Museum, Haarlem). He is recorded as working in London in 1632, and according to Arnold Houbraken (1660–1719) he painted 'the British King with his wife from the life, with various great men of that Kingdom'. This lost painting must have been a ceremonial piece depicting a council or state function, perhaps looking something like fig. 23 (p.37).

The present work can be dated by analogy with an almost identical portrait of Charles I standing alone, signed and dated 1632 and now in the Louvre. The painting is more a scaled-down family group than a conversation piece. However, at exactly this date Charles I was experimenting with introducing dialogue into royal portraits: in the double portrait of 1630–32 (fig. 18), for example, Daniel Mytens shows the King sharing his glory with his Queen, symbolised by the passing of a laurel crown. Pot's family group is spread out across the space as if in a real room, though the curtain, column and backcloth are all props derived from formal portraiture (compare fig. 18). This arrangement gives prominence to the Queen seated upon the dais, and the infant Prince perched on the side of a table, which he shares with the crown and sceptre. We are to imagine that the Prince has been allowed to play with some sprigs of foliage: he has scattered laurel leaves on the floor and holds an olive branch. Thus he is being introduced to the two qualities of royalty: Glory (symbolised by the laurel) and Good Governance (symbolised by its result, the Olive of Peace). He has clearly been encouraged to value the latter virtue most highly.

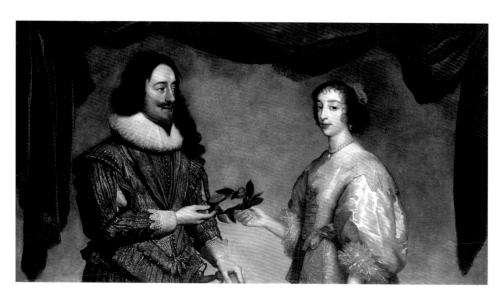

FIG. 18 Daniel Mytens, *Charles I and Henrietta Maria*, painted for Charles I in *c*.1630–32; oil on canvas (Royal Collection, RCIN 405789)

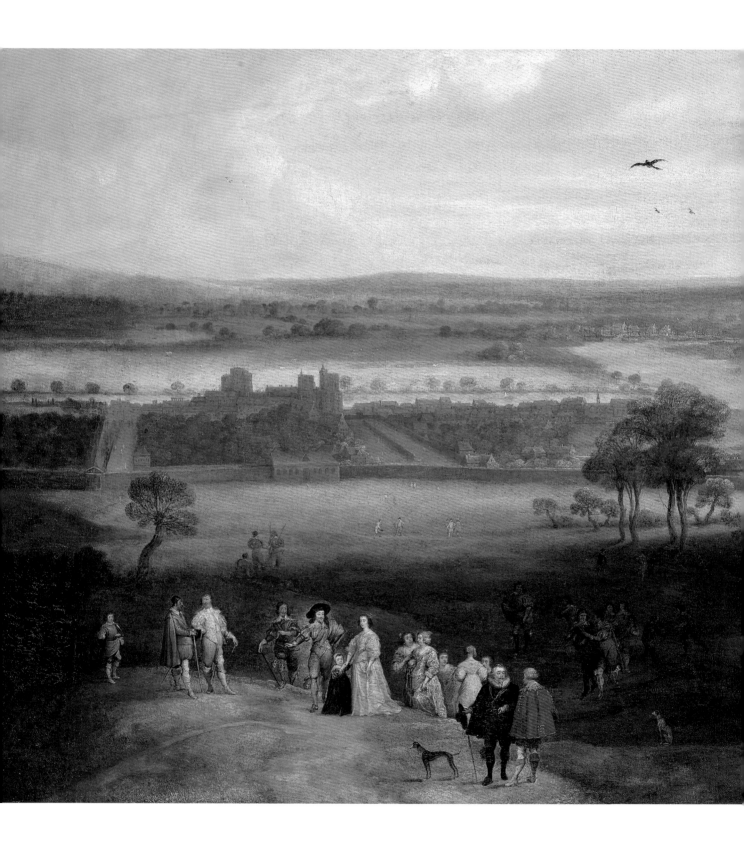

2 ADRIAEN VAN STALBEMT (1580–1662) with JAN VAN BELCAMP (c.1610–53)

A View of Greenwich

Oil on canvas
82 × 107 cm
Signed: *A v Stalb . . J v B*
Probably painted *c.*1632
Painted for Charles I
RCIN 405291
Millar 1963, no. 197

THIS work is a collaboration of two minor artists brought over by Charles I from the Low Countries: Adriaen van Stalbemt was a landscape painter from Antwerp, and Jan van Belcamp a Dutch copyist (rather than portrait painter) who worked with Abraham van der Doort on the management of the King's collection of paintings.

Greenwich Palace was the favourite haunt of the Tudor monarchs; Henry VIII, Mary I and Elizabeth I were all born here. The broad outlines of the Tudor palace, known to us from Antonis van der Wyngaerde's watercolours (figs. 19–20), can be made out: to the left, the remains of the Friary (little more than a rectangular space), built *c.*1481; the main block running along the river front; to the right, Henry VIII's tilt-yard, with the two towers linked by a gallery for spectators. James I settled Greenwich upon his Queen, Anne of Denmark, and in 1616–19 began building the Queen's House, visible here as a single-storey stump, occupying the

FIG. 19 (below) Antonis van der Wyngaerde, *Greenwich Palace and London from Greenwich Hill*, 1558; pen and brown ink and watercolour over black chalk (Ashmolean Museum, University of Oxford)

FIG. 20 (below, bottom) Antonis van der Wyngaerde, *Greenwich Palace from the North Bank of the Thames*, 1558; pen and brown ink and watercolour over black chalk (Ashmolean Museum, University of Oxford)

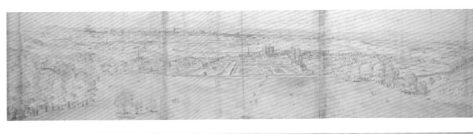

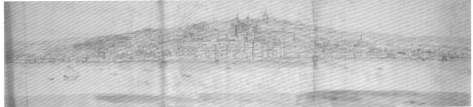

position of the gatehouse in the older palace and similarly straddling the public road. The view must be taken from directly in front of the observation tower, built in the 1430s by Humphrey, Duke of Gloucester (1390–1447), on the site of the present observatory.

The City of London, which appears in the background of Wyngaerde's watercolour (fig. 19), lies off the left-hand margin of Stalbemt's view. On its right-hand side, in the bend of the Thames and at the mouth of the River Lea, is Blackwall, the site of a shipyard and mooring for large ocean-going vessels (a few visible here), especially those owned by the East India Company. It was from here that the English adventurer Captain John Smith sailed for America in 1606; the East India Dock occupied this site from 1806 until 1967. The field over the river is now the site of the Millennium Dome.

The figures strolling in the foreground are probably all copied by Belcamp from larger portraits and added as if in a sticker-book. Apart from the three members of the Royal Family (who appear to be the same age as in the previous painting), few can be recognised: the man on the left may be the Richard Weston, 1st Earl of Portland (1577–1635, Lord High Treasurer 1628–33) or Inigo Jones (1573–1652); the swaggering man talking to him is certainly Endymion Porter (1587–1649); the figure labouring up the hill between him and the King could be Philip Herbert, 4th Earl of Pembroke (see fig. 10). Three or four of the other figures look like portraits, and would no doubt have been recognised by contemporaries; the others must be generic lords and ladies of the court. Some pikemen rest behind, while further down the slope other men practice fencing.

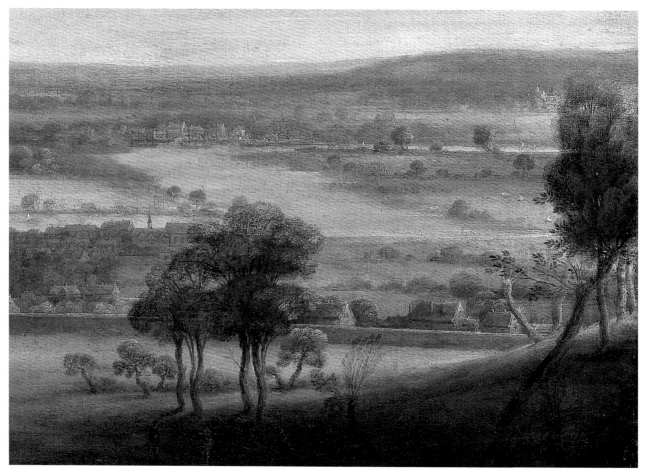

No. 2 (detail)

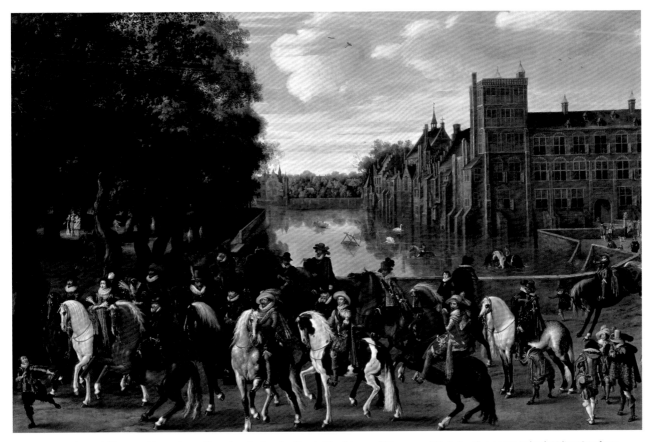

FIG. 21 Pauwels van Hillegaert (formerly attributed to Ambrosius Pacx), *The Princes of Orange and their Families on Horseback Riding Out from The Buitenhof, The Hague, c.*1621–2; oil on canvas. This cavalcade is led by the King and Queen of Bohemia (Royal Cabinet of Paintings, Mauritshuis, The Hague)

These are the elements of this painting; it is more difficult to say what brings them together. The most likely explanation is that this is a 'site visit' and marks the resumption of work on the Queen's House, completed by Charles I during the years 1630–38 for his Queen, Henrietta Maria. This identification clearly depends upon whether the left-hand figure is indeed the architect of the house and prominent courtier, Inigo Jones. Alternatively, it may be that the King simply wanted to be seen frequenting a park which had been so important to the previous dynasty. This is not dissimilar to the way in which the Prince of Orange had recently had himself painted with his extended family (including his heroic ancestor William the Silent, apparently brought back to life) riding in front of a similarly venerable palace, the Buitenhof (fig. 21).

3 BARTHOLOMEUS VAN BASSEN (*fl.* 1613–32)

The King and Queen of Bohemia Dining in Public

Oil on panel
55.2 x 86. 4 cm
Signed: *B. van Bassen*
Probably painted 1634
Acquired by George II or Queen Caroline from the Countess of Pomfret in 1729
RCIN 402967
White 1982, no. 14

THE Elector Palatine, Frederick V (1596–1632), succeeded his father in 1610 and in 1613 married Princess Elizabeth (1596–1662), daughter of James I. In 1619 he accepted the crown of Bohemia and, after a single winter's reign (for which reason he is known as the 'Winter King'), was defeated by Emperor Ferdinand II and driven into exile. Here he enjoyed the protection of his first cousins, the Princes of Orange and Stadtholders of the Dutch Republic, Maurice (1567–1625) and Frederick Henry (1584–1647). The Winter King and Queen are granted the honour of leading the cavalcade in van Hillegaert's celebration of the Orange dynasty (fig. 21). Charles I paid out regularly to maintain his sister and brother-in-law's court at The Hague and was heartbroken by Frederick's death in 1632.

Van Bassen was born in Antwerp but migrated to the Northern Netherlands in 1622 and worked for the rest of his career in The Hague. He was one of a small group of artists who at this date specialised in fantastic palace interiors and courtyards, with a precise perspective learned from the treatise of Hans Vredeman de Vries. Dirck van Delen and Dirck Hals's *Banquet Scene* of 1628 (fig. 22) gives a good idea of the way in which such scenes allow us to enjoy the spacious elegance of the architecture and to laugh disapprovingly at the careless extravagance and affectation of these peacock revellers. Van Bassen was also commissioned by the States of Utrecht in 1629 to transform the Convent of St Cunerakerk into a palace for the King of Bohemia, described by Evelyn as 'a neate, & well built Palace, or Country house, built after the Italian manner' (*Diary*, 30 July 1641).

The circumstances of the creation of this painting are somewhat conjectural. Another version of this composition (Sotheby's, 27 March 1974, no. 119) is

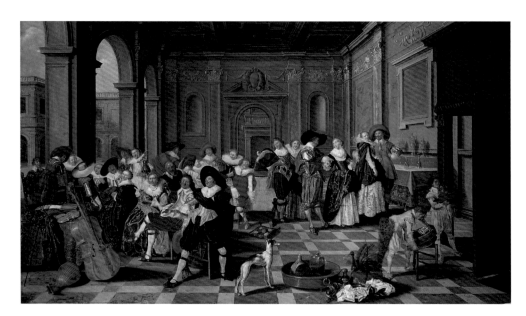

FIG. 22 Dirck van Delen and Dirck Hals, *Banquet Scene in a Renaissance Hall*, signed and dated 1628; oil on panel (Gemäldegalerie der Akademie der bildenden Künste, Vienna)

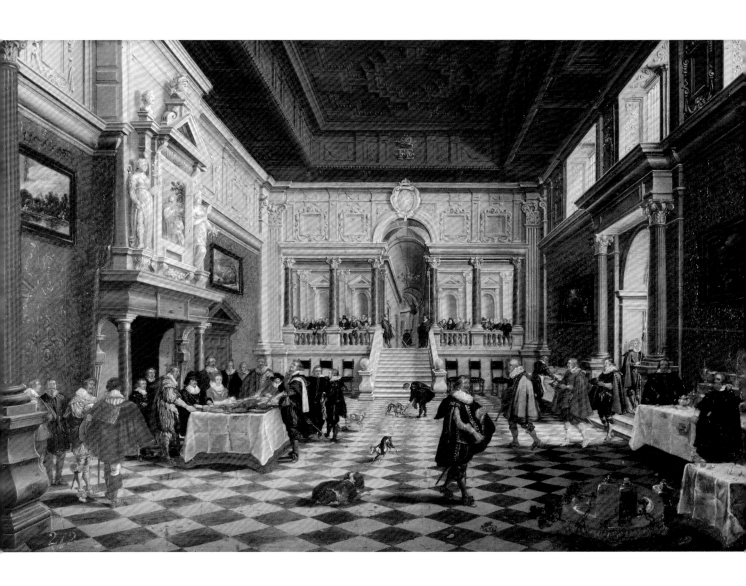

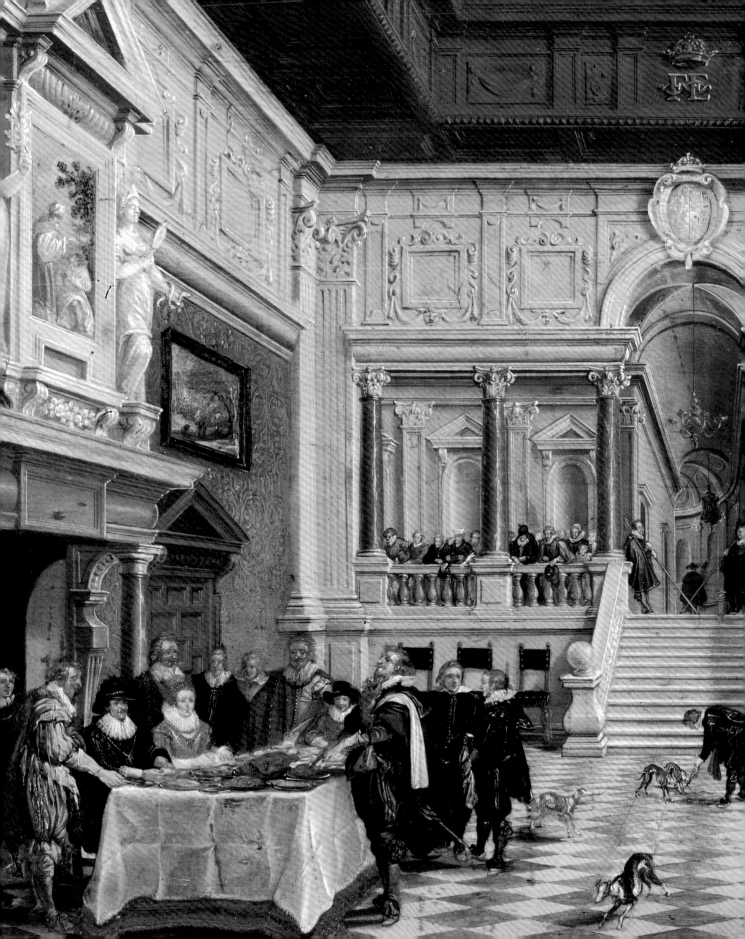

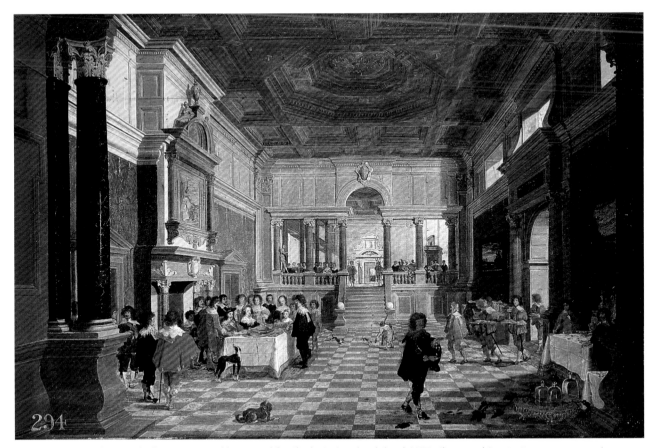

FIG. 23 Gerrit Houckgeest, *Charles I Dining in Public*, painted for Charles I, signed and dated 1635; oil on panel (Royal Collection, RCIN 402966)

signed and dated 1634; a derivation by Van Bassen's pupil, Gerrit Houckgeest, showing Charles I dining (fig. 23) is dated 1635. These two facts suggest that this painting was created in or around 1634, two years after Frederick's death. It is probably intended to depict the Bohemian reign of the winter of 1620, when the couple's eldest son, Prince Frederick Henry (1614–29), was six, though this is a little younger than he appears to be here. The incident of the pet monkey attacking the principal courtier as he attempts to carve was said have taken place in Prague in 1620, when the couple were first served by the local nobility.

The architecture is imaginary; Van Bassen may have been involved in designing the real interior in which they lived, but his special talent lies in creating something much more splendid in paint. In the same way, it did not occur to Houckgeest to draw Whitehall Palace if he visited London or request drawings of it if he did not; his imagination (and the model provided by his master in the present work) can furnish Charles I with a virtual dining hall far surpassing reality (fig. 23).

Van Bassen's painting is a nostalgic and fanciful evocation of the former splendour of the exiled King, in an appropriately grand setting and with all the formality of public state dining (described above and quite unlike the careless anarchy of the revelry seen in fig. 22). There is an *FE* monogram in the ceiling; a painting of a patriarch blessing his son and statues of Prudence and Peace (encouraging commerce) above the mantle. Everything celebrates the glory, wisdom and virtue of a rule that never happened.

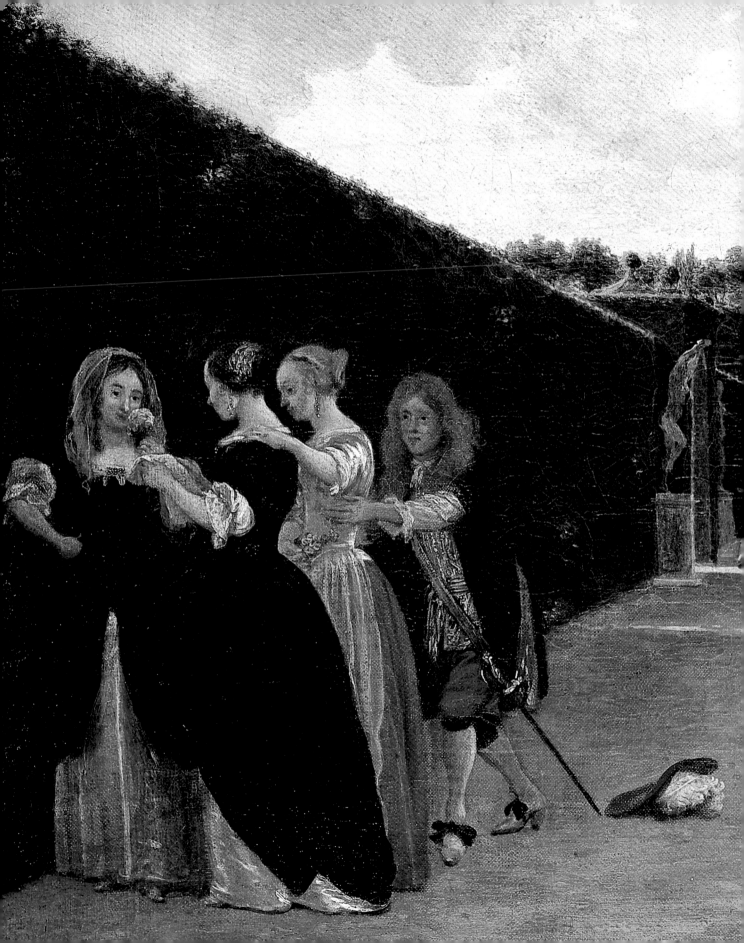

The Dutch Republic (1648–1714)

2

2 The Dutch Republic (1648–1714)

THE revellers in Dirck van Delen and Dirck Hals's *Banquet Scene* (fig. 22) would have been called 'Spanish Brabanters', a phrase originating in the Southern Netherlands meaning fashion victims, local fops (from the province of Brabant) adopting the manners of Spain. Such scenes were popular in Holland in the first quarter of the seventeenth century, sometimes set out of doors in fanciful palace gardens, bowers or woodland glades. Steenwyck's *Figures on a Terrace* of *c*.1615 (fig. 24) is an example produced in Antwerp by an artist who subsequently worked in London. Some such scenes have titles to point out their moral message: the 'Prodigal Son wasting his inheritance', 'Men before the Flood' and so on. The medieval tradition of the idyllic 'Garden of Love' does survive in isolated examples, such as the *Maze*, a complex allegory of love's progress by the Flemish artist working in Venice, Lodewijk Toeput, known as Pozzoserrato (*c*.1550–*c*.1605; fig. 25). Painted in *c*.1580 and already in London by 1615, this work embodies the positive evocation of an *earthly* but not *worldly* lovers'

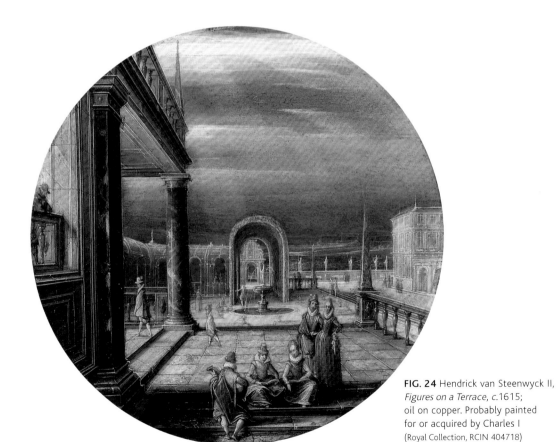

FIG. 24 Hendrick van Steenwyck II, *Figures on a Terrace*, *c*.1615; oil on copper. Probably painted for or acquired by Charles I (Royal Collection, RCIN 404718)

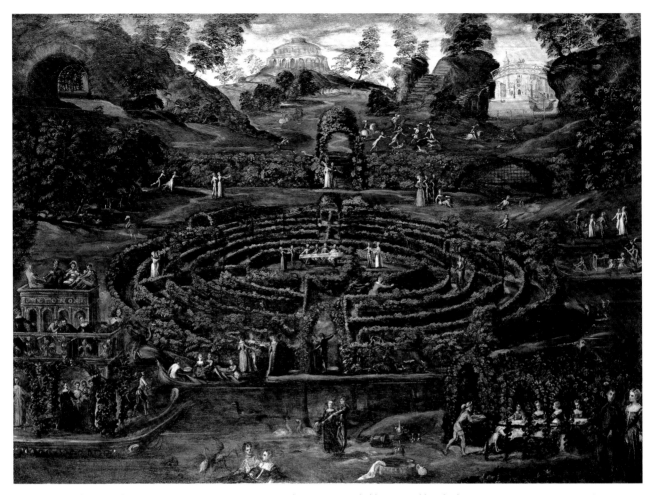

FIG. 25 Lodewijk Toeput, known as Pozzoserrato, *Maze*, *c.*1580; oil on canvas. Probably acquired by Charles II (Royal Collection, RCIN 402610)

paradise, which Rubens draws upon for his *Garden of Love* (fig. 35). However, Pozzoserrato's painting is the exception; for the most part these 'outdoor parties' (*buitenpartijen*), as they were called, are intended to deliver a simple message: thinking about pleasure means forgetting duty.

We have already seen another tradition which includes images of families, like that in Visscher's *Grace before Meat* of 1609 (fig. 6), who evidently remember their duty very well. Jan Molenaer's portrait of his own family engaged in making music, painted *c.*1635 (fig. 26), lies somewhere between these two opposites and is an early example of a Dutch conversation piece. In some respects the members of this real family are behaving like the imaginary revellers in Van Delen and Hals's *Banquet Scene* (fig. 22), enjoying the moment and wearing their finest clothes. There is even

an allusion in the little boy carelessly blowing bubbles on the right to the insubstantial nature of earthly things, which usually accompanies scenes of vanity. There are other symbols of mortality here: the skull and hourglass in the portraits behind, the clock between them. In this case, however, the episode concerns the continuity of the dynasty rather than the death of the individual. This is a middle-class version of Holbein's royal mural (fig. 15): the eldest brother and painter of the scene clearly identifies himself on the right; family portraits are arranged across the back wall, with his parents presiding in the form of an imposing pair of half-lengths. Dynastic pride and continuity are not symptoms of vanity here, but its antidote: the circle is a solemn one, the symbolism of harmony and *measure* (the girl in the middle beats time) is reinforced by the carved allegory on

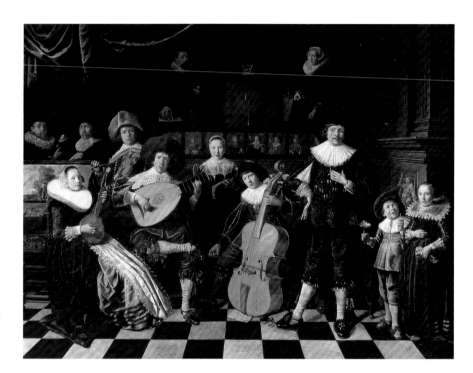

FIG. 26 Jan Miense Molenaer, *The Artist's Family Playing Music*, *c.*1635; oil on panel (Netherlands Institute for Cultural Heritage, on loan to the Frans Hals Museum, Haarlem)

the pedestal of the columns depicting Justice, which dispenses a different sort of measure. This serious play on words also operates in Dutch where the word *maat* means 'rhythm' as well as 'moderation'. A similar Molenaer group portrait of 1635, depicting the Van Loon family (private collection), shows four ages of man disposed across a single room: mischievous children playing; a young bachelor courting a girl; a married couple making music together on lute and virginal; an elderly couple sitting at a table with their hands resting on a skull and a prayer book. Both works combine a solemnity appropriate to the seriousness of the theme with an element of innocent play – music-making and childish disruption – that belongs to the tradition of the conversation piece.

The conversation pieces in this section were produced during a period of political and social change in the Dutch Republic. In the 1640s the Dutch fought the Spanish to a standstill and concluded their eighty-year war of independence with the favourable terms of the Treaty of Münster in 1648. It was also through this Treaty that the Dutch Republic gained international recognition. During the same period the House of Orange, the family of the hereditary governor (Stadtholder), cemented its royal credentials through the marriage in 1641 of Prince William II (1626–50)

to Mary Stuart (1631–60), daughter of Charles I. A difficult period then followed for both families: Charles I was executed in 1649 and his family escaped to Holland where the future Charles II lived in exile, supported by his brother-in-law, William II of Orange, and in the same town as his aunt, the Winter Queen (see no. 3). Perhaps coincidentally, this time also marked the high tide of republicanism in Holland, which decided to dispense with the services of the Stadtholder after the death of William II in 1650.

In 1660 the tide turned in favour of absolutism. Charles II was invited back to England. His farewell party was organised by the House of Orange on 30 May 1660 at the Mauritshuis in The Hague and is recorded in a huge conversation piece by the Flemish artist Hieronymus Janssens (1624–93; fig. 27). Charles II is shown dancing with his sister, Mary; his brothers, James, Duke of York (later James II, 1633–1701) and Henry, Duke of Gloucester (1640–60), and Mary's son, William III of Orange (1650–1702), are recognisable from their blue Garter slashes and the fact that they are the only individuals wearing hats. The host, John Maurice, Count of Nassau-Siegen (1604–79), appears deferentially behind Charles II.

It was also at this time (in 1661) that Louis XIV of France, the Sun King, attained his majority and decided

not to replace his First Minister, Cardinal Mazarin (1602–61), but to rule on his own account. In the same year Louis began the expansion of a small hunting lodge at Versailles. The next fifty-four years (until Louis's death in 1715) may be described as the 'Age of Versailles', even in relation to society in the Dutch Republic and Great Britain, such was the influence of the Sun King. Frederick the Great (1712–86) claimed that during the reign of his grandfather, Frederick I (born 1657, reigned 1688–1713), 'a young gentleman was taken for a fool if he had not been some time at the court of Versailles' (*Memoirs of the House of Brandenburg*, 1751). Certainly Charles II attempted to emulate his first cousin, Louis XIV, in every aspect of his reign: his building, patronage and the stage-management of court ceremony. The fact that Stuart rule came to an end with the death of Queen Anne in 1714, a year before Louis's death, emphasises the parallel.

Louis XIV also unwittingly encouraged absolutism and aristocratic manners within the Dutch Republic. When he invaded the Low Countries in 1672 the position of Stadtholder was hastily reinstated; William III of Orange was restored and the French army was beaten back. In 1677 William III married Mary Stuart (1662–94), daughter of James, Duke of York, and in 1688 he crossed the Channel to become King of England, Scotland and Ireland. Louis XIV's invasion of Holland may have incited an implacable hostility to his authority, especially in the breast of William III, who used his arrival in England as an opportunity to resist French advances. His policy led to the Anglo-Dutch alliance against the French in the War of the Spanish Succession (1710–14), the successful conclusion of which in 1714 marks the close of the period under discussion in this section (though technically peace between the French and the Anglo-Dutch allies was settled at the Treaty of Utrecht a year earlier). Enthusiasm for French culture in Holland and England seems to have been unaffected by these and previous conflicts: William's improvements to Hampton Court are as Versailles-fixated as Charles II's to Windsor, and Dutch merchant-aristocrats aped the costume and manners of the French court.

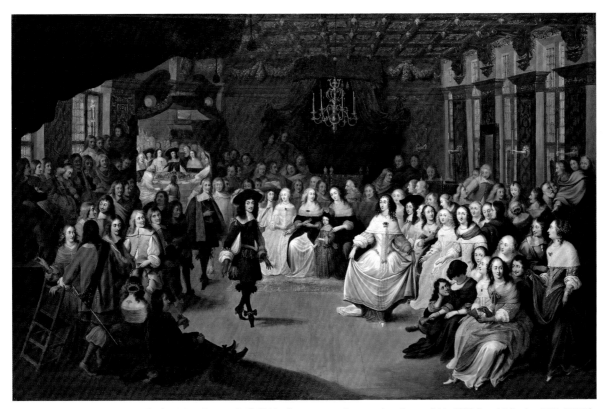

FIG. 27 Hieronymus Janssens, *Charles II Dancing at a Ball*, 1660; oil on canvas. Presented to George IV in 1828 (Royal Collection, RCIN 400525)

4 BARENT GRAAT (1628–1709)

Family Group

Oil on canvas
58 x 67 cm
Signed and dated 1658
Acquired by George IV in 1811
RCIN 405341
White 1982, no. 55

IN the period 1655–75 Dutch painters transformed the depiction of middle-class interiors and courtyards in group portraits and genre paintings. Various aspects of this transformation can be seen in this oil and the other works in this section. The present family group, probably painted in Amsterdam, is similar to the *Family in a Courtyard in Delft* of *c*.1657–60 by Pieter de Hooch (Gemäldegalerie der Akademie der bildenden Künste, Vienna), but the imprecision of their dates and the fact that they were produced in different cities makes it impossible to say whether their similarity is a question of influence and, if so, in which direction that influence might have flowed. Both paintings demonstrate the emergence at this time of a naturalistic, informal depiction of figures in space, which makes the settings of the previous generation (no. 3 and figs. 22–3) appear like theoretical perspectival exercises. Unlike De Hooch's Delft courtyard, Graat's portico appears too Italianate to be a Dutch home, but the rendering of atmospheric light and tactile detail in the two works is comparable. Graat seems also to have been influenced by Ter Borch's

'trademark' depiction of fine silk (figs. 60 and 92), which he first developed in the 1650s.

This family group depicts Dutch burghers at their most jocularly unceremonious, enjoying fruit and wine on a terrace, with no suggestion of the excess or foppishness of the 'outdoor party' scenes of the previous generation. Notwithstanding Owen Felltham's remarks (quoted above, p. 16), the master and mistress of this house are easily spotted: he sits centrally and is the only man wearing a hat; she is enthroned in the only chair with arms, on his left. It was conventional for portraits of husbands and wives to be hung this way round, in order to give the former due prominence (see also the background of Molenaer's family group, fig. 26). This comparison with Molenaer's family also reveals how old-fashioned the father's ruff and pointed beard must have appeared in 1658; the importance of Molenaer's deceased parents perhaps allows the supposition that the father in the present work is portrayed posthumously, the likeness taken from a portrait painted in the 1620s and inserted into the heart of a living family group.

5 PIETER DE HOOCH (1629–84)
A Music Party

Oil on canvas
52.1 x 58.4 cm
Signed: *P. D. Hooch 1667*
First recorded at Hampton Court in 1850
RCIN 403028
White 1982, no. 86

DE HOOCH moved from Delft to Amsterdam in 1660 and his painting correspondingly went up-market. The same change took place in the work of his associate in Delft, Johannes Vermeer (1632–75), and can be seen in his *Music Lesson* of *c.*1665 (fig. 90). Both artists realised that a tiled floor (or indeed a plaster wall) is not merely a perspectival diagram but a precious surface, reflecting light with a lustre comparable to Ter Borch's silks (which incidentally are consciously emulated here by de Hooch in the women's dresses). De Hooch and Vermeer also decided that a scene is more effective if it appears glimpsed rather than stage-managed: in comparison to Molenaer's *Family Playing Music* (fig. 26) the present composition is lopsided and asymmetrical, with figures apparently unaware of the viewer's presence, even turning their backs. Our experience of the world, as opposed to a stage, is partial: in de Hooch's interior we are dazzled by the street outside bathed in brilliant sunshine so that our eyes can only just make out the cloth backing of the wall as a shadowy veil.

This scene is almost certainly imaginary, but is directly comparable in its sumptuous definition of space and surface to de Hooch's portrait groups of the same time, such as his *Family Playing Music* of 1663 (fig. 28). The music-making in no. 5 is probably not symbolic of family harmony as in fig. 28 (and as in so many other cases, including figs. 4 and 26), but rather of courtship.

FIG. 28 Pieter de Hooch, *Portrait of a Family Making Music*, 1663; oil on canvas (The Cleveland Museum of Art, Ohio)

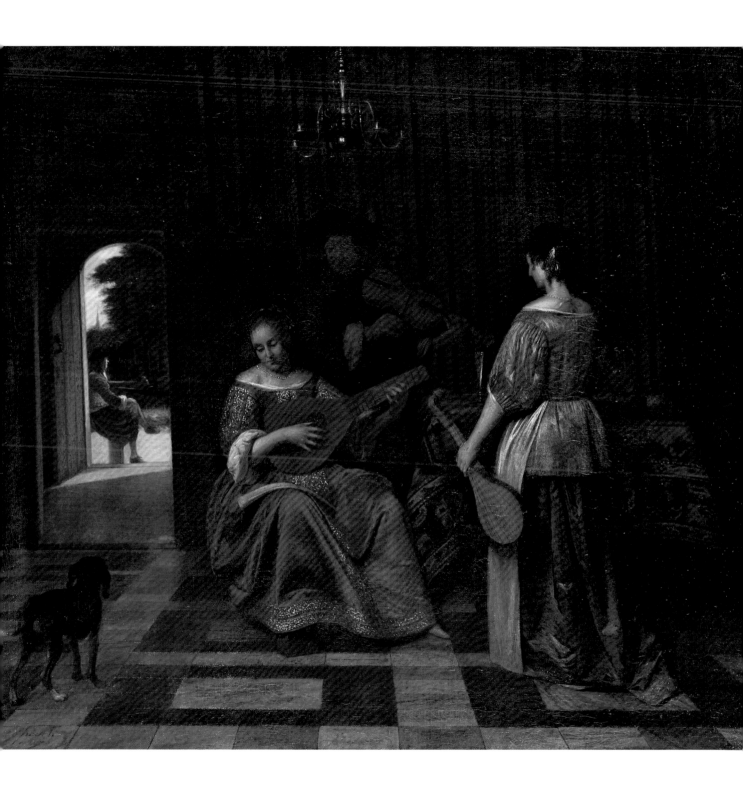

6 GODFRIED SCHALCKEN (1643–76)

'Lady Come into the Garden'

Oil on panel
63.5 x 49.5 cm
Signed, painted *c.*1668–70
Acquired by George IV in 1803
RCIN 405343
White 1982, no. 180

IF THE 'Delft School' of Vermeer and De Hooch and the works of Gerard Ter Borch represent two strands in the transformation of Dutch genre painting, the third is provided by Gerrit Dou and his many followers. Godfried Schalcken studied with Dou in Leiden during the years 1662–5, before returning to his native Dordrecht where this work was created. Dou taught 'fine-painting' – the meticulous depiction of minute detail. According to his pupil and biographer Arnold Houbraken, Schalcken was said to have worked for one month on the tapestry in this painting alone. This level of application requires more than just patience: every part of this warmly glowing candlelit scene analyses the impact of light. Detail is to be found only where there is light enough to reveal it, mostly around the foreground, although the tapestry itself is fitfully lit.

Many early seventeenth-century interiors are sight-tunnels, where the illusion of maximum distance is created by telescoped single-vanishing-point perspective (see figs. 10 and 23). Schalcken does the same thing with shadow: we are made to peer into the darkness, which seems at first to preclude any depth, but gradually our eyes pick out the fireplace, the far wall of the room and the curtain opened to reveal another room beyond.

Houbraken also provides the best information we have as to the events depicted in this bizarre gathering:

> in the cabinet of Mr. Joh. van Schuilenburg hangs the representation of a certain game that the youngsters of Dordrecht would commonly play at that time, whenever they gathered with each other to have fun together, called 'Lady come into the Garden' [*Vrouwtje kom ten Hoof*]. He [Schalcken] portrayed himself dressed in his shirtsleeves and underwear and seated against the lap of a girl. The other faces are also portraits, and were recognized by all at the time
> (*The Great Theatre of Netherlandish Painters and Paintresses*, 1718–21)

With so many innocent-looking Dutch scenes actually depicting brothels (see fig. 12), it seems counter-intuitive to suggest that the risqué horse-play presented here is in fact innocent; but this is what Houbraken says and he remains our best witness. It has to be said that respectable Dutch women of this period were renowned for their apparent licence but actual chastity. The English naturalist John Ray (1627–1705) remarked in his *Observations* of 1673 on their habit of kissing, 'frequently used among themselves either in frolics or upon departures and returns though never so short'. The participants certainly appear to be frolicking in this painting, but to what end? What are the rules of this game 'Lady Come into the Garden'? Presumably the young man (a self-portrait) has undergone a series of tests, failure in which has resulted in his surrendering one item of clothing at a time until he is reduced to the state visible here, stripped to his undergarments. We can be relieved that the game will go no further as the girl behind, said to be the artist's sister Maria, is already beckoning to the next victim. Schalcken appeals to the audience as if to say, 'Women! They'll have your shirt!'

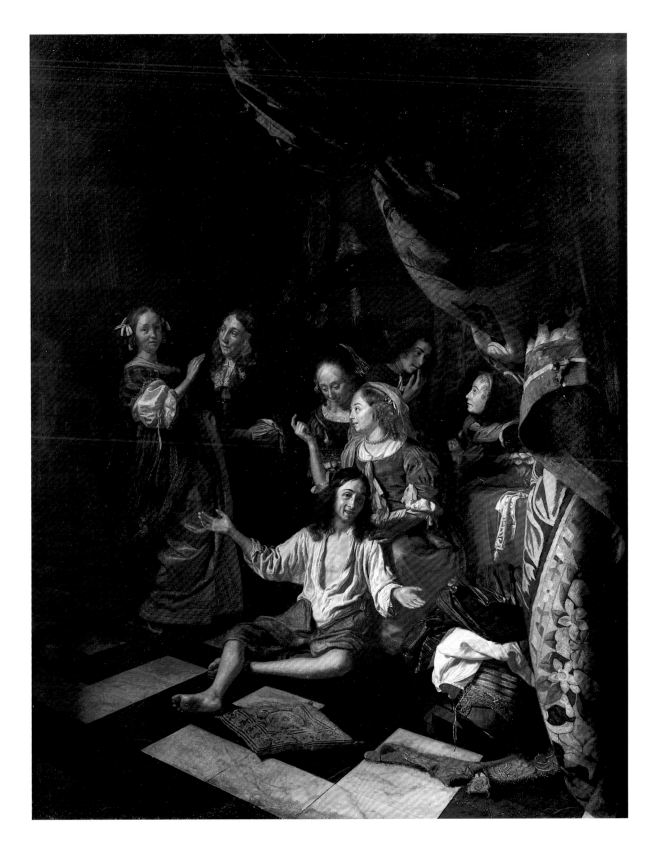

7 LUDOLF DE JONGH (1616–79)

A Formal Garden: Three Ladies Surprised by a Gentleman

Oil on canvas
60.3 x 74.9 cm
Probably painted in 1676
Acquired by George IV before 1806 as by Pieter de Hooch
RCIN 400596

DE JONGH is best known for his courtyard or garden scenes, closely resembling the late work of Pieter de Hooch. This is a perfect demonstration of the way in which prosperous Dutch merchants adopted the manners of aristocrats in the latter part of the century, especially after the French invasion of 1672. There is a similarity between this palace garden and its occupants and those depicted in moralising scenes at the beginning of the century, such as Steenwyck's *Figures on a Terrace*

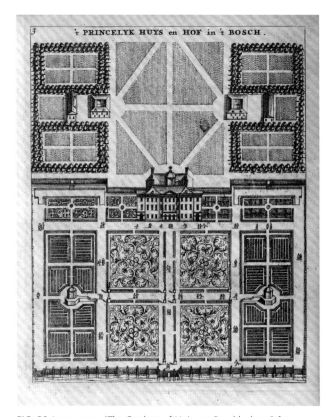

FIG. 29 Anonymous, 'The Gardens of Huis ten Bosch', plate 3 from Jan van der Groen, *Le Jardinier Hollandois*, Amsterdam, 1669 (British Library)

(fig. 24). The main difference is that de Jongh's figures are not 'Spanish Brabanters' but an equally parodied type, which replaced them towards the end of the century: imitators of French fashion. Furthermore, the palace gardens of Steenwyck and his contemporaries were imaginary and impossible, whereas the present one may be imaginary but is certainly possible. This is the kind of country house, built in the classical style and with a rectilinear formal garden, which became fashionable after the construction of the Huis ten Bosch ('House in the Woods') near The Hague in 1645–55 (fig. 29), the royal summer palace and a sort of patriotic shrine to the Stadtholder, Frederick Henry of Orange.

There may be something similarly patriotic in the present scene, for it does not seem to be mocking courtly indolence in the same way as Steenwyck (and others) did. The garden is designed like a fortress, with high hedges defended by a magnificent replica of the Borghese Gladiator, catching the evening sun. This perhaps expresses the heroism of the aristocratic owner who, we are led to imagine, protected the Dutch Republic and made it safe for Dutch maidens to gather roses like the Three Graces. The man with them wears a sword, which was much less common for civilians in Holland during this period than it was in other countries, where it was the ubiquitous badge of a gentleman. He starts forward so abruptly that his hat has fallen off; is he coming to protect or to steal a kiss from the women? Either way, this looks like the sort of frolicking seen in the previous work. This is a 'gallant' scene; the word, as universal in European languages as 'conversation', has two meanings exactly describing the combination of arms-bearing courage and attentive courtship depicted here.

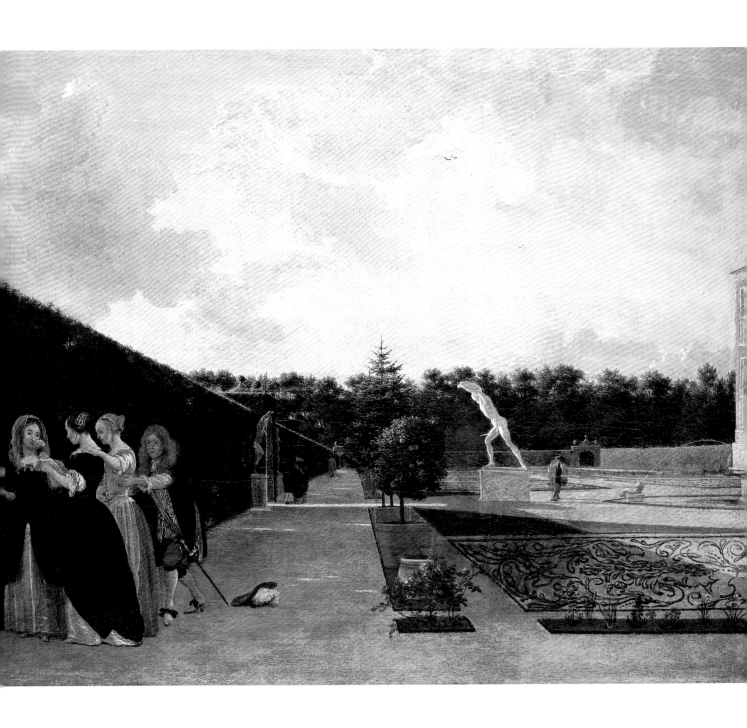

8,9 MELCHIOR DE HONDECOETER (1636–95)
& 10 Views of Nijenrode Castle and its stud

All three oil on canvas
Acquired by George IV between 1802 and 1806
White 1982, nos. 71–3

8 *A Groom Assisting a Riding Master at the Manège*

81.3 x 97.2 cm
Signed: *M D Hondecoeter*
RCIN 405957

9 *Johan Ortt on Horseback Outside the Gate of Nijenrode Castle*

80 x 97.2 cm
Signed: *M. Hondekoe . . ./ Ao 1687*
RCIN 405956

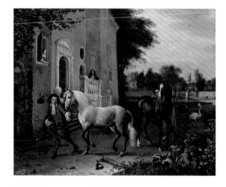

10 *Grooms with Horses at Nijenrode Castle*

79.4 x 95.9 cm
Signed: *M. D. Hond . . . /168 [6?]*
RCIN 405955

NIJENRODE Castle near Utrecht was begun in the middle of the fourteenth century and considerably enlarged in the early years of the seventeenth. Its appearance at this time is recorded in a print by Herman Saftleven (fig. 30). It was destroyed during the French invasion of 1672 and rebuilt, complete with moat, by the Amsterdam merchant Johan Ortt (1642–1701), when he acquired it in 1673 (see fig. 31). Ortt became Lord of the Manor of Nijenrode in 1675 and appears as such in no. 9, with his crest branded upon the horse's hindquarters, complete with spurious coronet. The castle appears today largely as it does in fig. 31, though with some medieval-revival elements added in 1914–17.

Johan Ortt's castle was build around a courtyard, the blocks meeting at oblique angles as if three sides of an octagon, surrounded by a moat and reached by a bridge. The main entrance is seen in *Grooms with Horses* (no. 10), flanked by two polygonal towers; the left-hand one is also visible in the right-hand background of *Johan Ortt* (no. 9), where it is viewed from across the bridge. No. 10 accurately records the balustrade separating the castle courtyard from the moat, but a complete range of the castle between this and the entrance has been omitted (compare fig. 31). The left background of no. 9 depicts a seventeenth-century formal garden lying outside the moat, with classical stone gateway, statuary and pyramidal topiary-cage. This seems to contradict the evidence of contemporary views, including fig. 31, which show a large building, possibly a stable block, immediately across the bridge from the castle.

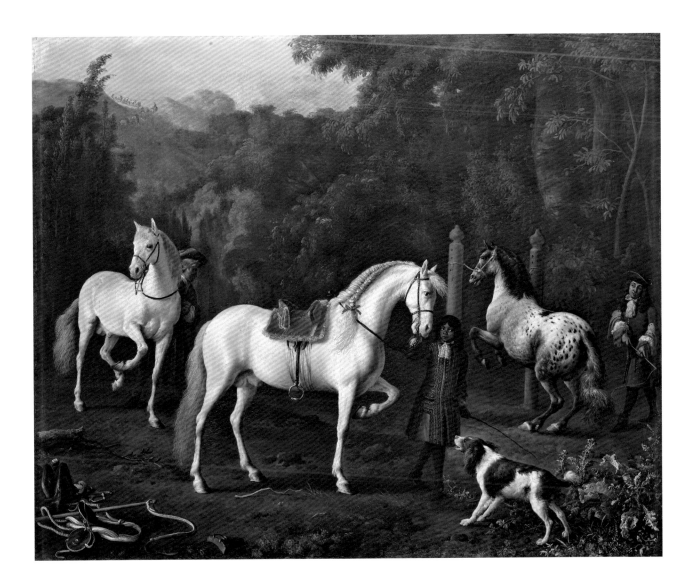

FIG. 30 Herman Saftleven, *Nijenrode Castle*, 1653; engraving (Utrecht Archive)

FIG. 31 P. Stoopendaal, *Nijenrode Castle*, 1710–19; engraving (Utrecht Archive)

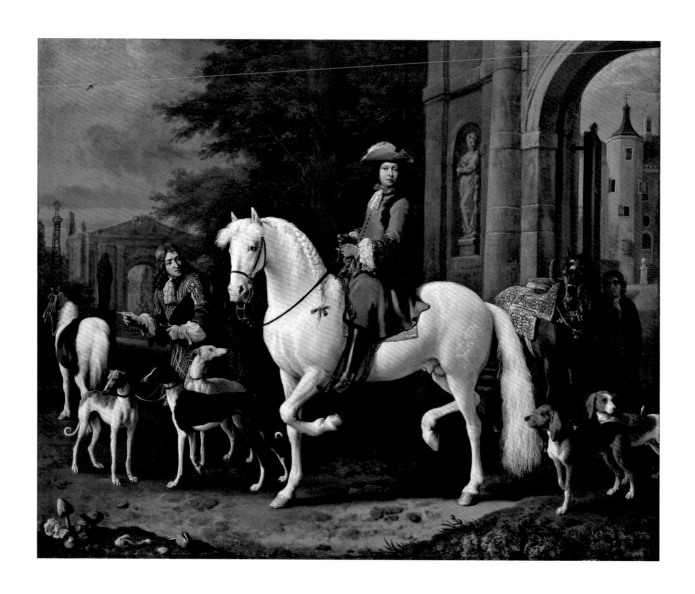

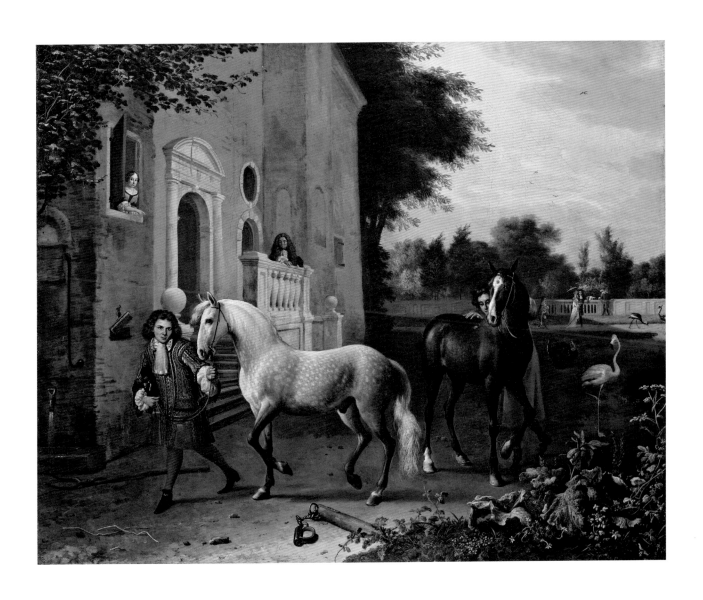

The Utrecht historian Cornelis Booth recounted that as well as restoring the castle, Johan Ortt

> built a riding school and stables to the right of the house, capable of holding up to fifty horses, of which he was a great lover. Of horses he had an incomparable collection, not only measured against others in the county of Utrecht, but possibly in the whole Netherlands. Magnificent riding and coaching horses were raised in his own stud.

Assuming that these paintings were conceived as a group of three (and that a further one has not been lost), they should hang in the order given above, with the grooms at the riding school (no. 8) and in the castle courtyard (no. 10) flanking the proud owner (no. 9). The 'left-hand' scene (no. 8) depicts Spanish horses undergoing training in an imaginary landscape, one saddled in the Spanish fashion and held by a black servant boy in livery, another taught the *Levade* by the riding master, dressed as a nobleman and holding a schooling whip. This horse is held between two pillars by a rope attached to its bit. A pile of equipment lies in the foreground – saddle, whip, blinkers and scraper; a string of horses are exercised on the hill behind. In the central scene (no. 9) Johan Ortt appears to be setting off on a hunt; he rides another Spanish horse while a groom holds a smaller mount fitted with a side-saddle, presumably for his wife; a servant in livery holds three greyhounds on a

FIG. 32 Cornelis van Caukerken after Abraham van Diepenbeeck, 'Welbeck', plate 9 from William Cavendish, *Méthode et invention nouvelle de dresser les chevaux*, Antwerp, 1658 (Royal Collection, RCIN 1070972)

leash and a pair of beagles follow. Another liveried servant leads a horse towards the pump in the right-hand scene (no. 10); a horse-brush and metal curry-comb hang on the wall nearby. In the background an elegant couple are followed by a page holding the lady's shawl, as they stroll along the terrace towards a pair of crested cranes. This order leads the viewer from the wild landscape of Johan Ortt's estate through the main gate of his castle into its courtly and protected heart. This final scene is the only one to include women and corresponds to de Jongh's fortress garden (no. 7). The anonymous aerial view of Huis ten Bosch (fig. 29) shows a clear contrast between

FIG. 33 George Stubbs, *The 3rd Duke of Portland Riding Out past the Riding School, Welbeck Abbey*, 1767; oil on canvas (Private collection)

When Cavendish was living in exile in Antwerp during the Commonwealth (see fig. 5) he published his *Méthode et invention nouvelle de dresser les chevaux* (Antwerp, 1658), with illustrations after drawings by Abraham van Diepenbeeck (fig. 32). These have exactly the same mix of favourite horse, trusty stable hands, brand new buildings and ancient vernacular castle as we see in De Hondecoeter's works, and are a further example of the close connection between the Dutch and English aristocracy, especially at this period, on the eve of the 'Dutch invasion' of 1688. One of the Dutch noblemen who accompanied William of Orange to England was Willem Bentinck (1649–1709). Stubbs's image of the riding stables at Welbeck, painted in 1767 (fig. 33), depicts Bentinck's great-grandson, William Henry Cavendish Bentinck, 3rd Duke of Portland (1738–1809).

There is the tantalising possibility that Stubbs knew these three paintings by de Hondecoeter, which were brought to England by Mary Doublet of Groeneveldt (*c*.1702–1801), who married Robert Darcy, 4th Earl of Holderness (1718–78) in 1743 and lived at Sion Hill. The Earl of Holderness was tutor to George III's eldest sons, Princes George and Frederick, in 1771–6; it is conceivable that as a child George IV saw these three paintings that he was to acquire as a man. He then took them to Royal Lodge in Windsor Park in 1822, along with his collection of works by George Stubbs (see p. 144 below), though whether or not they were hung together cannot be determined.

the formal garden behind the palace and the simpler landscaping in front where the stables are sited; it is probable that Johan Ortt's castle was laid out with a similar separation of function. De Hondecoeter seems deliberately to have confused the two elements, as he does in so many of his paintings of exotic birds and animals, which combine the characteristics of the palace and the farmyard.

There is a close parallel between Ortt's equestrian interests (and these images) and those of William Cavendish, 1st Duke of Newcastle (1592–1676), who built great riding stables at Welbeck Abbey in 1625.

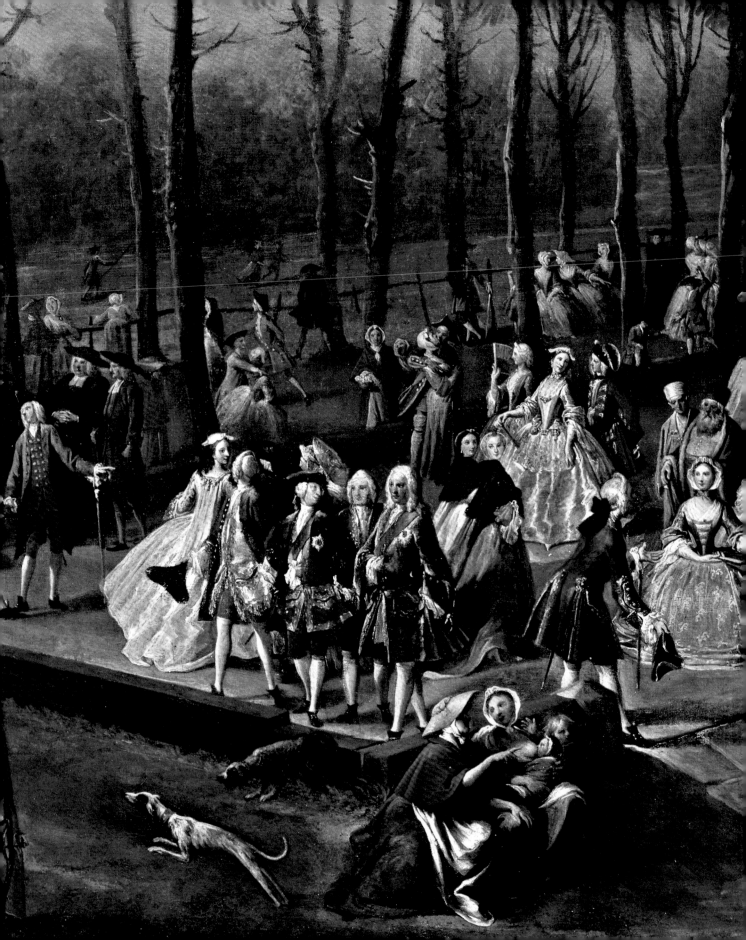

Frederick, Prince of Wales (1707–1751)

3

3 Frederick, Prince of Wales (1707–1751)

THE period covered in the previous section (*c.*1660–1715) has been described as the 'Age of Versailles'; the years that followed saw a pan-European reaction against the place and everything it stood for. This began most obviously in France itself where, upon the death of Louis XIV in 1715, the new ruler, the Regent, moved his court from Versailles to Paris. Very soon the court of the Most Christian King was replaced as the centre of French cultural life by the salon of the most sceptical *philosophe*. The huge shop-sign painted by Antoine Watteau (1684–1721) in 1720 for his friend the Parisian art dealer Edme-François Gersaint (fig. 34) shows this shift symbolically through a fusty portrait rudely

dropped into the straw of a packing case, while the beau monde congregate to admire some frivolous modern mythological paintings opposite. These men and women would have called themselves 'good company' ('*la bonne compagnie*'): though well-born, they do not parade their rank, nor are they slaves to those of a higher rank. The man prostrating himself does so not in obeisance but to get a better view of a painting. They pride themselves on their wit, politeness, independence and cultivation.

Antoine Watteau is the painter who best expresses this moment in French culture, partly because he was not French: he was born of Flemish parentage in the border town of Valenciennes, which had only become French in

FIG. 34 Antoine Watteau, *L'Enseigne de Gersaint*, 1720; oil on canvas (Schloss Charlottenburg, Berlin)

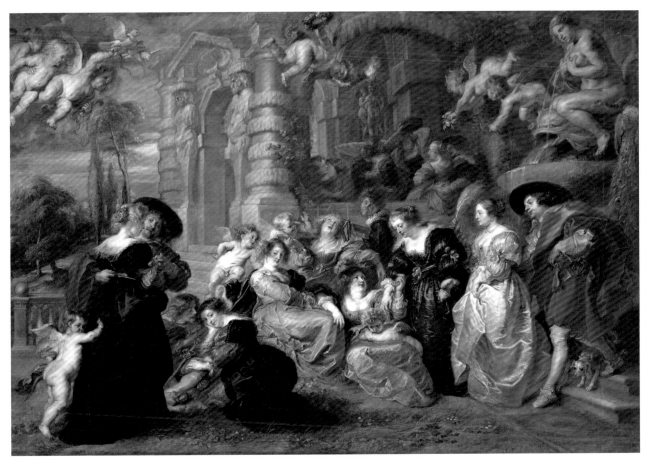

FIG. 35 Peter Paul Rubens, *The Garden of Love*, c.1630; oil on canvas. (Museo Nacional del Prado, Madrid)

1678. He was trained at a time when a faction at the French Academy, who called themselves the *Rubenistes*, were turning against their native tradition of painting, represented by the example of Poussin, and looking for inspiration at recent Netherlandish painting, and in particular the work of Peter Paul Rubens. Following their lead Watteau seems especially to have singled out Rubens's *Garden of Love* (fig. 35) as the source of another more gallant and aristocratic tradition of conversation, which infuses a glamour of setting and a sensual, elegant warmth into the family portraits of Flemish artists like Gonzales Coques (fig. 36). Watteau's *fêtes champêtres* take as their point of departure the pavilion architecture, gallant couples, graceful pliancy of figures and soft evening light of Rubens and Coques. Watteau grafts this visual tradition onto a French seventeenth-century literary tradition, represented by the marquise de Rambouillet (1588–1665) and her band of *Précieuses*,

FIG. 36 Gonzales Coques, *The Family of Jan-Baptista Anthoine*, signed and dated 1664; oil on copper. Acquired by George IV in 1826 (Royal Collection, RCIN 405339)

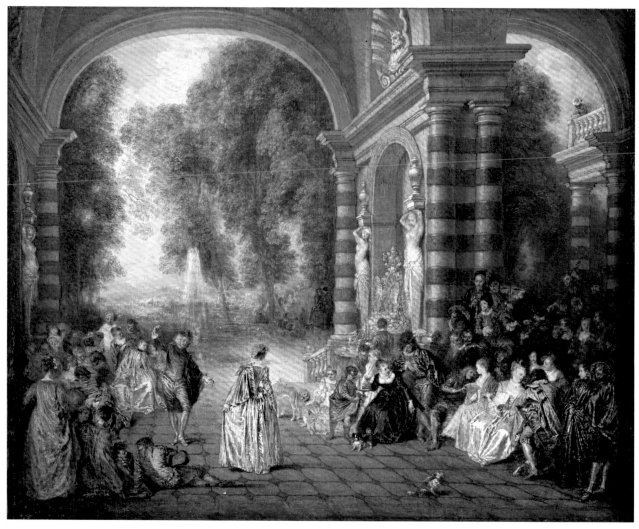

FIG. 37 Antoine Watteau, *Les Plaisirs du Bal*, 1717; oil on canvas (Dulwich Picture Gallery, London)

who cultivated a delicacy of friendship and refinement (almost pedantry) of courtship.

The European conversation piece relaunched itself with Watteau, whose scarce works were admired and avidly collected in France, Germany and England. In 1720 he travelled to London to consult the fashionable physician Dr Richard Mead and painted two small scenes for him. His fame was further spread by the publication after his death of a series of prints by his friend and patron Jean de Jullienne (1686–1766), the first group after his drawings and the second after his paintings. These prints give Watteau's genre scenes titles – *L'Amour paisible*, *Fêtes vénitiennes*, *Les Charmes de la Vie*, *Les Plaisirs du Bal* (fig. 37) – all of which convey

a similar idea of amorous dalliance, and one of which, appropriately enough, is *La Conversation* (fig. 38). As a result of the *Recueil Jullienne*, one of the most modest and least prolific of artists became posthumously one of the most effectively publicised in the history of art.

In France Watteau's influence spawned a generation of high-life genre painters whose subject matter exhibited the same range of elegant imaginary groups out of doors and perfectly observed interiors as had been seen in the Low Countries in the previous century. A set of four *fêtes champêtres* by Jean-Baptiste-Joseph Pater (1695–1736) was almost certainly acquired by Frederick, Prince of Wales, probably bearing an attribution to Watteau; one of these

FIG. 38 Jean-Michel Liotard after Antoine Watteau, *La Conversation*, engraving of 1733 after a painting of 1715. One of the *Recueil Jullienne*, a set of prints after Watteau's paintings published by Jean de Jullienne (Royal Library, RCIN 820419)

depicts a scene from Molière's *Monsieur de Pourceaugnac* (fig. 39), a reminder of Molière's prominence throughout Europe at this date. He was the acceptable face of Versailles: elegant and polished, but also comic, middle-class and full of good sense. The interior conversation of *c*.1730 by Jean-François de Troy (fig. 40) became known as *The Reading from Molière (La Lecture de Molière)*, though this was probably not de Troy's own title. This is a French equivalent of a Gerard Ter Borch or a Godfried Schalcken. That perfect rendering of light, space and precious fabrics celebrates here the latest in French luxury design: rococo architecture, silk damask wall-hanging, screen, seat furniture, mantel clock, and 'thrice gorgeous' costume. These are beautiful things beautifully painted. This is a complete celebration of modern French life, with no hint of Dutch moralising: we are to admire the easy intimacy, gracious politesse and animation of the circle as much as the beauty of the costumes and setting. It was this kind of gathering occupying a Parisian salon, that Madame de Staël had in

FIG. 39 Jean-Baptiste-Joseph Pater, *Monsieur de Pourceaugnac*, *c*.1730; oil on canvas. Probably acquired by Frederick, Prince of Wales, and first recorded in the Royal Collection in 1816 as by Watteau (Royal Collection, RCIN 400672)

FIG. 40 Jean-François de Troy, *The Reading from Molière*, c.1730; oil on canvas (Private collection)

mind when she wrote almost a century later, '*La bonne compagnie* in Germany means the court; in France it was all those who could place themselves on an equal footing with the court' (*De l'Allemagne*, 1814).

Fashionable Europe wanted to dress, to live and to paint like this. England was no exception. In the first thirty years of the eighteenth century a generation of continental artists (the majority Netherlandish, but with many French) came to London to paint scenes of modern life. The subjects were essentially those of the Dutch and Flemish masters – market scenes, cityscapes, conversations and elegant genre paintings – but with a modern French (and especially Watteau-like) flavour. A crowd of minor talents flocked to fill a gap in the market, as demonstrated by the uncertain attribution of a view of Windsor Castle in the Royal Collection (fig. 41). This painting demonstrates a strange combination of pedantically recorded topography, peopled with amorous figure groups, borrowed from Watteau, though dressed in English fashion – a sort of *Embarquement pour l'Isle de Runnymede*. It can be dated

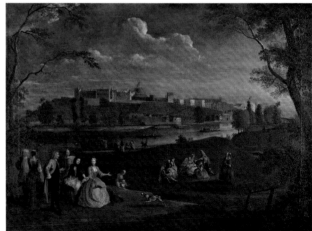

FIG. 41 British School, *Windsor Castle*, c.1730–40; oil on canvas. Presented to George IV in 1829 (Royal Collection, RCIN 402409)

by costume to 1730–40 and is usually assumed to be by one of these visiting artists. The following names have been suggested: Peter Tillemans (*c*.1684–1734), who was born in Antwerp and in 1708 settled in England, where he trained Joseph Francis Nollekens (1702–48) and Arthur Devis (1712–87; see fig. 57); Joseph van Aken (*c*.1699–1749), who came to London in 1720, also from Antwerp, and painted small genre and conversations until he became a drapery specialist in 1735; Peter Angelis (1685–1734), who arrived in England from Dunkirk in 1712–28, and was described by Horace Walpole as lying half-way between Teniers and Watteau. In fact this painting is probably not by any of these artists but by a lesser visitor or English follower.

The most important of this generation of immigrant artists was Philippe Mercier, a French Protestant born in Berlin who arrived in England in about 1725, bringing with him prints after Watteau's work, some of them of his own invention. Works such as his *Schutz Family and their Friends on a Terrace* of 1725 (fig. 42) form the basis for the English conversation piece for the next century. This oil is essentially Watteau brought down to earth, with its exquisitely drawn costumes, vivid architectural setting and atmospheric painting of the evening sky, but with doll-like

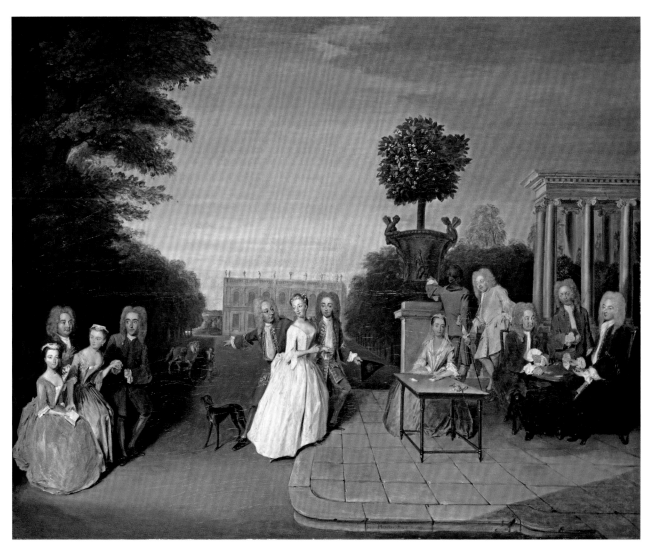

FIG. 42 Philippe Mercier, *The Schutz Family and their Friends on a Terrace*, 1725; oil on canvas (Tate, London)

figures whose interaction is stiff and polite rather than poetic. One of the latest arrivals of the group was the Parisian artist Hubert François Gravelot (1699–1773), a pupil of Jean Restout (1692–1768) and François Boucher (1703–70), who worked in England from 1732 until 1746 and taught at the St Martin's Lane Academy (see fig. 66), where his most important pupil was Thomas Gainsborough (see no. 27 and figs. 78–9).

Although this period was generally agreed to be the least distinguished in the history of British painting, it was during just these years that a distinctive native tradition did develop, becoming less dependent upon continental visitors as the century progressed. These tender early shoots are seen in retrospect to be of such importance that there is inevitably some exaggeration in the assessment of the quality of works by John Wootton, Arthur Devis, Charles Philips or even William Hogarth. They are often frankly mediocre, but it is still possible to see in them distinctively British characteristics (some also, incidentally, seen in the work of foreign visitors), which justifies some of the claims made on their behalf. While the French generally painted high-life genre scenes, British artists preferred small-scale group portraits; both types could equally well be called 'conversations'. The French pieces of this period tend to show a harmonious world, whereas the British frequently include some element of comical discord, usually associated with children. The French depict a fashionable world that is up-to-date in every detail, while the British invariably include something old for good luck: in fact, the presence of out-of-date pieces of architecture, furniture or even costume is one of the most consistent elements in the conversations painted in Britain included in these pages. Unlike the French, the British never could throw their old portraits into packing cases (see fig. 34).

The final element which distinguishes the British Enlightenment from its French equivalent is its active engagement in politics. The British were especially resistant to the glamour of the monarchy during the reigns of George I and George II (1714–60) because these kings were uncultivated, unattractive and German – and the subject of constant ridicule in the uncensored public press. The British believed that they had a unique and *contractual* relationship between King and subject: Queen Caroline's favourite, Lord Hervey (1696–1743), wrote in 1734 that he believed

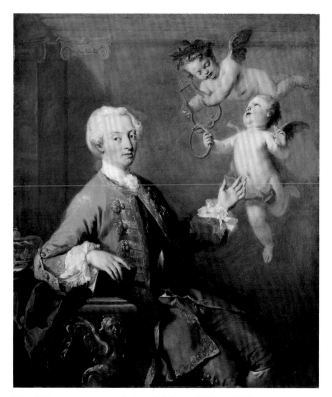

FIG. 43 Jacopo Amigoni, *Frederick, Prince of Wales*, 1735; oil on canvas. Acquired by George IV by 1816 (Royal Collection, RCIN 401500)

although money and troops are generally esteemed the nerves and sinews of all the regal power, and that no king ever had so large a civil list or so large an army in time of peace as the present King, yet that the Crown was never less capable of infringing the liberties of this country than at this time, and that the spirit of liberty was so universally breathed into the breasts of the people, that, if any violent act of power had been attempted, at no era would it have been more difficult to perpetrate any undertaking of that kind. The King was often told, both in Parliament and in print, that his crown had been the gift of the people; that it was given on conditions; and that it behoved him to observe those conditions; as it would be both as easy and as lawful, in case he broke any of them, for the people to resume that gift, as it had been for them to bestow it.

(*Memoirs of the Reign of King George II*, 1734)

This way of thinking could clearly influence the way in which groups are shown interacting in painting. The most

important player in royal conversation pieces at this period was the eldest son of George II, Frederick, Prince of Wales, seen in a portrait by Jacopo Amigoni (1682–1752; fig. 43). Frederick was detested by his parents and responded by throwing himself into the world of opposition politics. Lord Hervey, admittedly a highly prejudiced witness, thought him a pawn:

> The Prince, who always imagined himself the idol of the people, was to the full as unpopular as his parents … [but] … nothing could open his eyes, the bandage of vanity bound them so close, and so determined he was to believe that every discontent centred in the King, the Queen, and Sir Robert Walpole, and that all the nation wished as much as he himself, that the time was come for him to ascend the throne.
>
> (*Memoirs*, 1735)

The Prince set himself up politically as a champion of British liberty, and personally as a clubbable, democratic fellow, even becoming a Freemason in 1737. Clearly for Frederick, as for many others in England at this time, the conversation piece was an expression of the same ethos, with its informality, its equality (or at least its lack of obvious subordination) and its unconstrained exchange of ideas. When we see Frederick rubbing shoulders with all sorts, either socialising in clubs, shooting or visiting a public park (nos. 16–18), we are supposed to think of him as the 'King of Courtesy' and a champion of liberty. He wished to be *popular*, with all the democratic baggage that this word implies. Needless to say, his mother was horrified: '"My God," says the Queen', again according to Lord Hervey, '"popularity always makes me sick; but Fretz's popularity makes me vomit"' (*Memoirs*, 1736).

An account of Frederick's enthusiasm for the conversation piece would not be complete without mentioning

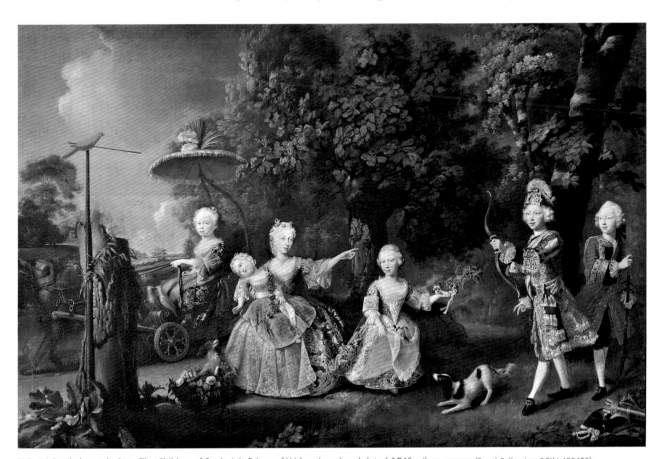

FIG. 44 Barthelemy du Pan, *The Children of Frederick, Prince of Wales*, signed and dated 1746; oil on canvas (Royal Collection, RCIN 403400)

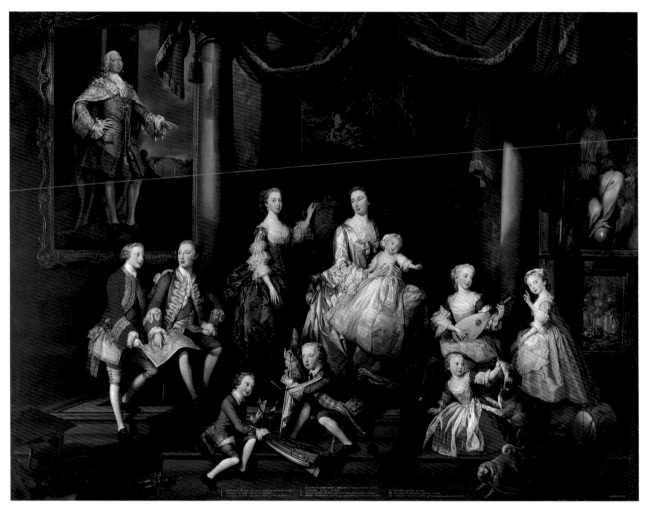

FIG. 45 George Knapton, *The Family of Frederick, Prince of Wales*, painted for Augusta, Princess of Wales, in 1751; oil on canvas
(Royal Collection, RCIN 405741)

two life-sized group portraits of his family. Barthelemy du Pan (1712–63) was a Swiss artist who came to England in 1743; he depicted the Prince's six eldest children engaged in a sort of country festival, involving an archery contest just won by the future George III (fig. 44). The rustic setting, spirited games and folklore suggestion that a king is chosen through some contest rather than by right of birth all anticipate the cult of nature usually associated with the later writings of Jean-Jacques Rousseau.

After Frederick's death his widow, Princess Augusta of Saxe-Gotha (1719–72), commissioned another family portrait, this time from the artist and assistant surveyor of the Royal Collection, George Knapton (1698–1778; fig. 45).

The Princess of Wales is enthroned centrally, though she appears more as a mother than a monarch. She is flanked to her right by a portrait of her late husband and to her left by a statue of Britannia on a carved plinth, on which a pair of scales balances the attributes of Monarchy and Liberty. Tumbling around her in a disorderly group, her nine children are cheerfully playing, learning and treating each other with unselfconscious affection. The warmth and animation of the children's interaction, which exactly matches the political message of the painting, is reminiscent of the group portrait of the Gerbier family by Rubens's studio (fig. 46) acquired (as a Van Dyck) by Frederick in 1749. In this same year Frederick's children mounted a

production of Joseph Addison's *Cato*, with a special pro-
logue spoken by Prince George, which could supply the
rubric for Knapton's painting:

> A boy in England born – in England bred;
> Where freedom well becomes the earliest state,
> For here the love of liberty's innate.
> Yet more; before my eyes those heroes stand,
> Whom the great William brought to bless this land,
> To guard with pious care that gen'rous plan
> Of power well bounded, which it first began.

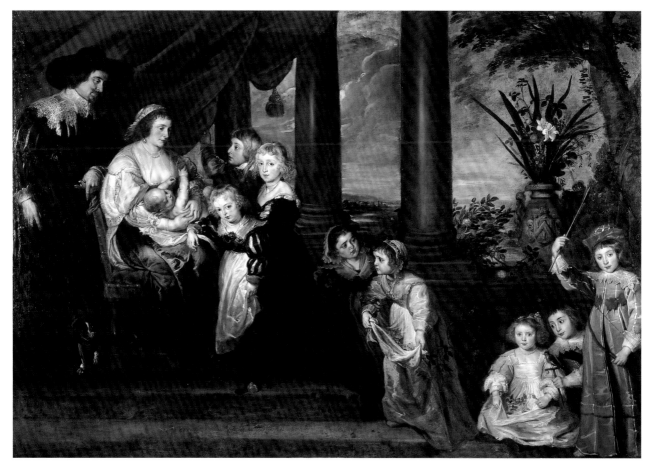

FIG. 46 Studio of Peter Paul Rubens, *The Family of Sir Balthasar Gerbier*, *c*.1630–40; oil on canvas. Acquired by Frederick, Prince of Wales, in 1749
as by Van Dyck (Royal Collection, RCIN 405415)

11 MARCELLUS LAROON THE YOUNGER (1679–1772)

A Dinner Party

Oil on canvas
91.4 x 86 cm
Painted in 1725
First recorded at Kensington in 1818
RCIN 403539
Millar 1963, no. 520

MARCEL Lauron was a French painter who had settled in The Hague in Holland in the mid-seventeenth century. He moved to England sometime before 1674, accompanied by his son, Marcellus Lauron (1653–1702). By 1680 Marcellus had married an Englishwoman and settled in London, where his son, Marcellus II Laroon, the author of this work, was born in 1679. Laroon the Younger travelled in Italy, France and Holland, and served for many years as a soldier before taking up painting, specialising in scenes of this type.

A drawing for this composition (formerly P.D. Matthiesen, London) is signed and dated 1719 and inscribed '*Premiere pensee | Presented to King George 1st |*

a picture I painted in 1725'. This provides a date for the painting, but no identification of the sitters. The fact that the host is wearing the sash of the Order of the Garter has been taken to imply that such an identification should be possible, and various names have been suggested. However, none of Laroon's scenes of fashionable life has figures which can be identified, which suggests that they were never intended to be portraits. Furthermore, there is no reason why a fictitious character may not be a Garter knight, particularly as the scene is full of the exaggerated expressions and ludicrous physiognomies of a stage comedy. This is surely a satire on the manners of the fashionable elite of the day: even the curtain raised to reveal the scene is a theatrical property. It is no doubt significant that Laroon himself was a distinguished amateur actor and musician.

We are to imagine that the dinner guests have left the main house during the meal and proceeded to the 'banquet-house' for sweets. Through the open door we can see glimpses of wrought iron decorated with the host's coronet, which also appears with the gilded phoenix above the mirror. The arched space for the buffet is reminiscent of the open pavilion architecture employed by Watteau (compare fig. 37). At the table, members of the company are served jellies and fruit with white and red wine. We must imagine that a contemporary audience would have read the characters (and distinguished guest from servant) better than we can, but the following episodes can be proposed (many of necessity conjectural). At the extreme left a red-faced gardener tries to scrounge some wine from a servant; two grave-looking characters standing to their left hold plates and could be servants or guests; a young black man wears the silver collar of a slave; a fat clergyman looks straight out at the viewer,

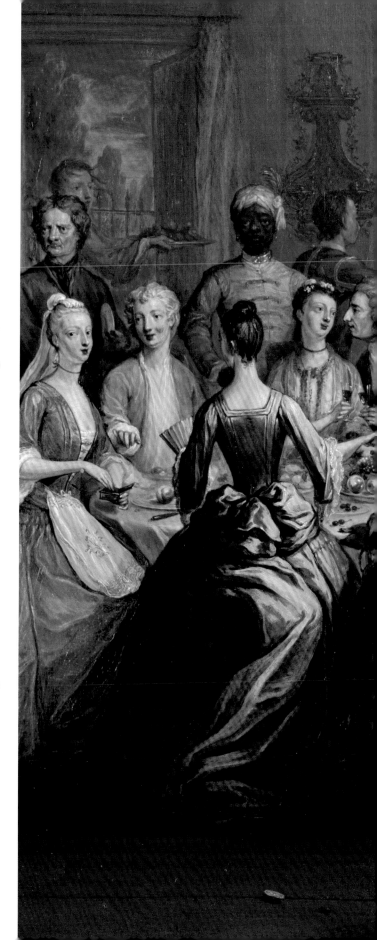

his shiny round face and apple cheeks like a toby jug, seeming to symbolise the mood of worldly satisfaction. Seated around the table there is a lady taking snuff to the left, entertained by a milk-sop; the lady next to him has captured the attention of her lover, a solemn, wedge-faced man, his nose to her ear as he whispers sweet nothings; at the head of the table the host pours wine with a flourish, presumably letting it breathe. The servant boy, holding a tray of wine glasses and casting a knowing look at the viewer, has a springing gait echoing the dog behind him, suggesting that he is an 'insolent young puppy'.

For a scene of high fashion the figures here seem to be very simply dressed. It was the fashion during these years in England to use less brocade on coats made of subtle colours, which gave rise to the frequent complaint of French visitors that in England one could not tell servants from their masters. The writer and spy John Macky (d. 1726) noted that:

> The dress of the English is like the French but not so gaudy; they generally go plain but in the best cloths and stuffs ... not but that they wear embroidery and laces on their cloathes on solemn days, but they dont make it their daily wear, as the French do.
>
> (*A Journey through England*, 1722)

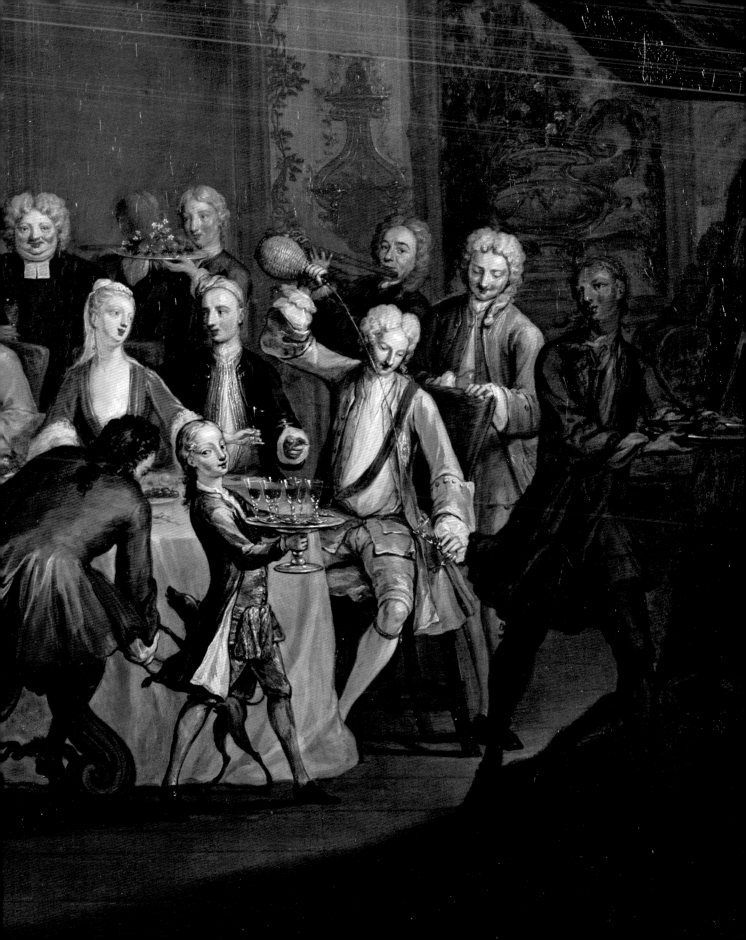

12 MARCELLUS LAROON THE YOUNGER (1679–1772)

A Musical Tea-Party

Oil on canvas
91.4 x 71.7 cm
Signed: *Mar. Laroon. F. 1740.*
Presented to the Royal Collection by Mr Humphrey Ward; first recorded at Kensington in 1903
RCIN 403544
Millar 1963, no. 521

THIS is another 'comedy of manners', though, like the previous work, it has sometimes been considered a group portrait. This is a *levée*, defined by Dr Johnson as the 'concourse of those who croud round a man of power in a morning'. Here a lady is attended by 'suitors' (professionals seeking work, distant acquaintances or relations with letters of introduction seeking favours, and so on) as well as her friends. A servant opens the curtains; in fashionable undress, the hostess sits beneath a huge portrait of her heroic husband, served by a maid and a black slave boy (again wearing a silver collar; see no. 11). This 'dishabille' (a word then pronounced with no hint of its French origin) was considered daringly immodest by Joseph Addison, who describes a lady in a 'Night-Gown which was thrown upon her Shoulders' and 'ruffled with great Care', as well as his own confusion

every time 'she stirred a Leg or an Arm' (*Spectator*, no. 45, 21 April 1711).

Various types compete for the lady's attention: two musicians to the right; a fat clergyman diverted from his quest for a rich living by the attractions of the lady in silver-coloured silk; a grim-looking thug, scowling out at us to the left, with black scars on his face, presumably offering his services as a fencing-master (or worse) and suitably disgusted by the effete company he is obliged to keep. There would seem to be six guests (as opposed to suitors) and three servants (including the slave boy). A lapdog reclines on a cushion as a metaphor for the pampered idleness of the human figures in the scene. The contrast of foppish affectation and manly heroism (represented by the portrait and the pugilist) exactly matches that found in *The Plain Dealer*, a Restoration comedy by William Wycherley (1640–1716) published in 1677, but still admired by Voltaire in 1734.

Laroon's style is loosely based on that of Watteau and his followers, though he seems to have learned directly from Watteau's drawings, made available through Julienne's prints, rather than his paintings. Laroon's figures have a stringy, linear, almost ribbon-like quality, which gives his scenes a liveliness and exaggeration of posture and expression appropriate for a satirist. The two lovers seated in the foreground show his style at its best, while the insubstantial bench on which they sit also shows its limitation.

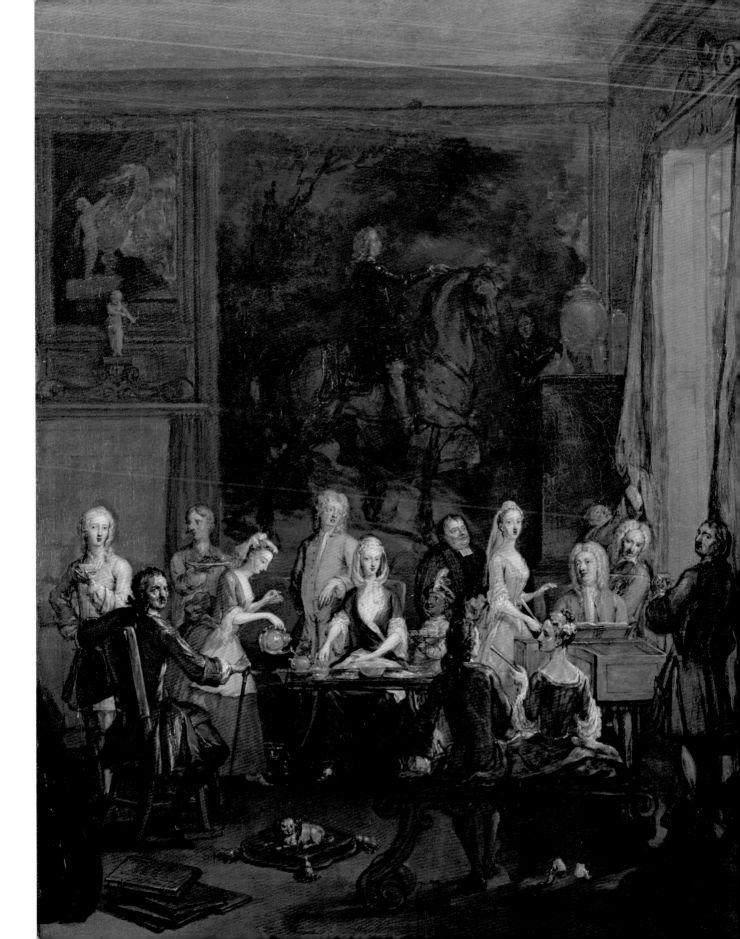

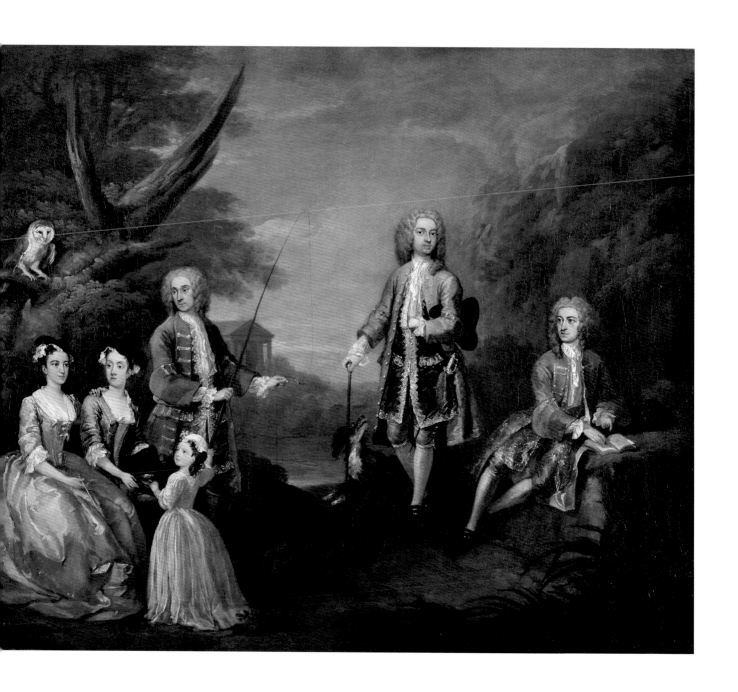

13 WILLIAM HOGARTH (1697–1764)
The Popple Family

Oil on canvas
62.9 x 74.9 cm
Signed: *W^m Hogarth: pinx^t 1730*
Bequeathed to Queen Victoria in 1887
RCIN 400048
Millar 1963, no. 561

THE identity of the sitters is most convincingly established by Elizabeth Einberg in her forthcoming catalogue of the works of William Hogarth as representing four siblings from a prosperous mercantile and colonial family. Three Popple brothers are arranged in discreet order of seniority: in the middle, and standing highest, is Henry (date of birth unknown but probably the eldest), who was Clerk at the Board of Trade and Plantations in 1727 and published a map of the British North American Colonies in 1733; to his right stands Alured (1699–1744), appointed Secretary to the Board of Trade and Plantations in 1730 and Governor of Bermuda in 1737–44; sitting on a bank on the right is their younger brother William (1701–64), who was a playwright and poet as well as Solicitor to the Board of Trade and Plantations and Governor of Bermuda (1747–63). Alured fishes, with the help of his wife, Mary (1704–73), and daughter, Marianne (1724–99); at the extreme left sits their sister, Sophia (1704–78), with an owl perched in a tree above her head. Einberg suggests that Sophia may have commissioned this family group prior to one or more of the brothers' departures for colonial service. This would explain the following item in her will: 'to my Niece Marianne Mathias [the little girl here married one Vincent Mathias] I leave my [meaning 'her'?] ffathers and Mothers picture painted by Hogarth'. Marianne's granddaughter Marianne Skerrett (1793–1887) was Head Dresser and Wardrobe Woman to Queen Victoria, to whom she bequeathed this painting, along with the identification of her grandmother but unfortunately none of the other sitters.

One of the earliest of Hogarth's conversations, this work betrays the awkwardness of a self-taught painter: the figures are isolated and the composition rambling. The brothers seem to be engaged in some sort of debate, with William pointing to what appears to be an illustration in his book. However, the only really successful element of narrative is in the family group fishing, with a patient mother consoled by her affectionate sister-in-law, and an excited daughter, who has presumably had the idea of storing the bait in her father's hat, a piece of comic seasoning typical of Hogarth's later conversation pieces. The landscape is wilder than the man-made parklands of the day and suggests the remote wildernesses that the brothers were already involved in mapping and administering. The temple in the background may be dedicated to Minerva, goddess of wisdom, whose attribute is the owl and who seems an appropriate deity for a family of merchants and colonial governors.

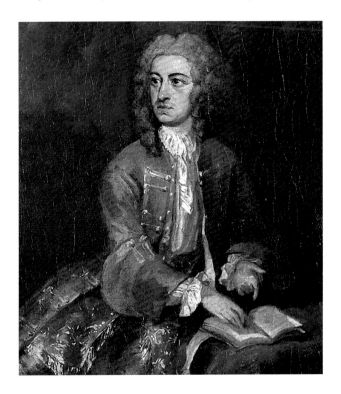

14 WILLIAM HOGARTH (1697–1764)

The Family of George II

Oil on canvas
63.8 x 77.5 cm
Painted *c*.1731–2
Acquired by Her Majesty Queen Elizabeth II
RCIN 401358
Millar 1963, no. 559

THIS oil sketch records an unhappy incident in Hogarth's life. His friend George Vertue claimed that when he heard of the forthcoming marriage of Princess Anne and Prince William of Orange he 'made applicaton to some Lady about the Queen that he might have leave to make a draught of the ceremony & chapel & paint it & make a

FIG. 47 Jacques Rigaud after William Kent, *Marriage of Princess Anne to the Prince of Orange, March 1733*; engraving (Royal Collection, RCIN 750381)

print of it for the public'. The Queen granted permission but when he came to make the sketches he was driven off by his rival artist William Kent, who enjoyed the favour of the Queen and was anxious to preserve the monopoly status of his own image (fig. 47). To add insult to injury, Hogarth had some time earlier 'begun a picture of all the Royal family in one peice by order the Sketch being made. & the P. William the Duke had sat to him for one. this also has been stopt'. It is for this reason that this sketch and the smaller variant in the National Gallery of Ireland are all that survive of this project.

We should treat Vertue's words 'by order' with some suspicion: it is surely likely that this was a commission actively sought by the artist, perhaps with a view to creating a profitable print (as in the case of William Kent's image, fig. 47). This would explain the existence of the work under discussion, presumably a full-sized oil sketch, to be presented to the King (or his agent) for his approval, a process seldom required with commissioned conversation pieces. Hogarth then produced a smaller revision (National Gallery of Ireland), when the garden setting was disliked.

This setting is the first distinctive aspect of Hogarth's image: this is a landscaped garden, of the type which Queen Caroline was creating at Richmond and Frederick, Prince of Wales, at Carlton House. According to a contemporary account of the Carlton House garden, 'this method of gardening is the more agreeable, as when finished, it has the appearance of beautiful nature, and without being told, one would imagine art had no part in the finishing' (letter from Sir Thomas Robinson to the 3rd Earl of Carlisle, 23 December 1734). Such gardens were also intended to celebrate people and ideas: Queen Caroline's Hermitage at Richmond Park contained busts of various British worthies. Hogarth depicts a temple

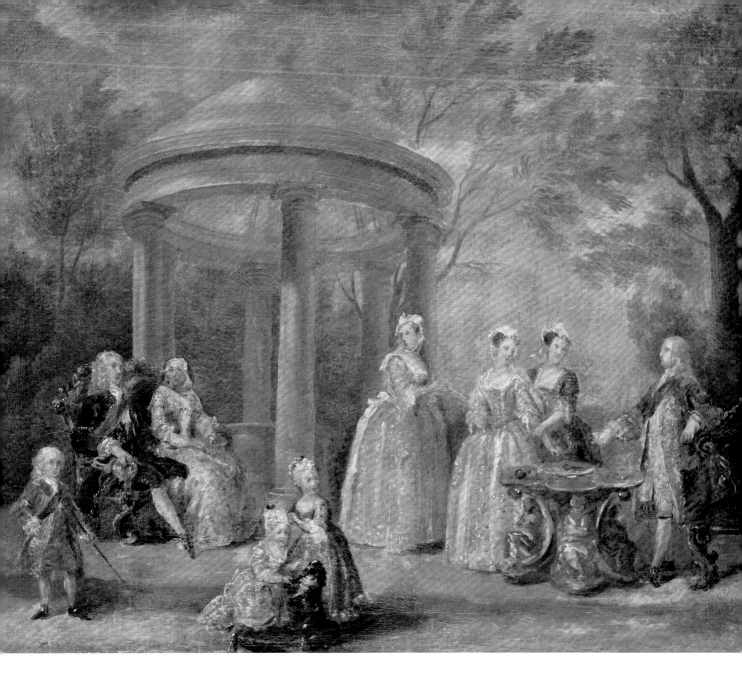

flanking the enthroned royal couple, almost upstaging
them (a fault corrected in the National Gallery of Ireland
revision where their double bench-throne acquires
a glorious baldachin above). This composition should
perhaps be read as depicting the reigning monarch and
his consort on one side, his heir on the other (not yet
sitting upon his slightly inferior armless throne), while
in the centre a temple symbolises some concept – such
as Liberty or The British Constitution – which trumps
them all. Similar ideas are expressed in George Knapton's
group portrait of the next generation (fig. 45).

Hogarth also introduces some interest with the
subsidiary characters here: the two younger princesses
teach a dog to shake hands; this is a common detail in
Dutch painting and alludes to the 'aptitude to learn' of
good children, especially girls. Frederick, Prince of
Wales, chats with the three eldest princesses (who also
appear in no. 15), and seems to be offering fruit from a
strange Baroque fountain-altar. This last episode looks
like a retelling of the story of the Judgement of Paris
and would perhaps have been made more effective and
comprehensible in the finished work.

15 PHILIPPE MERCIER (1689–1760)

'The Music Party': Frederick, Prince of Wales,
with his Three Eldest Sisters, Anne, Caroline and Amelia

Oil on canvas
79.4 x 57.8 cm
Probably painted 1733
Presumably painted for Frederick, Prince of Wales; first recorded in 1767
RCIN 402414
Millar 1963, no. 522

MERCIER served as Painter and Librarian to Frederick, Prince of Wales, from 1728 until 1738. There are three versions of this celebrated image; the other two (National Trust and National Portrait Gallery, fig. 48) are set out of doors with the so-called 'Dutch House' at Kew in the background. Since the scene depicted here makes more sense indoors, it is usually assumed that this is the first treatment of the theme; however, the date of 1733 inscribed on the National Portrait Gallery version provides an acceptable dating for all three.

The Prince of Wales is shown playing the cello, accompanied by his sister Princess Anne (1709–59) at the harpsichord; Princess Caroline (1713–57) plays the mandora (a type of lute) and Princess Amelia (1711–86) reads a volume of Milton's poems. The setting seems to be specific – the red brick back of a large building glimpsed through the window is certainly not an idealised artist's impression of a palace, but it is impossible to identify with certainty. The sconce to the right (one of a group supplied in 1733 by Benjamin Goodison, *c.*1700–1767) and the painting of the sleeping Endymion on the wall (by Giovanni Antonio Pellegrini, *c.*1675–1741) are both accurately recorded and still in the Royal Collection.

The Princesses are dressed, in Aileen Ribeiro's words, 'with an almost bourgeois sobriety', with 'closed gowns' fastened across the bodice, covering a white linen kerchief round the neck and wearing plain caps with lappets, one pinned up, one hanging down and the last fastened under the chin. The more formally dressed Frederick is given centre stage and yet the effect of the scene is one of informality, ensemble music-making and sibling harmony (something which in reality was starting to evaporate at this time).

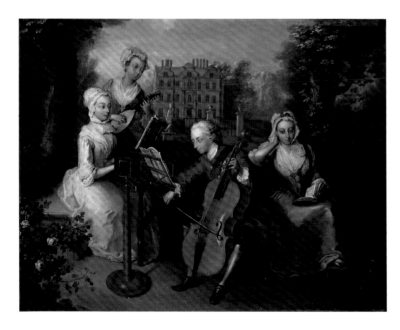

FIG. 48 Philippe Mercier, *Frederick, Prince of Wales, and his Sisters*, signed and dated 1733; oil on canvas (National Portrait Gallery, London)

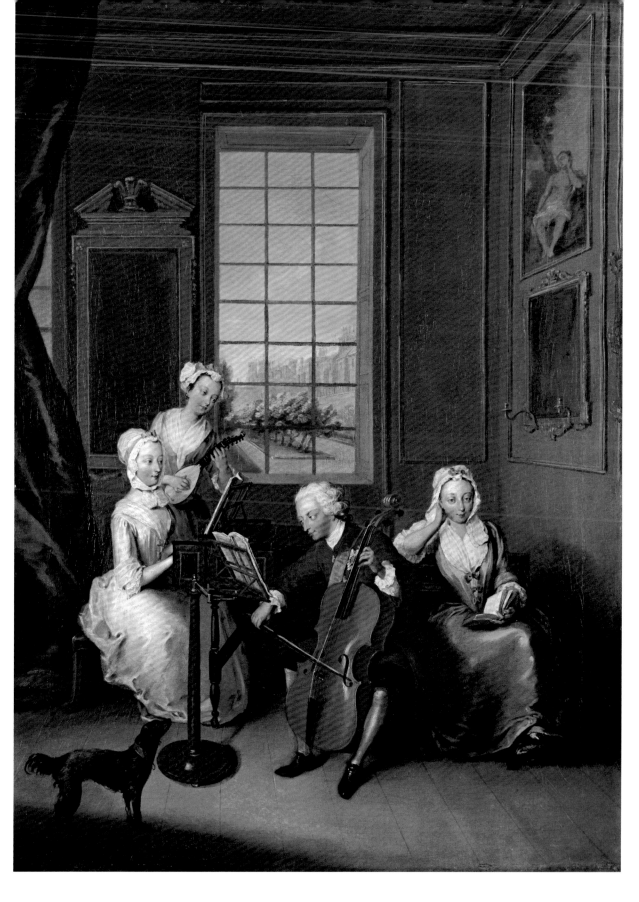

English noblemen would have been unlikely to play the cello as well as Frederick or to be depicted engaged in the activity with such eagerness. Lord Hervey clearly found Frederick's playing undignified, likening it to Nero's public performances on the lyre and recalling this royal 'fiddler once or twice a week during this whole summer at Kensington seated close to an open window of his apartment, with his violoncello between his legs, singing French and Italian songs to his own playing for an hour or two together, whilst his audience was composed of all the underling servants and rabble of the palace'. Hervey concludes by asking 'how much does such a buffoon fiddler debase the title of a Prince of Wales' (*Memoirs*, 1737). Princess Anne had been taught by Handel; her harpsichord playing was by all accounts worthy of her master, and nobody at this date would have thought that playing an instrument or singing debased the title of Princess Royal.

If the musical application seems rather Germanic, there is a tribute here to English culture typical of Frederick, Prince of Wales: Amelia reads from Milton, adopting a listening pose which recalls that of the inspired Endymion on the wall behind; she is like a personification of the pleasure of the scene as she smiles gently at the viewer. Given that Milton's poetry is generally grave, it is at least possible that Amelia is intended to represent the character of Mirth or 'L'Allegro' from Milton's pair of poems of 1631–2, *L'Allegro* and *Il Penseroso*, which were later set to music by Handel. Milton's *L'Allegro* concludes with the following celebration of the beauties of music:

Lap me in soft Lydian airs,
Married to immortal verse,
Such as the meeting soul may pierce
In notes with many a winding bout
Of linkèd sweetness long drawn out,
With wanton heed and giddy cunning,
The melting voice through mazes running,
Untwisting all the chains that tie
The hidden soul of harmony;
That Orpheus' self may heave his head
From golden slumber on a bed
Of heaped Elysian flow'rs, and hear
Such strains as would have won the ear
Of Pluto, to have quite set free
His half-regained Eurydice.
These delights if thou canst give,
Mirth, with thee I mean to live.

(Milton, *L'Allegro*, ll. 136–52)

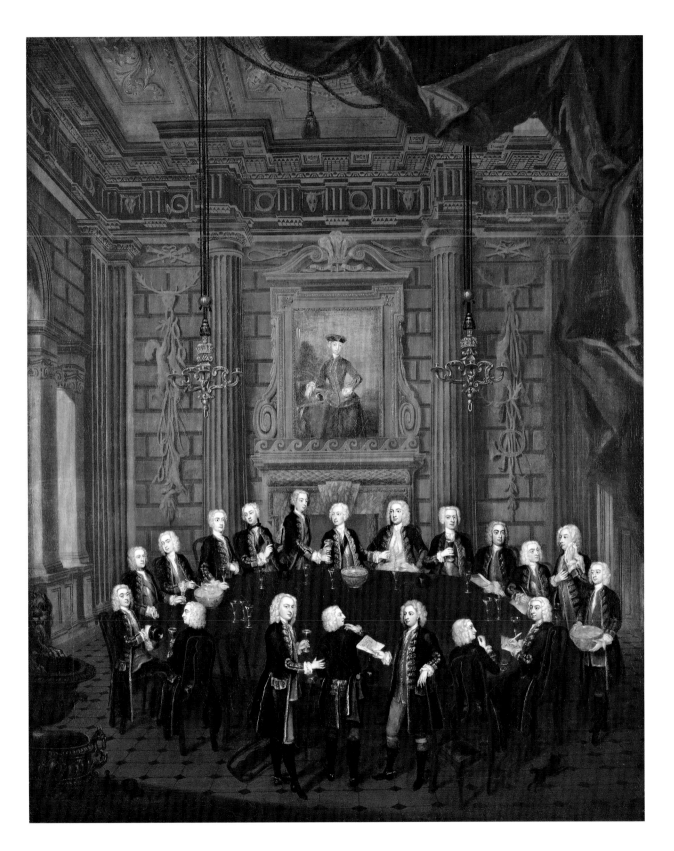

16 CHARLES PHILIPS (1708–47)

Frederick, Prince of Wales, with Members of 'La Table Ronde'

Oil on canvas
128 x 102.2 cm
Signed: *CPhilips. Pinxit 1732*
Acquired by George IV
RCIN 406101
Millar 1963, no. 533

THIS is one of two paintings in the Royal Collection, both now ascribed to Philips and both acquired by George IV, which document the existence of clubs of which there is no other surviving record. This painting was described in a Carlton House inventory of 1816 as 'The late Prince of Wales, with the members of "La Table Ronde"'.
On 21 May 1813 George IV's agent recorded the receipt of 'a Painting Consisting of Seven Portraits' from one General Wilkes, adding that 'Frederick Prince of Wales Established a Club – Called the Gang or Harry The Fifth's Club – the members of which were Call'd Fallstaffs Points – Bardolph &c'.

In so far as it is possible to characterise a club from its name, both of those recorded in Philips's paintings appear to be versions of 'Liberty Hall'. In one (fig. 49) Frederick casts himself as a previous Prince of Wales, the mad-cap Prince Hal, carousing like a fellow with his disreputable boon companions before becoming the legendary hero-king Henry V and leading another 'band of brothers' to victory. In the present painting Frederick is depicted as King Arthur meeting on terms of equality with his Knights of the Round Table. He sits centrally, under some imposing voussoirs and a carved version of the Prince of Wales feathers, but not at the head of a table which can have no head; no servants are seen because the knights serve each other as the punchbowl circulates; none wears a hat. Even the inscriptions – 'Interruption' written under the man in the centre foreground who has overturned his chair and spilt his wine, 'Orders and Constitution' on the paper held by the man next to him – suggest the jocular solemnity of club democracy. In both paintings the idea expressed is best summed up in the description by engraver George Bickham (*c*.1706–71) of a temple in the Gardens of Stowe dedicated to Frederick, Prince of Wales's

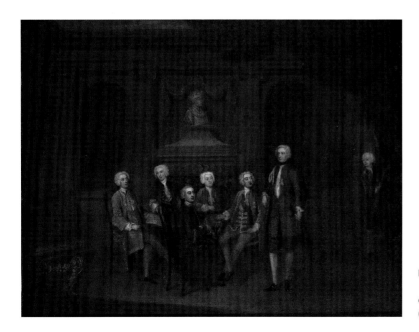

FIG. 49 Attributed to Charles Philips, '*The Henry the Fifth' Club* or '*The Gang*', *c*.1630–35; oil on canvas. Presented to George IV in 1813 (Royal Collection, RCIN 405737)

political associates, the Patriots, in which he concludes 'Friendship has no monarchs' (*The Beauties of Stowe*, 1750).

The hunting uniform worn here, complete with boots and spurs, was designed by Frederick and seems to have caught on: a royal page described it in 1729, as 'blue, trimmed with gold, and faced and lined with red. The Prince of Wales, Princess Anne, the Duke of Cumberland, Princess Mary, and Princess Louisa wear the same, and looked charming pretty in them … a world of gentlemen have had the ambition to follow his Royal Highness's fashion'. Such a fashion is an interesting variation on livery – uniform specific to a household and worn only by servants – and seems here to express allegiance (perhaps reciprocal) rather than service. Wootton's hunting scenes (no. 17 and fig. 50) show the Prince's uniform worn by him and some of his friends as well as his livery (a red coat) worn by his servants. The same hunting uniform is worn by Princess Anne in the painting over the fireplace (from an original by Mercier). The idea of women sporting such masculine riding gear was not universally approved at this time:

> The Model of this *Amazonian* Hunting-habit for Ladies, was, as I take it, first imported from France, and well enough expresses the Gayety of a People who are taught to do any thing so it be with an Assurance; but I cannot help thinking that it fits awkwardly yet on our *English* Modesty. The Petticoat is a kind of Incumberance upon it; and if the *Amazons* should think fit to go on in this Plunder of our Sex's Ornaments, they ought to add to their Spoils, and complete their Triumph over us, by wearing the Breeches.
>
> (Richard Steele, *Spectator*, no. 104, 29 June 1711)

Seventy years later a satirical print of 1781 (fig. 80) shows an 'Amazon' in the same costume completing the triumph over her husband by plundering the reins of their carriage.

This painting is often said to depict the interior of Frederick's villa, the White House at Kew (seen in the background of Knapton's group portrait, fig. 45). The room is clearly lit by a Venetian window (that is, of straight-arched form), yet no such window occurred at the White House. It is most likely that this is an imaginary hunting lodge, with Doric columns appropriate for such a manly sport, and with every available space for decoration bearing some symbol of the chase: animal skulls and circular hunting horns in the metopes of the frieze, hanging trophies of the hunt between the columns, and more hunting horns in the decoration between the capitals.

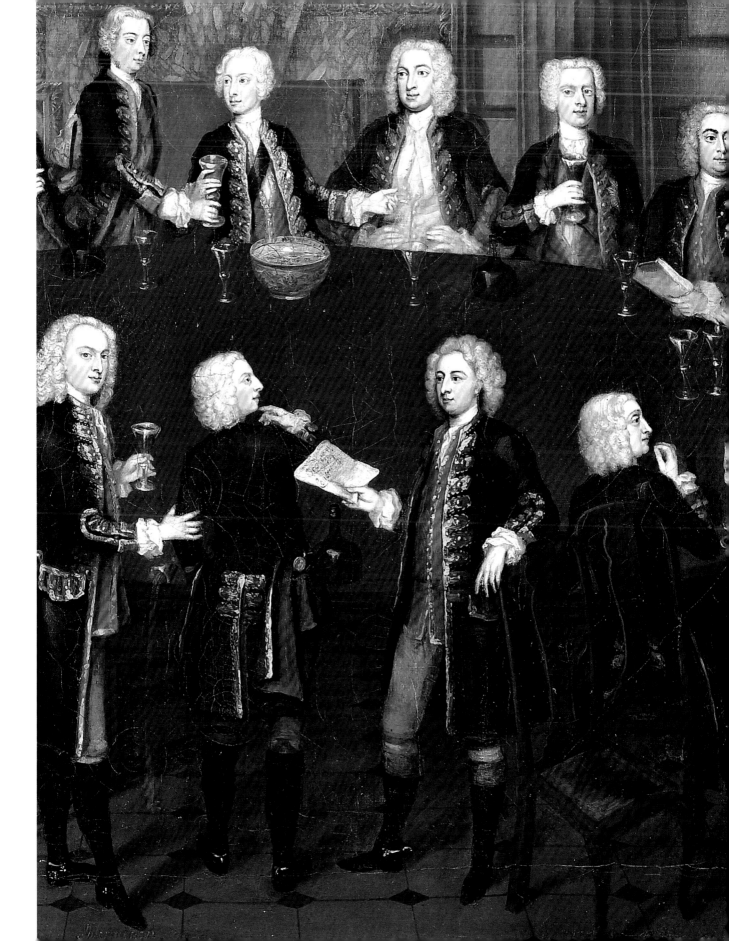

J. WOOTTON

17 JOHN WOOTTON (1686–1764)

The Shooting Party: Frederick, Prince of Wales,
with John Spencer and Charles Douglas, 3rd Duke of Queensberry

Oil on canvas
88.9 x 74 cm
Signed: *JW / 1740*
Painted for Frederick, Prince of Wales
RCIN 402421
Millar 1963, no. 547

FREDERICK'S earliest commission to John Wootton was for a hunting scene (fig. 50), dated 1734, with the varied and informal interaction of a classic conversation piece and with heads executed by the leading master of the genre, William Hogarth. It differs from other conversations of this date in the prominence given to horses and landscape and the huge scale of the canvas (approximately 7 by 9 ft), designed to decorate the Great Hall of the White House at Kew. Other commissions given to Wootton – for pairs of hunting and battle scenes – were similarly conceived to fill the large spaces of halls and staircases at the Prince's houses in Kew and Leicester Square. The scale of the figures here is comparable, but the composition reads as a vignette or fragment, with a very different character: instead of the heroic spectacle of a hunt we have the intimacy of a few friends relaxing during a rough shooting expedition.

John Spencer (1708–46), on the left, trying to keep a bird from an eager spaniel, was the favourite grandson of Sarah, Duchess of Marlborough (1660–1744), and succeeded her as Ranger of Windsor Great Park in 1744. Charles Douglas, 3rd Duke of Queensberry (1698–1778), in the centre, pointing in the direction of the party's next foray, was Gentleman of the Bedchamber to the Prince of Wales. Both men wear a jockey cap, an article of plebeian dress fashionable at the time, and wait upon Frederick, Prince of Wales, who sits nonchalantly on a bank, stroking a dog and wearing his own hunting

FIG. 50 John Wootton and William Hogarth, *Frederick, Prince of Wales, Hunting at Windsor*, painted for the Prince in 1734; oil on canvas (Royal Collection, RCIN 401000)

uniform (as seen in no. 16). Two of Frederick's liveried servants act as loaders behind him and the booty shot so far lies at his feet: hare, pheasant, snipe and kingfisher.

The closest visual precedent for this sporting elegance can be found in French scenes of hunters of both sexes resting or eating *en plein air*, such as François Lemoyne's *Déjeuner de Chasse*, 1723 (fig. 51). The landscape in Wootton's image has a very different character from Lemoyne's: darkening as evening approaches, heavily wooded and suggestive of the wilder recesses of Windsor Great Park. According to Horace Walpole, Wootton turned to landscape late in his career, following the style of Gaspar Dughet (1615–75, then always called Gaspar Poussin) and sometimes, as in the sky here, imitating 'happily the glow of Claud Lorrain' (*Anecdotes of Painting in England*, 1762).

The magnificent frame was acquired from Paul Petit in 1742 for 20 guineas (probably only slightly less than the painting itself); within the asymmetric rococo carving appear game, dogs, bulrushes and various weapons, all surmounted by a lion's head crowned with the Prince of Wales feathers.

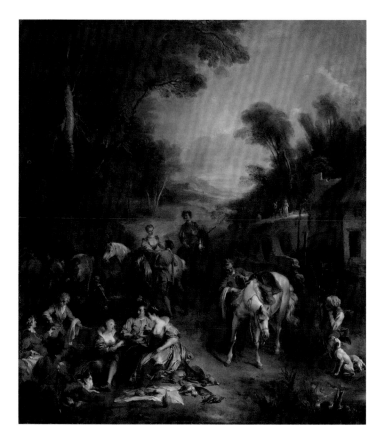

FIG. 51 François Lemoyne, *Déjeuner de Chasse*, 1723; oil on canvas (Alte Pinakothek, Munich)

18 ATTRIBUTED TO JOSEPH NICKOLLS (*fl. 1726–55*)

St James's Park and The Mall

Oil on canvas
104.1 x 138.4 cm
Painted after 1745
Acquired by George IV
RCIN 405954
Millar 1963, no. 617

ST JAMES's Park was laid out by Charles II in the formal French style with avenues of trees and a long rectangular canal. This scene is viewed as if from the upper right of Leonard Knyff's bird's-eye drawing (fig. 52), looking back towards Whitehall Palace down the oblique avenue of trees. Westminster Abbey is visible in the distance, including Hawksmoor's façade towers completed in 1745. To the right of Nickolls's view and clearly visible across the top right of Knyff's is the quadruple avenue of trees with a wide aperture down the middle, containing a surface of crushed cockle-shells. This was originally created (though at this date no longer used) for a game resembling croquet, called pall-mall, which was why this road was called 'the Mall', a name it retains today.

This royal park was kept open for the public, though chairs, horses and carriages were forbidden except by special permission of the King. It became a favourite resort for all fashionable (and not so fashionable) society, the Mall in particular being a place to be seen in the eighteenth-century London equivalent of the *passeggiata*. According to a French visitor,

> Society comes to walk here [along the Mall] on fine, warm days, from seven to ten in the evening, and in winter from one to three o'clock ... the park is so crowded at times that you cannot help touching your neighbour. Some people come to see, some to be seen, and others to seek their fortunes; for many priestesses of Venus are abroad ... all on the look out for adventures.
>
> (César de Saussure, *Letters from London*, 1725–30)

Other accounts tell of cows and deer in the fields around the park, while a visitor in 1765 especially appreciated the

FIG. 52 Leonard Knyff, *Whitehall and St James's Park*, 1694–8; pen and ink and watercolour (City of Westminster Archives Centre)

availability of udder-fresh cow's milk 'served with all the cleanliness peculiar to the English, in little mugs at a penny a mug' (P.-J. Grosley, *A Tour to London*, 1772) and seen here in the lower left-hand corner.

The chief purpose of an image like this is people-watching: contemporaries would clearly have recognised familiar scenes (like the milk-bar) and types within the extraordinary variety of the London crowd. The low-life characters are kept somewhat to the periphery of the image: the woman pulling up her stocking in the left foreground and the suckling mother on the right. Three different regiments are represented: two soldiers from a 'Grenadier Company' of a Guards or Line regiment with their high mitres chat in the centre background; two Hungarian Officers, the one in scarlet probably a Nádasdy Hussar, appear at the lower left corner – Austria was Britain's ally during the war of the Austrian Succession (1740–48); two Highland Officers in

government tartan stride across the centre just in front of a foot-soldier. Wearing tartan at this time was outlawed for all except men like these, serving in Highland regiments in the British Army, though disgust at the brutality of the Duke of Cumberland made sporting tartan a fashionable badge of protest at this time. Immediately behind the Scottish soldiers is a sailor, talking to a friend, while a well-dressed black woman, presumably his wife, walks in front of him. Two priests in black walk in the centre right, while further to the right an exotic-looking robed and bearded middle-eastern elder instructs a younger man. Otherwise, the Mall itself is given over to the *beau monde*, dressed in

the height of fashion and saluting each other with elaborate grace and courtesy.

This group is dominated by the clearly identifiable figure of Frederick, Prince of Wales, speaking to a fellow Garter Knight in the centre of the composition. Immediately behind the viewpoint of the picture was the gate leading to the Prince's garden at Carlton House, so he is almost literally on his own doorstep. Royalty had mingled with the public in this setting at least since the time of Charles II, but Frederick's presence here is a perfect expression of his common touch – or his nauseating habit of ingratiation, depending upon your point of view.

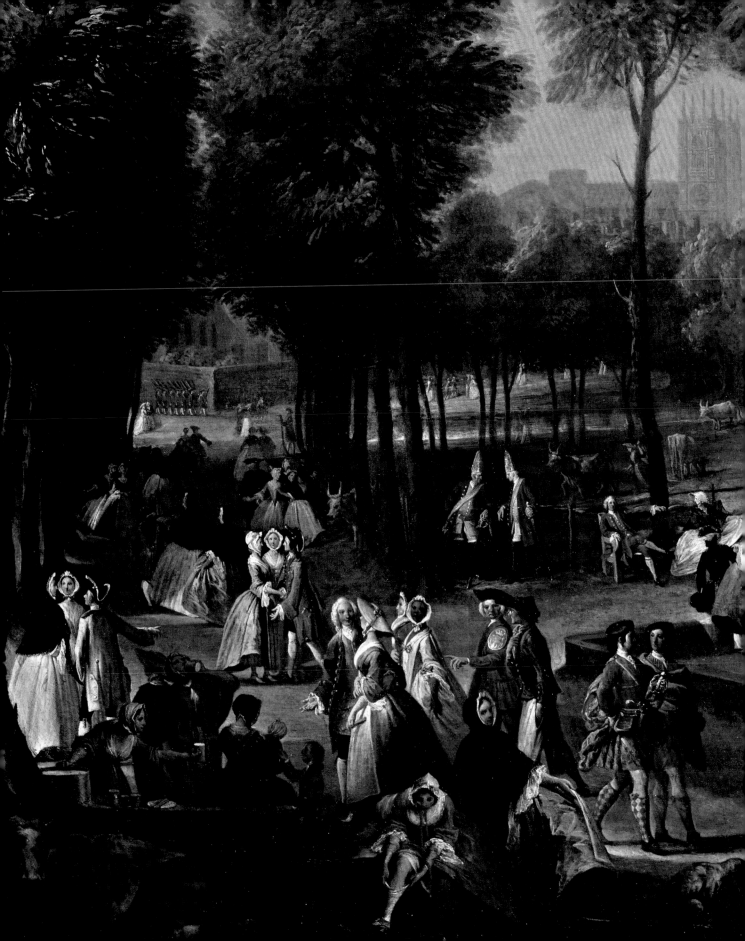

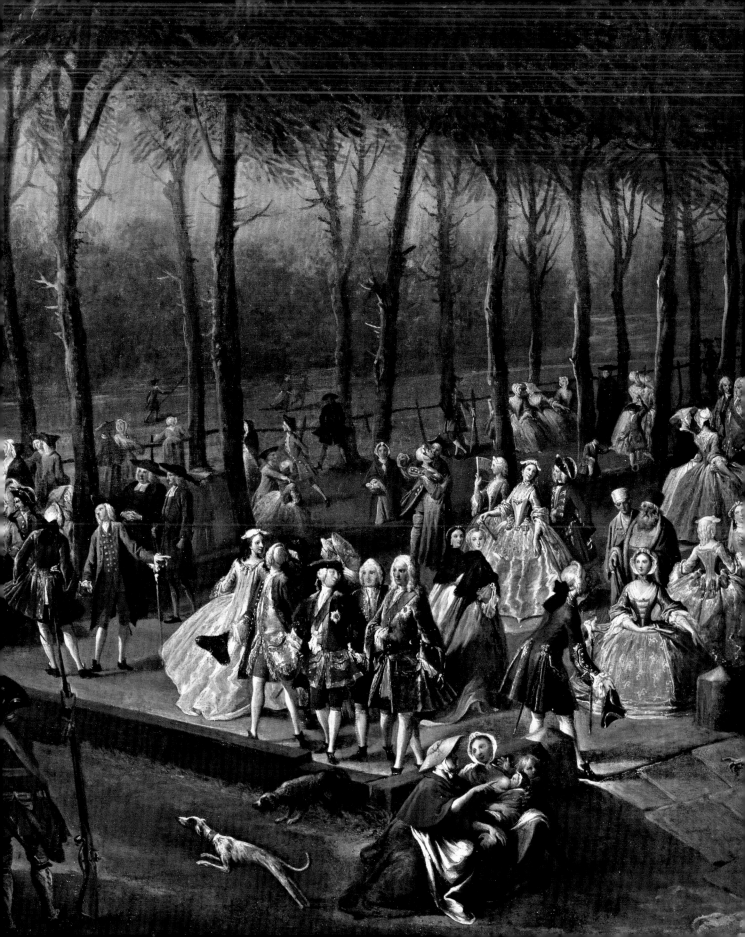

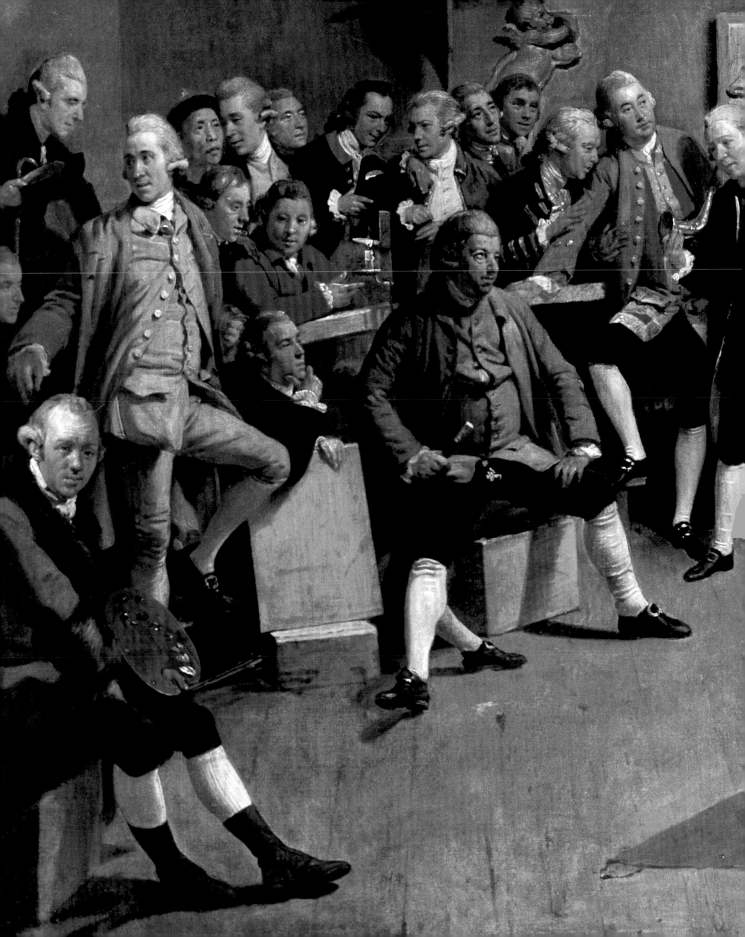

George III (1739–1820)

4

4 George III (1739–1820)

JOHN Wootton's view of the procession of George III to open parliament in 1762 (fig. 53) shows the same corner of St James's Park as no. 18, with the viewer turned somewhat to the east. The royal coach leaves the grounds of Carlton House at the rear of a magnificent procession riding down the diagonal avenue towards Horse Guards between cheering crowds. It is as if the popular King is a realisation of the promise of his father, the affable Prince of Wales, rubbing shoulders with

the crowd down the Mall some seventeen years earlier.

The accession of George III in 1760 was greeted with general enthusiasm. Even if this decayed rapidly into discontent, with hostility especially directed at Lord Bute, most contemporary commentators agreed that the new King was a man of good sense in public and good character in private. George III adopted many of the ideas of his father, without his vanity and without needing to oppose or encounter opposition from his family. The idea of a

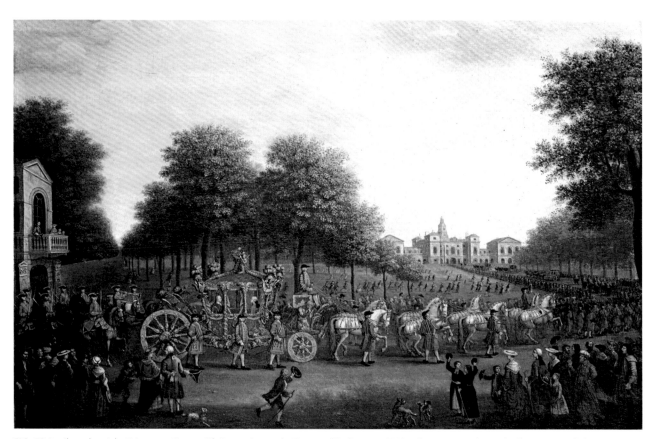

FIG. 53 Attributed to John Wootton, *George III's Procession to the Houses of Parliament*, 1762; oil on canvas. This is the first outing of the new Gold State Coach, designed by Sir William Chambers; the painting was acquired by George IV as by Hogarth (Royal Collection, RCIN 402002)

constitutional balance between monarch and liberty, as expressed in Knapton's family portrait (fig. 45), was the frequent boast of patriotic poets of the age, such as Francis Gentleman, who in 1766 wrote:

If ROME could boast her TITUS, may not we
A GEORGE proclaim, the king of Liberty?
(*Characters, an Epistle*, London, 1766)

The King had a strong sense of duty: his son, Frederick, Duke of York, described a walk with him in Kew Gardens in 1773, during which the 'King gave us many instructions in regard to the duties of princes: told us that princes not being obliged to labour with their hands, were to labour with their heads, for the good of their people'. Fanny Burney considered George III a 'pattern of modest, but manly superiority to rank' (*Diary*, 19 December 1785); she describes the King conversing with 'perfect good-humour' with her father, the musicologist Dr Burney, in spite of the fact that 'he was so totally unacquainted with the forms usually observed in the royal presence, and so regardless or thoughtless of acquiring them, that he moved, spoke, acted, and debated, precisely with the same ease and freedom that he would have used to any other gentleman whom he had accidentally met' (*Diary*, 29 December 1786). George III was a devoted family man who, according to the children's wet-nurse, Margaret Scott, 'at times would shed the dignity of the monarch in the natural impulse of the parent' and crawl about on the floor with the children; but 'on the approach of the Queen (at all times dignified and strict, especially with the Duke of York) His Majesty would assume a royal demeanour' (Scott, *Memorials*, 1876). Dignity did not prevent Queen Charlotte from being a loving mother, with, according to Fanny Burney, 'all the domestic affections warm and strong in her heart' (*Diary*, 1 December 1786).

The Royal couple seem to have valued what might now be called 'normal' family life. They chose to live in private houses of more recent construction and modern fashionable decoration – Buckingham House, the Queen's Lodge and Frogmore House in Windsor – rather than in the venerable palaces and castles which they had inherited. According to the Duchess of Northumberland, the King 'was certainly naturally of a chearfull even Sociable Disposition & a clear Understanding, yet he lived in the utmost Retirement'

FIG. 54 Allan Ramsay, *Queen Charlotte with her Two Eldest Sons*, painted for the King c.1764; oil on canvas (Royal Collection, 404922)

(*Diaries*, 1768). The couple seemed to have made a conscious decision to live as 'Mr and Mrs King'. When their third son, William, was sent away in 1779 to be a midshipman in the Royal Navy, Queen Charlotte wrote to her brother, Prince Karl (see no. 22), that, while she was no Roman mother wishing him a glorious death, she nonetheless wanted him to share danger with his comrades and to do his duty. Her ideas are summed up in a mixture of French and German: 'Ce cher fils commencera donc a apprendre sa profession ganz von unten auf et a servir comme un gemeinen Mann' ('This dear son will therefore begin to learn his profession from the bottom up and to serve like a common man', letter of 1 July 1779).

These ideas had a profound influence on full-length formal portraiture during George III's reign. Allan Ramsay's

THE ARCHBISHOP of ARMAGH AND BROTHERS WHEN BOYS.

FIG. 55 Johan Zoffany, *Three Sons of John, 3rd Earl of Bute*, c.1763–4; oil on canvas (Tate, London)

portrait of the Queen with her two eldest sons, Princes George and Frederick, painted *c.*1764 (fig. 54), shows her as an affectionate mother and enlightened instructress, having read John Locke's *On Education* (the book visible on the harpsichord). But the idea of the *gemeine Familie* is best expressed through the conversation piece. The royal couple found the greatest exponent of the form in Johan Zoffany, and they commissioned from him the most important group of conversation pieces in any collection.

Like Allan Ramsay, Zoffany was recommended to George III by his mentor, Lord Bute, having painted for the latter in 1763–4 a pair of conversations depicting his three sons and three daughters (figs. 55–6). Furthermore, like

Ramsay, Zoffany no doubt pleased the Queen by speaking to her in her native German. However, many things had changed in the London art world in the thirty years separating Hogarth's conversation pieces for George II and Zoffany's for George III. The genre had certainly taken root in England, but by the 1760s conversation pieces were far from representing the height of fashion: compared to the life-size portraiture of Reynolds or Ramsay, the small scenes of Arthur Devis (fig. 57) appeared provincial and stiff. Gainsborough painted conversations in this manner during his earlier years in rural Ipswich, as can be seen from his *Gravenor Family* of *c.*1754 (fig. 78), but he had deserted the genre entirely in favour of life-size portraiture

DAUGHTERS of JOHN 3ʳᵈ EARL of BUTE.

FIG. 56 Johan Zoffany, *Three Daughters of John, 3rd Earl of Bute*, *c.*1763–4; oil on canvas (Tate, London)

by the time he moved to fashionable Bath in 1759. Philippe Mercier and his generation of continental artists (see pp. 66–8 above) had brought with them to London various artistic and composition conventions, based largely on Watteau. Zoffany, however, brought only a way of painting; he was happy to draw upon the local fashions in setting, deportment and general appearance, which is why he has seemed of all artists the most English. According to Sacheverell Sitwell, 'Under his hands the Conversation Piece freed itself from every extraneous derivation and became the picture of English life'. There is almost an element of parody in the way in which Zoffany took up the quaint manner of Arthur Devis.

Zoffany also differs from Mercier, Laroon and their generation in painting not the flicker of movement across a casually constructed stage, but the solidity of precious stuffs and the precisely calculated volume of a real room, filled with air and light. This is something Zoffany had learned from the great generation of Dutch genre painters, discussed above: Gerard Ter Borch, Gerrit Dou and his followers (Gabriel Metsu, 1629–67, Frans van Mieris, 1635–81, and Godfried Schalcken), and members of the 'Delft school', Pieter de Hooch and Vermeer. This type of painting was beginning to be appreciated by English collectors at this time: Vermeer's *Music Lesson* (fig. 90) was acquired by George III in 1760, though admittedly as a Frans van Mieris

FIG. 57 Arthur Devis, *William and Lucy Atherton*, c.1743–4; oil on canvas (Walker Art Gallery, Liverpool)

and as part of the block purchase of the collection of Consul Smith. More surprising is the enthusiasm for fine and polished technique voiced at this date by some theorists in opposition to the academic orthodoxy which favoured the broad, boldly finished Italianate handling exemplified by Titian, Raphael or Correggio.

The Swiss pastellist Jean Etienne Liotard (1702–89) was in Paris during the decade 1725–35, when Dutch-style painting of tactile reality was greatly appreciated. Liotard visited England in 1753–5, when he drew the future George III and his siblings; in 1781 he published his *Traité des principes et des règles de la peinture*, a sustained defence of the values of Dutch art. One of the rules in Liotard's treatise is to 'Finish as much as possible', adding that: 'the painters who, in my opinion, have best finished

their works are Frans and Willem van Mieris, Gerrit Dou, Jan van Huysum, Van der Werff, Van der Heyden, Adriaen and Willem van de Velde, Philips Wouwermans, Ter Borch, Ostade and many other Flemish and Dutch masters'.

Elsewhere Liotard compiles an almost identical list of artists, commending them for avoiding visible brushstrokes, which, he says, does not prevent their work from being 'very vigorous and full of life'. Such artists may be compared to 'the English painter, Hogarth', who has 'a great deal of expression, but lacks finish'.

Zoffany studied in Paris and would surely have approved of these sentiments. It was certainly his technique and his successful imitation of Dutch and Flemish masters which impressed his English audience: Horace Walpole wrote of him: 'I look upon him as a Dutch painter polished or civilized.

He finishes as highly, renders nature as justly, and does not degrade it, as the Flemish school did' (letter to Horace Mann, 12 November 1779, about no. 25). Perhaps the best tribute to Zoffany's craftsmanship was the amount he was able to charge. His most common size of canvas was 40 x 50 in (102 x 127 cm), which was the format of one of the standard portrait sizes of the period (called a 'half-length') set on its side. Sir Joshua Reynolds, the most expensive painter in England by a margin, charged 70 guineas for a half-length during the years 1765–78; there are several records of Zoffany charging 100 guineas for this size of canvas in 1770 (though unfortunately there is very imperfect documentation for the rest of his career). Clearly there is much more work per square inch in a Zoffany than there is in a Reynolds, but even to compete with the first President of the Royal Academy is a considerable feat.

This interpretation of Zoffany as a 'Flemish master' implies that the appreciation of Old Master painting in England had reached a very high level of subtlety by the 1760s. Old Master paintings played an increasingly important part in the furnishing of rooms, as can be seen by comparing the symmetrical hanging of paintings against undecorated silk-covered walls in the Drawing Room at Buckingham House (no. 19 and fig. 58) with the more elaborate decoration typical of the 1720s and 1730s, which allows space for paintings only as overdoors, as can be seen in Laroon's *Dinner Party* (no. 11). Zoffany's visual erudition – his ability to mimic styles, whether as full-scale parody or glancing allusion – could only be appreciated by an audience familiar with Old Master painting displays of this kind. Most English aristocratic collections began to be formed only in the Georgian era; Charles I gave the Royal Collection a century's head start, but important acquisitions were also made during the reigns of George I and George II and the displays were completely reconceived during these years. The best example of the topicality of interest in Old Masters was George III's re-acquisition in 1765 of Van Dyck's *Five Eldest Children of Charles I* (fig. 17) for the princely sum of 500 guineas. The arrival of a conversation piece of this importance must have had a profound influence on the young Zoffany, who was at this time just beginning his first works for the King (nos. 19 and 20). It is not surprising that so much of Zoffany's work for George III is conceived as a tribute to Van Dyck and other seventeenth-century Flemish masters. It is also worth noting that he painted on a slightly larger format than his predecessors, and one derived from mainstream portraiture (see above), and that many of his works, including some of those illustrated here, seem to have been planned as pairs. This all suggests that Zoffany conceived his works to hang in public reception rooms, like that illustrated in fig. 58, rather than in private cabinets (as might have been the case with the work of Laroon, Mercier or Hogarth).

George Stubbs employed the same standard canvas size as Zoffany – a portrait painter's 'half-length' on its side. Unfortunately no records show exactly how either artist's paintings were originally hung, and we must wait for another century and Joseph Nash's watercolour of Queen Victoria's sitting room in Windsor of *c*.1850 (fig. 91) for the first record of the display of a conversation piece. Here Grant's *Queen Victoria Riding Out* (no. 31) and Landseer's *Windsor Castle in Modern Times* (no. 34) are hung as a pair: although both works are only slightly larger than Zoffany's standard size, they dominate the ensemble of the room just as life-size portraits might.

19 JOHAN ZOFFANY (1733/4–1810)

George, Prince of Wales, and Frederick, later Duke of York, at Buckingham House

Oil on canvas
111.8 x 127.9 cm
Probably painted for Queen Charlotte *c.*1764–5
RCIN 404709
Millar 1969, no. 1200

THIS scene must have taken place shortly before March 1765, when Prince George was 'breeched' (first dressed in breeches). Zoffany depicts the Queen's Second Drawing Room, also known as the 'Warm Room', at Buckingham House, which is also recorded in James Stephanoff's watercolour of 1818 (fig. 58). This room lay on the first floor of the garden façade (the windows can be seen reflected in the mirror in both views), in the space now occupied by the northern third of the Picture Gallery. This is an intimate glimpse of the Queen's new home. Buckingham House was acquired in 1762 and the Queen's apartments were redecorated in the next couple of years, under the direction of the architect William Chambers (1723–96). The crimson damask wall hangings were supplied by Robert Carr in 1762–3. The seat furniture here is probably by Catherine Naish; the carpet may be one of a series of bordered Brussels carpets laid by Vile and Cobb. The fire screen was probably supplied by William Vile in 1763. The fireplace, designed by Chambers, is the only surviving element of the decoration, though now to be found in the King's Bedroom in Windsor. The simple classical door frame seen reflected in the mirror was designed by George III himself.

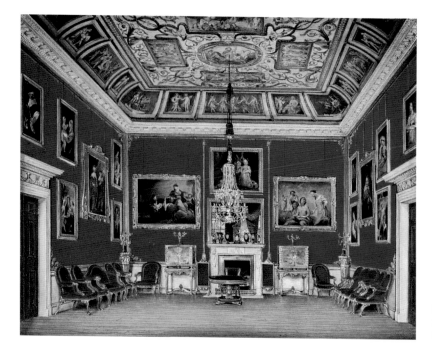

FIG. 58 James Stephanoff, *The Second Drawing Room at Buckingham House*, 1818; watercolour (Royal Library, RCIN 922143)

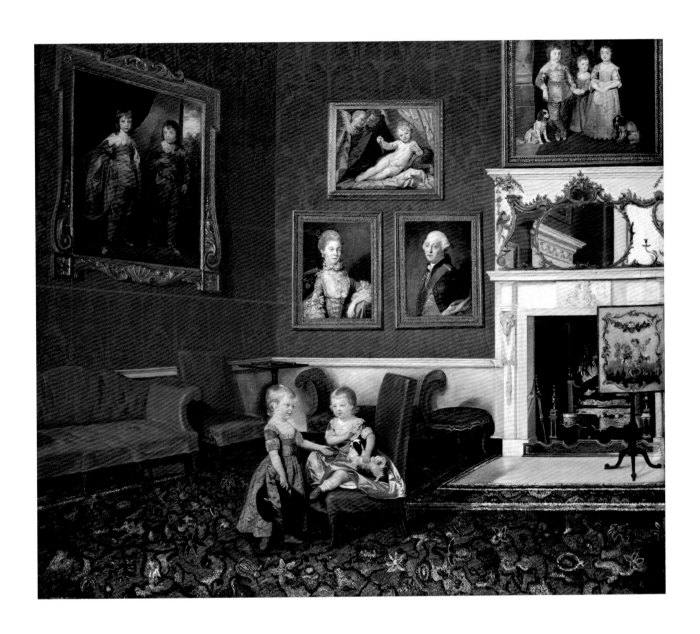

The paintings shown here were probably selected from those that actually hung in the space (though at this date there is no accurate record of the hang against which to check it). Two Van Dycks painted for Charles I and still in the collection, the *Villiers Children* and the *Three Eldest Children of Charles I* (Royal Collection, RCIN 404401 and 404403), were presumably hanging approximately where Zoffany puts them (compare fig. 58). The arrangement of the three other paintings is probably an invention: the Carlo Maratti *Vision of St Stanislaus Kostka* (Royal Collection, RCIN 405693), visible in fig. 58, could have hung here in 1764; it has been replaced by Zoffany with a Carlo Maratti *Christ Child*, probably acquired by Queen Anne (Royal Collection, RCIN 405555). This figure is placed so as to appear to bless the Royal couple below (presented in portraits apparently of Zoffany's own invention).

Sumptuous and fashionable though this interior is, it could at first glance belong to any wealthy family of the era. The trick of the image lies in the way in which we are invited to discover royal blood, through the presence of a portrait of the children of Charles I and through the way in which the living Princes play with the same dogs and adopt postures similar to their remote ancestors.

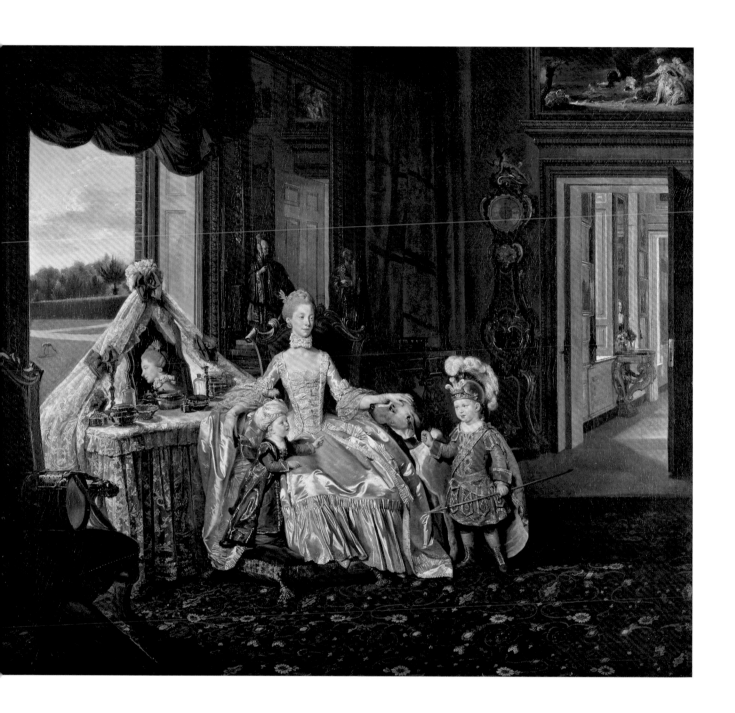

20 JOHAN ZOFFANY (1733/4–1810)
Queen Charlotte with her Two Eldest Sons

Oil on canvas
112.4 x 129.2 cm
Probably painted for Queen Charlotte in *c*.1765
RCIN 400146
Millar 1969, no. 1199

THIS painting shows the Princes fractionally older than in no. 19, suggesting that both works must have been on the artist's easel simultaneously. This might explain why the head of the Queen here and in the portrait on the wall of no. 19 follow the same pattern. Again, the setting here is Buckingham House, but this time the King's apartments on the ground floor garden façade; these were less comprehensively redecorated and therefore preserved more of the character of the 1702–5 building campaign depicted in an anonymous view of the rear of the house painted at this time (fig. 59). Zoffany has placed the Queen's dressing table directly in front of the back door at the centre of the garden façade – the glimpse of formal garden (seen also in fig. 59), the height of the aperture and the fenestration of the rooms visible beyond admit

of no other explanation. This is clearly a very unlikely position for a dressing table, and suggests either that the Queen was temporarily occupying these rooms while her apartments above were being redecorated or that Zoffany has stage-managed the scene in order to achieve the effect of vistas opening in every direction. The character of the interior is more heterogeneous and in some cases old-fashioned than in the previous work: dark-coloured panelling and door surrounds; pier glasses and table in the style of the 1730s; a French clock by Ferdinand Berthoud, with a case designed by Charles Cressent following a model of the 1730s; Chinese figures; an unidentified overdoor (perhaps depicting Ulysses and Nausicaa) resembling the work of Francesco Zuccarelli; a lace cover for the dressing table, supplied by Priscilla

FIG. 59 Anonymous, *Buckingham House*, *c*.1702–5; oil on canvas (Royal Collection, RCIN 404350)

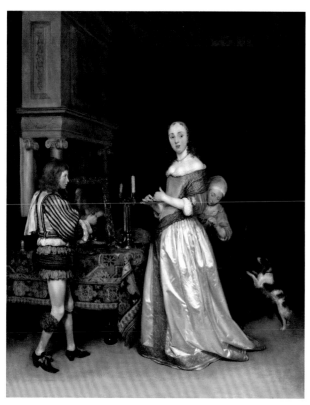

FIG. 60 Gerard Ter Borch, *Lady at her Toilet*, *c*.1660; oil on canvas
(The Detroit Institute of Arts, Michigan)

on the clock, but the face reads exactly 2.30pm, which means that the Princes have finished their dinner (which since November 1764 they had taken at 2.00pm) and are visiting their mother, after she has dressed (a process which began at 1.00pm) while their governess waits in the room beyond. The Queen will dine with the King at exactly 4.00pm. The splendid and highly formal character of the Queen's dress would be regarded at this date not as a sign of vanity but of respect for custom and ceremony; strict time-keeping is the sign of an orderly mistress of a household; playing with children is clearly the action of a devoted and dutiful mother. Even the way in which the view opens onto a formal garden suggests an appreciation of fresh air and Nature which were becoming popular at this time.

In September 1764 Lady Charlotte Finch (1725–1813), the Princes' governess, ordered 'a Telemachus Dress for the Prince of Wales and a Turk's for Prince Frederick'; it is assumed that this is what they wear in this painting. This attire may be associated with a famous educational text of the period, the *Telemachus* of 1699 by François Fénelon, which describes the son of Ulysses travelling round the Mediterranean (like his father) with his advisor, Mentor, and seeing examples of good and bad government. Or it may be that the contrast of Turkish and classical costume is merely fancy dress, the eighteenth-century equivalent of cowboys and indians. Certainly there is humour in the way that Prince George holds the dog like a warrior with his charger. The empty chair at the left side of the painting, with drum and standard, is surely intended to suggest the person and manly inspiration of the absent King.

Both of Zoffany's images of the royal toddlers were private: neither was engraved or exhibited at the Society of Arts, though the artist must have wished to advertise such a prestigious commission; both seem to have been given to the elder Prince. Both paintings are examples of Zoffany's love of layered reality, of a confusion of real, reflected, painted, carved and embroidered images of the world (something which reaches its apogee in the *Tribuna*, no. 25). In this dressing-room scene there is more than a suggestion that we may view the world with the eye of a child, lost in wonderment at the phantasmagoria of reality and reflection.

MacEune in 1762 for £1,079 14s; and a similarly modern silver-gilt toilet set.

The image is a conscious tribute to the great names of Dutch genre painting, and in particular the work of Gerard Ter Borch, as can be seen by comparison with his *Lady at her Toilet* of *c*.1660 (fig. 60). Zoffany has created the same miraculous effect of silk so glossy that it seems to be a collage of silver-paper; like Ter Borch, he takes an oblique view of the corner of a room with many other rich stuffs and precious objects; he even follows the same device of repeating the sitter's face in profile in the mirror. The perspective of the enfilade, chequered with light, pays tribute to the brightly lit interiors of Pieter de Hooch or Emanuel de Witte (*c*.1617–92).

The moral of Dutch seventeenth-century scenes of ladies dressing is that beauty is transient and that it is vanity to concern yourself with it; hence the extinguished candle on the table in Ter Borch's painting. Zoffany turns the moral around: Father Time appears, scythe-bearing,

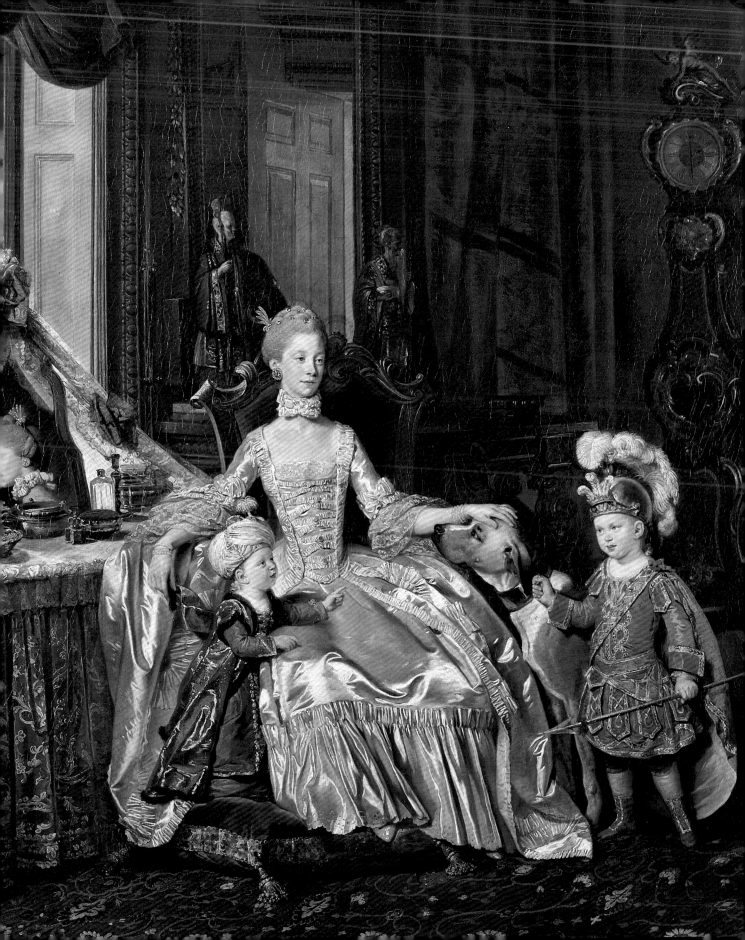

21 JOHAN ZOFFANY (1733/4–1810)

George III, Queen Charlotte and their Six Eldest Children

Oil on canvas
104.8 x 127.6 cm
Exhibited at the Royal Academy in 1770
Probably painted for George III
RCIN 400501
Millar 1969, no. 1201

UNLIKE the two previous works, this one was evidently conceived as a public conversation piece, immediately engraved by Richard Earlom (1743–1822), published 29 October 1770, and exhibited at the Royal Academy. This seems to be the type of image Hogarth was planning for his unsuccessful group portrait of the family of George II (see no. 14); as in that case, Zoffany chose (or was required) to provide an oil sketch for his composition (fig. 61). The sketch envisages a fairly conventional dynastic family group portrait: the King presides between the Princes (George, Frederick, William and Edward) to his right, in front of an instructive garden statue of Hercules wrestling an opponent to the floor; the Queen sits with the Princesses (Charlotte and Augusta) to his left, in front of the crown, orb and sceptre and an arrangement of columns and curtain typical of formal portraiture. Some informal disruption characteristic of the conversation piece is introduced: Prince William plays with a parrot while the two semi-naked babies of the family are engaged in vigorous play with a dog

(in the case of Edward) and their attentive elder sister (in the case of Augusta). These details are restrained in the final version: the babies are fully dressed and all the children pay more attention to the artist and less to their playthings than they do in the sketch. Such obvious concern for the business of a portrait sitting is exactly what the conversation piece proper seeks to avoid; the result therefore is stiff and conventional.

Zoffany's Old Master reference is here clearly to Van Dyck: the royal family are all in 'Vandyke dress', a fashionable style of the day popular for masquerades and portrait sittings; there are also generic references to the conventions of Van Dyck's portraiture, as if this were a record of a lost portrait of Charles I's family. The two eldest princes, George and Frederick, are precisely modelled on Van Dyck's portrait of George Villiers, 2nd Duke of Buckingham, and his brother, Lord Francis Villiers (1635), seen in the background of no. 19, the only difference being that in the present work they link arms affectionately, as becomes children of the age of sensibility.

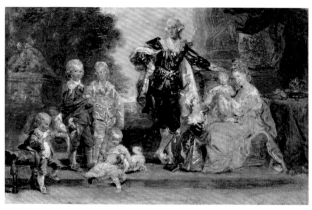

FIG. 61 Johan Zoffany, *George III, Queen Charlotte and their Six Eldest Children*, 1770; oil on canvas (Royal Collection, RCIN 400669)

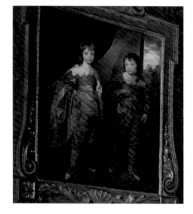

No. 19 (detail)

22 JOHAN ZOFFANY (1733/4–1810)

Queen Charlotte with her Children and Brothers

Oil on canvas
105.1 x 127 cm
Exhibited at the Royal Academy in 1773
Probably for Queen Charlotte but not recorded in the collection until 1862
RCIN 401004
Millar 1969, no. 1207

THIS painting, like no. 21, is also a public image, exhibited at the Royal Academy as a 'Portrait of her Majesty, in conversation with her two brothers and part of the Royal family'. But whereas no. 21 risks being merely a group portrait, this is a classic conversation piece, exhibiting the happy hubbub of affectionate relationships within an extended family.

It records the presence in London in 1771 of both of Queen Charlotte's beloved elder brothers, and must have been finished before Zoffany's departure for Florence in 1772. Prince Karl of Mecklenburg-Strelitz (1741–1816) stands on the Queen's right, wearing the order of St Andrew of Russia; Prince Ernst (1742–1814) stands on her left, sporting the white eagle of Poland. Both men are dressed with the distinctively unostentatious elegance of English fashion, in frock coats (a servant's coat with turned-down collar adopted by the *ton* as early as the 1720s), holding *chapeau bras* (literally 'arm-hats', to be held not worn) and carrying canes rather than swords. The royal children can be identified with less confidence: the girl holding a doll is certainly the Princess Royal (Charlotte, 1766–1828); the boy in red wearing the Order of the Thistle is Prince William (1765–1837), the future William IV; and the baby (held by the royal nanny, Lady Charlotte Finch, known affectionately as 'Lady Cha'), is probably Ernest (1771–1851), later Duke of Cumberland and King of Hanover, who had been baptised in July 1771, with his namesake, Prince Ernst, as his godfather.

The scene shows the family resting during a walk in the park, the over-excited children vying for the attention of a favourite uncle, Ernst. Charlotte wishes to show off her doll; William, held affectionately round the waist, seeks generally to monopolise and must be gently pushed aside by his mother so that she can get a word in edgeways. Karl watches indulgently from the sidelines. The whole scene breathes the spirit of Jean-Jacques Rousseau, whose ideas concerning the purity and innate goodness of natural inclinations and affections were popular in enlightened circles in England and Germany. In later life Prince Karl instigated a Rousseauesque festival for the local population in his picturesque English garden at Hohenzieritz, near Neustrelitz.

As so often, Zoffany has worked a clever visual allusion to the Old Masters into his scene of modern life. Rubens's *Holy Family with Saint Francis* (fig. 62) was recorded in the Drawing Room of the King's apartments at Buckingham House in *c*.1790, with a substantial strip of landscape background added at the top of the

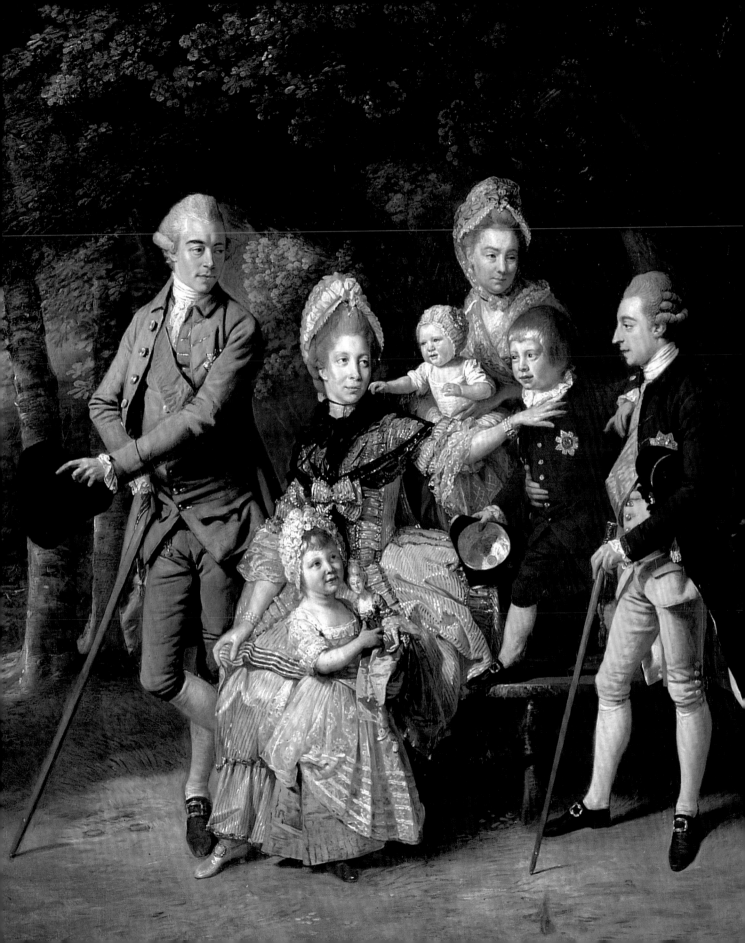

composition. In other examples Zoffany imitates visual types – Dutch interiors (fig. 60), Flemish alchemist scenes (fig. 63) – rather than individual paintings. Rubens's painting also represents a type, common to Italian and northern art, in which the Holy Family is depicted in a landscape with Christ's parents, grandparents, uncles and cousin (not to mention any saint that might be introduced), creating a variety of different opportunities for interaction. Zoffany's royal family group is a scrambled version of such a type, with several of the figures apparently lifted directly from the Rubens. Once the connection is made it is easy to see that the Queen plays the part of the Virgin; Lady Charlotte that of St Anne; Prince Karl is St Joseph; the Princess Royal is the infant Baptist; Prince Ernst is St Francis; and the two Princes compete for the role of the Christ Child.

23 JOHAN ZOFFANY (1733/4 1810)

John Cuff and his Assistant

Oil on canvas
89.5 x 69.2 cm
Signed: *Zoffanÿ pinx / 1772*
Exhibited at the Royal Academy 1772
Purchased by or painted for George III
RCIN 404434
Millar 1969, no. 1209

THE first work Zoffany exhibited in England, at the Society of Arts in 1762, was an image of David Garrick (1717–79) in *The Farmer's Return* (on loan to Tate); the first work he exhibited at the Royal Academy, in 1770, depicted Garrick playing the part of Abel Drugger in Ben Jonson's *The Alchemist* (private collection). Sir Joshua Reynolds bought this latter painting for 100 guineas and was immediately offered 120 guineas for it by the Earl of Carlisle. Zoffany's *Garrick as Abel Drugger* is a parody of an alchemist scene by David Teniers (fig. 63 is one example of many): Zoffany treats a seventeenth-century English satire on the fraudulence and vanity of alchemy through the lens of a seventeenth-century Flemish treatment of the same subject. David Garrick spotted the same connection when, in his *Essay on Acting* of 1744, he wrote of the postures required to play the part of Abel Drugger so as to present 'the compleatest low Picture of *Grotesque Terror* that can be imagin'd by a *Dutch* Painter' (English connoisseurs of the period made little distinction between Dutch and Flemish masters). Just as the elegant and intellectual Garrick gained the highest praise for playing this clumsy and gullible clown, so the erudite Zoffany shows that he can similarly stoop to mimic low-life Flemish painting to brilliant comic effect.

It is possible that Reynolds had Zoffany's painting

FIG. 63 David Teniers II, *The Alchemist*, *c.*1650; oil on panel. Acquired by George IV before 1806 (Royal Collection, RCIN 407264)

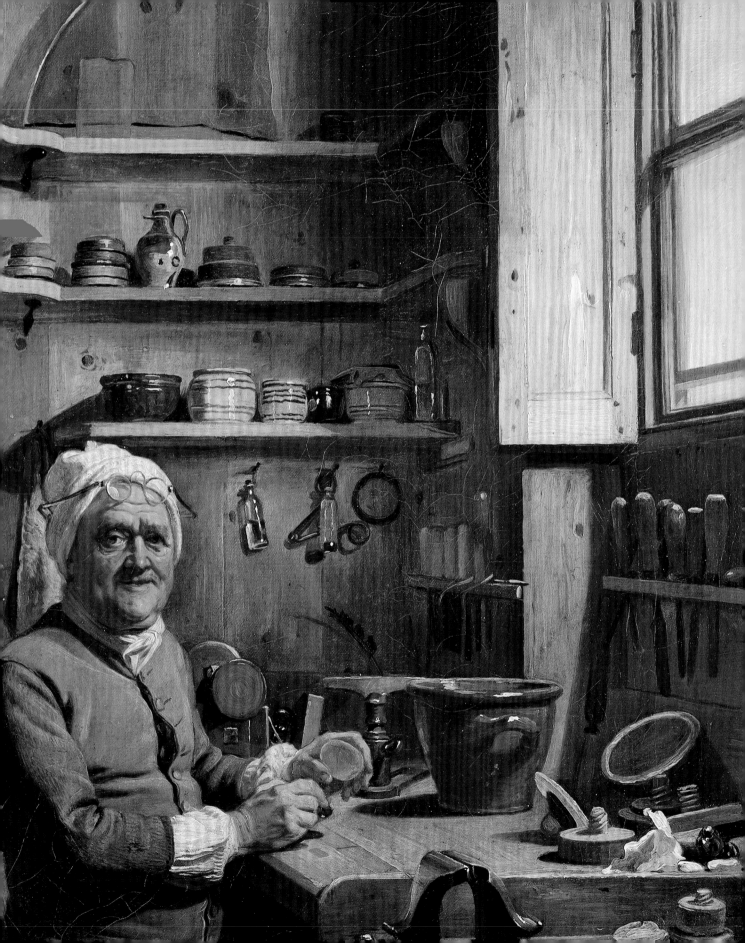

in mind when he delivered his sixth *Discourse* at the Royal Academy on 10 December 1774; having discussed lesser artists of the Dutch school, such as Adriaen Brouwer and Jan Steen, he suggested that 'though they cannot be recommended to be exactly imitated, [they] may yet invite an artist to endeavour to transfer, by a kind of parody, their excellencies to his own performances'.

Reynolds had not yet made this pronouncement when, in 1772, George III commissioned Zoffany to depict John Cuff (*c.*1708–72), a Fleet Street optician from whom he obtained microscopes; but Zoffany hardly needed the hint. This painting is the most perfectly observed parody in art: Zoffany has exactly caught the dingy colour-code of a Teniers alchemist scene, the awkwardness of tortoise-skinned, leather-aproned mechanics; the absurd clutter of incomprehensible pots, pans, tools and widgets; the daylight from a single window planting a droplet of light on each coarse but lovingly rendered surface.

Rather as he did with Ter Borch, Zoffany turns the joke on its head: Teniers's alchemists look benighted and confused, while Mr Cuff is cheerful and manifestly competent. Alchemists are symbols of scientific superstition, while Cuff's telescopes, microscopes and spectacles help one to see the real world. His workshop is not even confusing to the initiated: historians of science have shown that his shelves contain an orderly arrangement of grinding tools and crown glass; he himself is grinding a lens with a lathe operated by a treadle; his hair and arms are protected from glass dust by a headdress and special cuffs. This is an optician's painting, a loving celebration of the phenomenon of light, a tribute to the patient technicians of the Enlightenment.

24 JOHAN ZOFFANY (1733/4–1810)

The Academicians of the Royal Academy

Oil on canvas
100.7 x 147.3 cm
Exhibited at the Royal Academy in 1772
Painted for George III
RCIN 400747
Millar 1969, no. 1210

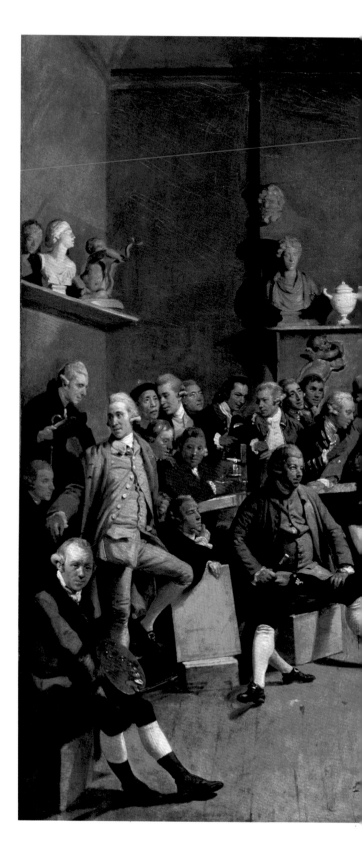

THE Royal Academy was founded in 1768 under the
protection of the King; it was probably soon after this
that George III had the idea of commissioning this group
portrait, from his favourite artist, who had become an
academician by royal nomination rather than election.
When it was exhibited at the Royal Academy in 1772
Horace Walpole annotated his catalogue thus: 'This
excellent picture was done by candlelight; he made no
design for it, but clapped in the artists as they came to
him, and yet all the attitudes are easy and natural, most
of the likenesses strong.' The painting is first recorded
hanging in a room at Buckingham House called the
'Upper Library', presumably not one of the four large
spaces on the ground floor (see fig. 70) but a smaller
room next to the 'Model Room' for which no interior
view survives. This seems such an appropriate location
that we can assume it was planned at the outset.

There is a long tradition of depicting an artist's
working academy as a dignified lumber-room. In
Pietro Francesco Alberti's *Academy of Painters* (c.1600)
recording the academy that Federico Zuccaro ran in
his palace in Rome (fig. 64) we see a cluttered and
undecorated working warehouse, peopled with heroic
masters and pupils who seem to have migrated from
Raphael's *School of Athens* (fig. 65). Alberti's groups
demonstrate the different components of an artist's
education: anatomy, geometry, sculpture, the study of
classical antiquity and so on. The diffuse light from
the window creates complex shadows of varying density
behind each of the objects, as if illustrating the principles
of light and shade. The heroic dignity of the figures
underlines the fact that all these things are subjects
of intellectual inquiry rather than mechanical
application, and are therefore suitable for noble minds.

Zoffany's image similarly shows the 'back-of-house'

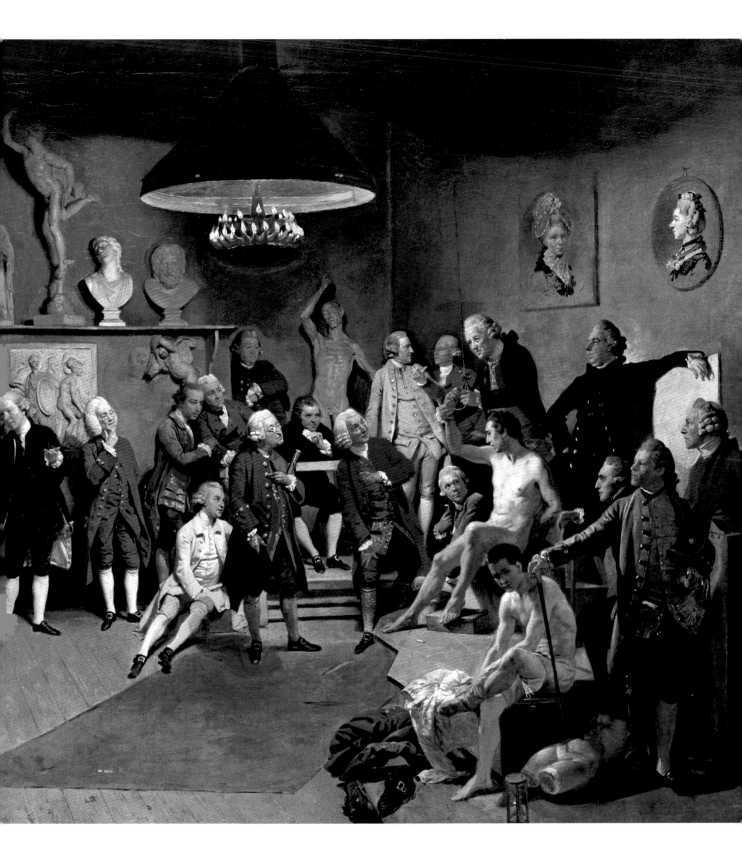

clutter and the intellectual dignity of working artists, where fine gentlemen sit on packing cases and converse with polish and good humour. He depicts the Academy's life-drawing room at Old Somerset House, with casts round the walls, a simple platform for the model (with chalk to mark out the pose), a single oil lamp suspended from the ceiling and a circular table running round the room with individual shaded candle-holders for each of the artists. A painting attributed to Zoffany of *c*.1761 of the life-school at St Martin's Lane (fig. 66) shows the same arrangement more clearly. In his *Academicians*, Zoffany depicts the circular table in a very summary and interrupted way, with only one candle-holder visible towards the left edge, presumably because it would otherwise have inhibited the picturesque grouping of this very animated conversation.

The artists are clearly setting up the life-class, and perhaps discussing its importance, rather than actually drawing from the nude. Rather as Alberti did, Zoffany uses the scene to convey the importance of the intellect in art and to suggest by a series of visual clues what these artists might find to talk about. They might discuss the importance of the antique and its survival in the sculpture of the Italian Renaissance, pointing to the objects displayed around the walls; or the need to find that beauty for oneself in nature, pointing to the boy unconsciously adopting the pose of the 'Spinario', a famous antique statue, as he undresses. They might discuss the relative merit of sculpture and painting, observing the fragment of marble torso and Zoffany's

prominently displayed palette balancing each other at either side of the composition. They could observe the same diagrammatic shadows seen in Alberti's print, or the Newtonian spectra visible in the flames of the oil lamp reminding them that all colour derives from light. Even the hourglass timing the duration of each pose held by the models is a reminder of the idea that life is short and art is long.

There is a considerable difference between the ideas of artistic nobility held by the Italian Renaissance and the English Enlightenment. This London academy has no place for saturnine Michelangelesque brooding: English artists are cheerful, clubbable, fraternal, polite, gentlemanly and chatty. They have *esprit* in the sense of wit as well as (in some cases) genius. Zoffany's group is conceived as a pastiche of the most famous intellectual conversation in art, Raphael's *School of Athens* (fig. 65), with Reynolds and William Hunter playing the parts of Plato and Aristotle. The reference is not quite an outright parody; nor is it a solemn tribute (as are passages of Alberti's print, fig. 64). Zoffany's painting is more a good-humoured mock-heroic version of the *School of Athens*. The members of the 'School of London' are as resistant to subordination as any Greek: Sir Joshua Reynolds, the President, recognised by his ear-trumpet, with which he is listening to the ideas of his fellows, is not the most central or prominent figure in the group, but rather a 'first among equals'.

The only gate-crasher to this party is the Chinese artist Tan-che-qua (fifth from the left), who happened to be in London at the time. Apart from curiosity value,

FIG. 64 Pietro Francesco Alberti, *Academy of Painters* (*Accademia di Pitori*), *c.*1600; etching (British Museum)

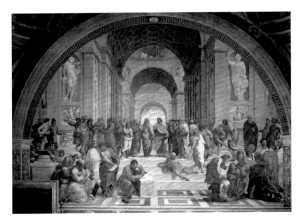

FIG. 65 Raphael, *School of Athens*, *c.*1510–12; fresco (Stanza della Segnatura, Vatican Palace, Rome)

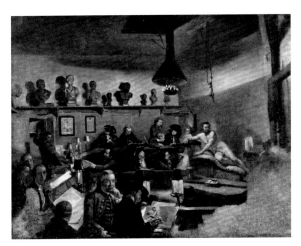

FIG. 66 Attributed to Johan Zoffany, *Life Class at St Martin's Lane Academy*, *c.*1761; oil on canvas (Royal Academy of Arts, London)

his inclusion here may be a reminder of the work of the Royal Academy's Professor of Poetry, Oliver Goldsmith (?1730–74), who published a series of letters with the title *The Citizen of the World*, supposedly written by a Chinaman visiting England. Letter no. 104 (26 January 1761), discussing learned societies, seems relevant here, especially when we remember the conscious decision of the Royal Academy to restrict membership to practising artists, excluding gentleman connoisseurs:

> A philosophical beau is not so frequent in Europe [as in China], yet I am told that such characters are found here. I mean such as punctually support all the decorums of learning, without being really very profound or naturally possessed of a fine understanding …
>
> Such men are generally candidates for admittance into literary clubs, academies, and institutions, where they regularly meet to give and receive a little instruction and a great deal of praise …
>
> But where true knowledge is cultivated, these formalities begin to disappear; the ermin'd cowl, the solemn beard and sweeping train are laid aside; Philosophers dress, and talk, and think, like other men …

Although depicted as part of a royal commission celebrating the formation of a royal academy, this is a group of artists who dress, talk and think like other men.

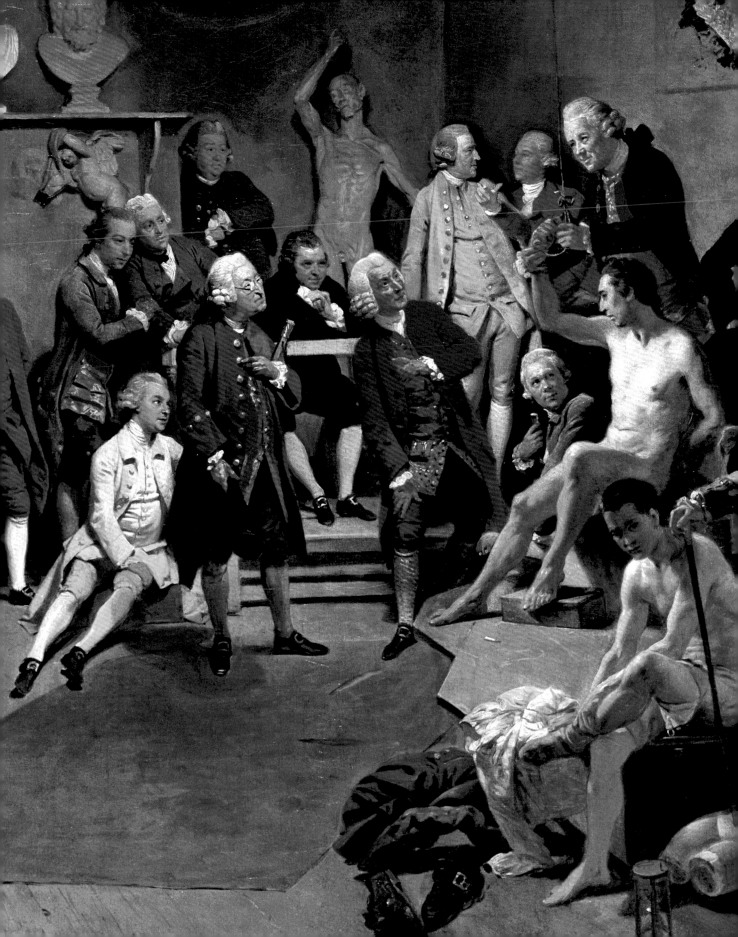

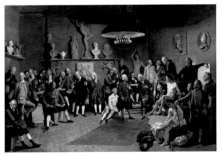

KEY

Unless otherwise stated, artists are founder members of the Academy

1 John Gwynn (1713–86), architect
2 Giovanni Battista Cipriani (1727–85), painter
3 Benjamin West (1738–1820), given a posture resembling his heroic history paintings and derived from the standing figure at the left foreground of the *School of Athens*; given prominence as an artist favoured by the King
4 Johan Zoffany, as if introducing his work, made RA by royal nomination in 1769
5 Mason Chamberlin (1727–87), portrait painter
6 Tan-che-qua, Chinese artist visiting London
7 George Barret (1732–84), landscape painter
8 Joseph Wilton (1722–1803), sculptor
9 Jeremiah Meyer (1735–89), miniature painter
10 Dominic Serres (1719–93), marine painter

11 and 12
The brothers Paul (1725–1809) and Thomas (1721–98) Sandby , behaving fraternally, the former wearing Windsor uniform, though the latter was Deputy Ranger of Windsor Great Park
13 William Tyler (1728–1801), sculptor and architect
14 John Inigo Richards (1731–1810), painter
15 Francis Hayman (1708–76), popular painter of the St Martin's Lane generation, resembling Falstaff from one of his own compositions
16 Francis Milner Newton (1720–94), painter
17 Sir William Chambers (1723–96), architect and treasurer of the Academy
18 Sir Joshua Reynolds (1723–92), first President
19 William Hunter (1718–83), famous surgeon and Professor of Anatomy at the Academy
20 Francesco Bartolozzi (1727–1815), engraver
21 Agostino Carlini (c.1718–90), sculptor and painter
22 Richard Wilson (1714–82), landscape painter; it was said that Zoffany painted and then removed a coat of arms of pipes and tankards to allude to Wilson's drunkenness
23 Charles Catton The Elder (1728–98), satirical painter appropriately adopting the pose of the Cynic, Diogenes, from Raphael's *School of Athens*
24 Richard Yeo (c.1720–79), medallist
25 Samuel Wale (1721–86), painter
26 Francesco Zuccarelli (1702–88), landscape

painter given prominence as an artist favoured by the King
27 Edward Penny (1714–91), painter
28 Peter Toms (c.1728–77), painter
29 George Michael Moser (1706–83), enamellist and Keeper of the Academy, here setting the model's pose and holding the sling to support his hand in comfort
30 Angelica Kauffmann (1741–1807), history painter, represented as a portrait hanging on the wall, as it was considered improper for a woman to attend the life school
31 Mary Moser (1744–1819), flower painter, represented as a painting for the same reasons as the above
32 Nathaniel Hone (1718–84), famously arrogant portrait painter given here a suitable swagger; his shadow across a canvas perhaps alludes to the supposed origin of painting (a Corinthian maid tracing her lover's shadow)
33 Edward Burch (1730–1814), miniature painter and gem-cutter elected in 1771
34 Joseph Nollekens (1737–1823), sculptor elected in 1772
35 Richard Cosway (1742–1821), flattering portrait painter and famous dandy, here looking the part and perhaps denigrating the antique with his cane, elected in 1771
36 William Hoare (1707–92), portrait painter working in Bath

25 JOHAN ZOFFANY (1733/4–1810)
The Tribuna of the Uffizi

Oil on canvas
123.5 x 154.9 cm
Painted for Queen Charlotte 1772–7
RCIN 406983
Millar 1969, no. 1211

IN THE summer of 1772 Zoffany set off for Florence with £300, letters of introduction and a commission from the Queen to paint highlights of the Grand Duke of Tuscany's collection shown within the Tribuna of the Uffizi Palace. The inspiration for the commission could have been the *Cabinet of Pictures* (fig. 67), then attributed to Gonzales Coques, which hung in Queen Charlotte's work-room at Kew. Progress was slow and painful: according to Lord Winchilsea, one of the sitters (no. 17 in the key), the task was

> really one of the Most laborious undertakings I ever saw. for he not only Copies a great Many Pictures & Statues & the Room &c. which is a great deal to do, but even the Frames & every the most minute thing Possible the small bronzes, the Table &c. to make it be a compleat & exact representation of the Room
> (letter to Lady Charlotte Finch, 2 January 1773)

It is clear that Zoffany had planned from the outset to introduce real people, as Horace Mann (no. 16 in the key) was already mentioning 'small figures (portraits) as spectators' in August 1772 (Horace Mann letter to Horace Walpole, 25 August 1772). Fairly soon these spectators came to seem inappropriate: Mann wrote to Walpole on 23 August 1774 that

> The one-eyed German, Zoffany [Mann here alludes to the artist's squint], who was sent by the King to paint a perspective view of the Tribuna in the Gallery, has succeeded amazingly in many parts of that and in many portraits he has made here. The former is too much crouded with (for the most part) uninteresting portraits of English travellers then here.

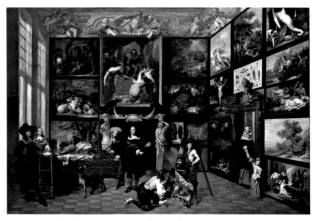

FIG. 67 Jacob de Formentrou, *Cabinet of Pictures*, 1659; oil on canvas. Acquired by George III (Royal Collection, RCIN 404084)

By the time the work was completed in 1777 and brought back to London in 1778, the error in judgement was generally acknowledged: Mann wrote again,

> I told him often of the impropriety of sticking so many figures in it, and pointed out to him the Great Duke and Duchess, one or two of their children, if he thought the variety more pictoresque, and Lord Cowper … If what he said is true, that the Queen sent him to Florence to do that picture, and gave him a large sum for his journey, the impropriety of crowding in so many unknown figures was still greater
> (letter to Horace Walpole, 10 December 1779)

The Royal Family took the same view: Joseph Farington reported in 1804 that

> The King spoke of Zoffany's picture of the *Florentine Gallery* painted for him, & expressed wonder at Zoffany having done so improper a thing as to

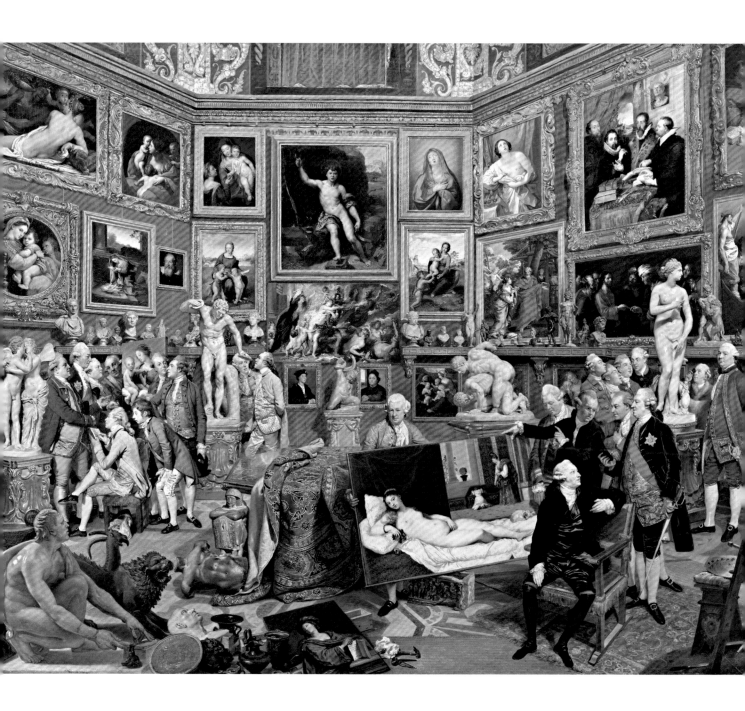

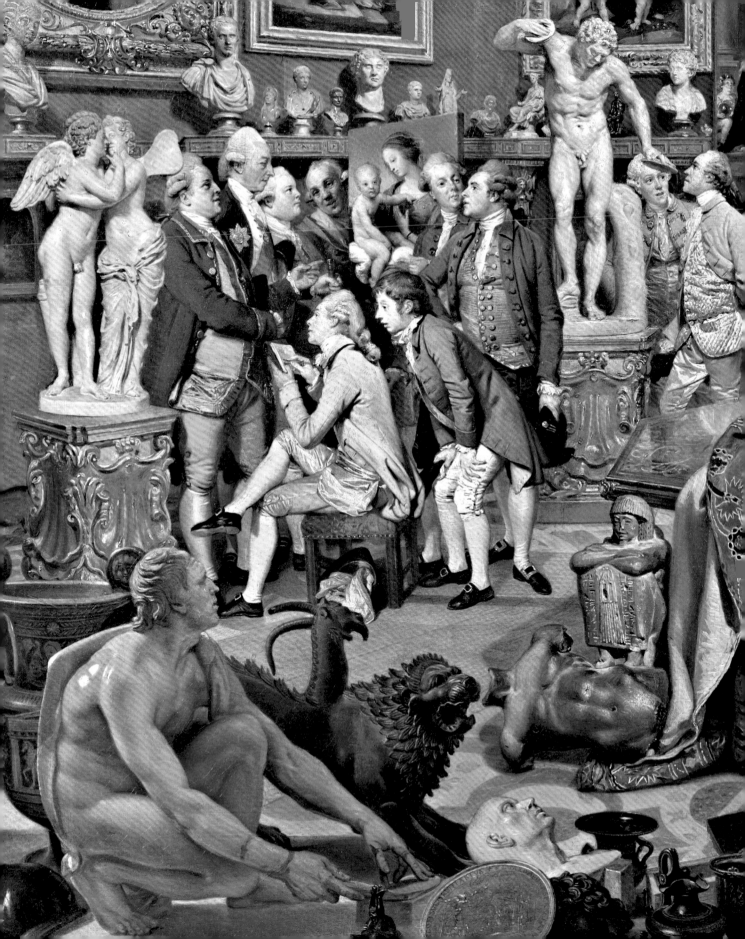

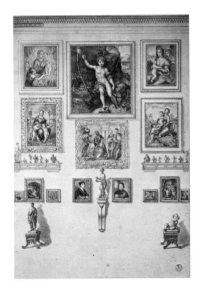

FIG. 68 Giuseppe Magni, *The Tribuna*, one of a series of drawings recording the arrangement of the Grand Duke's collection begun in 1748 (Gabinetto dei Disegni, Uffizi, Florence)

FIG. 69 The Tribuna, Uffizi Gallery, Florence

introduce the portraits of Sir Horace Man – Patch, & others. – He sd. The Queen wd. not suffer the picture to be placed in any of her apartments
(*Diary*, 15 December 1804)

Zoffany was certainly paid handsomely for the work and to cover his stay in Florence (though the actual sum is disputed); however he never again worked for the Royal Family. The painting hung briefly at Kew Palace and is recorded, with *The Academicians* (no. 24), in the Upper Library at Buckingham House in 1819 (see p. 124).

A 'tribune' (*tribuna* in Italian) is the semicircular (or semi-polygonal) domed end of a basilican church; *the* Tribuna is the hexagonal domed room created in 1585–9 by Bernardo Buontalenti (1536–1608) in the Uffizi Palace for the display of the masterpieces in the Medici collection (figs. 68 and 69). The idea of the space and the name was that the room (which originally had a single entrance) had the character of a chapel and formed a sort of Holy of Holies within the palace: indeed, it has remarkably similar shape and proportions to the much larger Capella dei Principi, the Medici funeral chapel begun in 1602, also with involvement of Buontalenti, next to the church of San Lorenzo in Florence. Both steep-domed hexagons are of course based on Brunelleschi's cupola of Florence cathedral,

completed in 1436. It is perhaps not a coincidence that George III's favourite architect, William Chambers, had recently created two octagonal temples to the Muses: the Great Room at the Society of Arts in 1759 and the Octagon, one of the four rooms housing the King's library at Buckingham House (fig. 70), in 1766–7. It is tempting to suggest that Zoffany's painting was intended for the overmantel space visible in Stephanoff's watercolour, where the match of real and painted architecture would have been perfect.

The Tribuna was seen in this period as Europe's most precious *Wunderkammer*, with its profusion of painting, sculpture, *pietra dura* and decorative arts set against the already richly decorated surfaces of floor, walls and vault. In the words of Tobias Smollett (1721–71), 'there is such a profusion of curiosities in this celebrated museum … that the imagination is bewildered and a stranger of a visionary turn would be apt to fancy himself in a palace of the fairies, raised and adorned by the power of enchantment' (*Travels through France and Italy*, letter 28, 5 February 1765). A comparison of Zoffany's view with the contemporary drawings of Giuseppe Magni (fig. 68) reveals that Zoffany's is a substantially accurate record of the arrangement. There are just two areas in which he has distorted or reinterpreted reality: he has adjusted the perspective of the interior; and he has taken liberties

FIG. 70 James Stephanoff, *The Octagonal Library at Buckingham House*, 1818; watercolour (Royal Library, RCIN 922147)

FIG. 71 Giovanni Paolo Panini, *Modern Rome*, 1757; oil on canvas (Metropolitan Museum of Art, New York)

with the paintings he has chosen to include, often introducing works from the Pitti Palace or elsewhere in the Uffizi (see key overleaf).

Zoffany's viewpoint is slightly behind the centre of the room: the central octagon of the floor pattern appears in the foreground. His field of vision includes a little less than three of the eight sections of the octagon, which would mean an angle of around 90 degrees. If he had carried this perspective through to its logical conclusion he would only have caught two of the four major sculptural groups placed in front of each alternate wall (see fig. 69), instead of the four visible here. Moreover, almost all the objects and figures within the room, especially those in the foreground, should appear significantly larger than they do here: clearly if he had followed a geometrically literal regime he would never have been able to fit in so much or to have made so many interesting and intelligible groups. Instead, he has treated the 'floor-show' differently, adopting a perspective as if set in a cut-away model of the space, like a stage, and viewed from some way back in the auditorium. Evidently this aspect of the painting was also criticised: according again to Horace Mann, 'they found great fault in the perspective which, they say, is all wrong. I know that he was sensible of it himself, and tried to get assistance to correct it; but it was found impossible, and he carried it away as it was' (letter to Horace Walpole, 10 December 1779).

In order to understand Zoffany's perspective it is necessary to examine his other source of inspiration, the encyclopaedic paintings of Giovanni Paolo Panini (1692–1765). For example, Panini's *Modern Rome* of 1757 (fig. 71) has some perspective, of course, but overridden by a clamour of surface detail – a brilliance of colour, light and touch – across the entire canvas. Zoffany achieves exactly this brilliance, this refusal to subordinate, this determination that the spaces between things are as eye-catching as the things themselves. He deliberately creates a world where nothing quite sits quietly behind anything else; everything pushes itself forward. As a result, the painting has the slight unreality of an advent calendar, but also the effect of a jewel cabinet that needs to be explored systematically in order to reveal all its treasures. This effect was, again, not universally appreciated: when the *Tribuna* was exhibited at the Royal Academy in 1780, the *Morning Post* criticised 'its want of keeping', that is, its harmony of colours; the *Morning Chronicle* wrote that 'this accurate picture has the same effect on the spectator which the gallery itself has on first entering it; the multitude of excellencies contained in it, dissipate our ideas, and it requires some time to arrange them before we can coolly examine the merit of any individual piece'.

The key here lists the contents of the room and the identity of the visitors, grouping the elements into separate conversations. As was the case with the previous

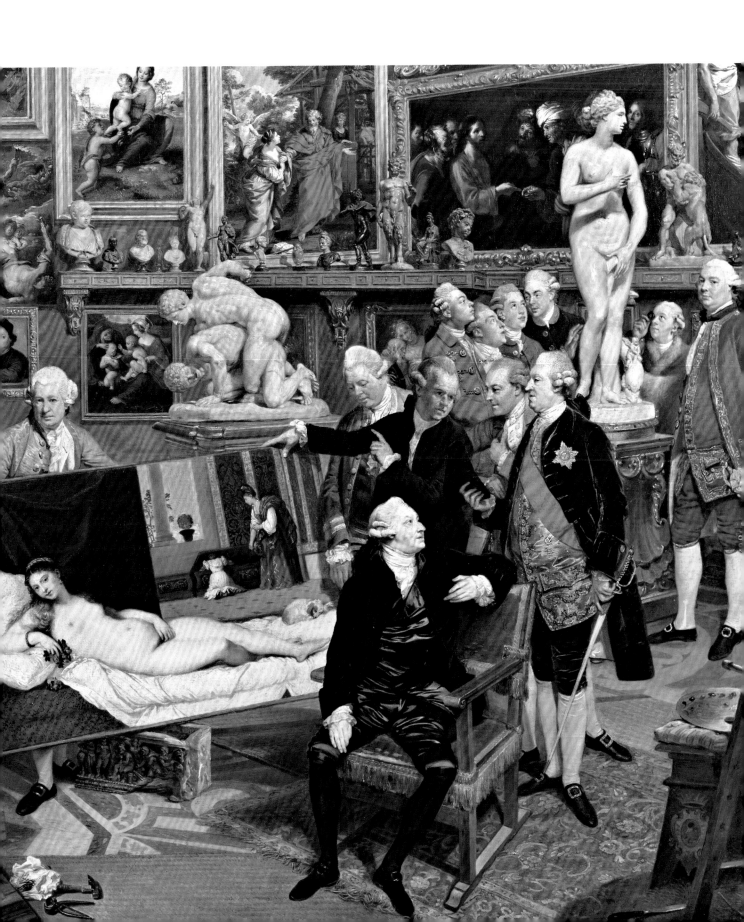

KEY

VISITORS (arranged in five separate conversations)
Two young men draw the *Cupid and Psyche*:

1 Charles Loraine Smith (1751–1835), a minor artist
2 Richard Edgcumbe, later 2nd Earl of Mount Edgcumbe (1764–1839)

Six men discuss Lord Cowper's Raphael; from left to right they are:

3 George, 3rd Earl Cowper (1738–89), an Englishman in Florence who tried to sell this

painting to the King in 1780 for £2,500
4 Sir John Dick (1720–1804), British Consul at Leghorn
5 Other Windsor, 6th Earl of Plymouth (1751–99)
6 Johan Zoffany
7 Mr Stevenson, companion to Lord Lewisham
8 George Legge, Lord Lewisham, later 3rd Earl of Dartmouth (1755–1810), who toured with Stevenson and was later Lord of the Bedchamber of the Prince of Wales, 1782–3

Two men discuss the *Satyr playing the Cymbals*:

9 Unkown man
10 Valentine Knightley of Fawsley (1744–96)

A group of six men discuss Titian's *Venus of Urbino*:

11 Pietro Bastianelli, the custodian of the gallery
12 Mr Gordon
13 Hon. Felton Hervey (1712–73), former Equerry to Queen Caroline of Ansbach
14 Thomas Patch (c.1725–82), artist living in Florence

15 Sir John Taylor Bt. (d.1786) father-in-law of the celebrated collector George Watson Taylor
16 Sir Horace Mann (1706–86), British Consul in Florence and Horace Walpole's friend and correspondent

Six men look at the *Medici Venus*:

17 George Finch, 9th Earl of Winchilsea (1752–1826)
18 Mr Wilbraham, probably Roger Wilbraham (1743–1829)
19 Mr Watts
20 Mr Doughty, travelling with Charles Loraine Smith (no. 1)
21 T. Wilbraham, probably Thomas (b.1751), brother of Roger (no. 18)
22 James Bruce (1730–94), the famous African explorer

PAINTINGS

23 Annibale Carracci, *Venus and Satyr*, c.1588, then in the Tribuna and called Ludovico, now elsewhere in the Uffizi

work, the art displayed here and its arrangement (by Zoffany as well as by the custodians of the Uffizi) clearly has the potential to provoke innumerable conversations: Zoffany seems to be more interested in suggesting a multitude of ideas than in providing a coherent programme. The Royal Academy catalogue of 1780 described the work as a 'room in the gallery of Florence, called the Tribuna, in which the principal part is calculated to show the different styles of the several masters'. Zoffany not only imitates their styles, he arranges them so that the relationships between them can be appreciated. The great tradition of painting is dominated by 'the divine' Raphael, his figure of St John 'pointing upwards' as if to suggest a heavenly source of inspiration (no. 30 in the key). The same tradition is maintained through the revered Bolognese school of Annibale Carracci (1560–1609) and Guido Reni (1575–1640), and the occasional Flemish artist such as Rubens. Zoffany invites us to play the familiar game of comparing painting and sculpture, ancient and modern: who is the most beautiful woman of all? Clearly Venus, but is it the modern painted *Venus of Urbino* (no. 47) or the antique sculpted *Medici Venus* (no. 53)? There is also some nationalism present: the Etruscan remains stress the importance of Tuscany; the Holbein portrait perhaps tries to bring England into the story.

For the last two hundred years Zoffany's *Tribuna* has been hung near to his *Academicians*, and there is evidence that they were originally conceived as a pair. They make a very effective contrast between creating and appreciating art, between back and front of house, the former with the dark, thinly painted character of a work-in-progress, the latter with the highest and most precious finish. Only two vignettes within the *Tribuna* tell of the labour of art: the easel, palette, knife, brushes and maul-stick at the right margin, and the hammer, pliers and pile of nails in the centre. Zoffany evidently feels that all these grand tourists should learn how to stretch a canvas.

24 Guido Reni, *Charity*, 1607, then and now in the Pitti
25 Titian (school), *Madonna and Child with St Catherine*, in this position in the Tribuna and called Titian, now elsewhere in the Uffizi
26 Raphael, *St John the Baptist*, c.1518, then in this precise position in the Tribuna, now elsewhere in the Uffizi
27 Guido Reni, *Madonna*, now untraceable
28 Guido Reni, *Cleopatra*, 1635–40, then and now in the Pitti
29 Rubens, *Justus Lipsius with his Pupils*, c.1615 then and now in the Pitti
30 Raphael, *Pope Leo X with Cardinals Giulio de' Medici and Luigi de' Rossi*, 1518, then and now in the Pitti
31 Raphael, *Madonna della Sedia* (*Madonna of the Chair*), c.1514, then and now in the Pitti
32 Correggio, *Madonna and Child*, c.1525, then and now in the Uffizi but not the Tribuna
33 Justus Sustermans, *Galileo*, c.1636, then on this wall of the Tribuna, now elsewhere in the Uffizi
34 Raphael, *Madonna del Cardellino* (*Madonna of the Goldfinch*), c.1505, then in this precise position in the Tribuna, now elsewhere in the Uffizi
35 Rubens, *Allegory Showing the Effects of War*, c.1637, then and now in the Pitti; here unframed and much reduced in scale
36 'Raphael', *Madonna del Pozzo* (*Madonna of the Well*), then in this exact location and now still in the Tribuna, though thought to be by Franciabigio rather than Raphael
37 Pietro da Cortona, *Abraham and Hagar*, c.1640,

then in the Uffizi, now in the Kunsthistorisches Museum, Vienna
38 Caravaggio (school), *Tribute Money*, then on this wall and attributed to Caravaggio, now in the Pitti and attributed to Manfredi
39 Cristofano Allori, *Miracle of St Julian*, then as now in the Pitti, here much reduced in scale
40 Unidentified painting in the style of Rembrandt
41 Raphael, *Niccolini-Cowper Madonna*, 1508, then in Lord Cowper's possession, having bought it from Zoffany, now National Gallery of Art, Washington, DC
42 Holbein, *Sir Richard Southwell*, 1536, then in this exact position, now elsewhere in the Uffizi
43 *Portrait*, then in this exact position and now elsewhere in the Uffizi; then thought to be a Holbein portrait of Martin Luther; now possibly a Raphael portrait of his master, Perugino
44 *Holy Family*, then attributed to Perugino, now to Niccolò Soggi, then as now elsewhere in the Uffizi
45 Unknown artist, *Roman Charity*
46 Guercino, *Samian Sibyl*, acquired in 1777 by Pietro Leopoldo, Grand Duke of Tuscany, now in the Pitti
47 Titian, *Venus of Urbino*, 1538, then as now elsewhere in the Uffizi

SCULPTURE
48 *Cupid and Psyche*, then and now elsewhere in the Uffizi, Roman copy of a Greek original of the 1st or 2nd century BC
49 The '*Arrotino*' (Knife-Grinder), a Pergamene original of 2nd or 3rd century BC, then and

now in the Tribuna; thought to represent a working slave, now identified as a follower of Apollo preparing to flay Marysas
50 *Dancing Faun*, then and now in the Tribuna, marble replica of a bronze original of the circle of Praxiteles, 4th century BC
51 *The Infant Hercules Strangling the Serpents*, then in the Tribuna
52 *The Wrestlers*, then and now in the Tribuna, now thought to be a marble copy of a bronze Pergamene original, 2nd or 3rd century BC
53 *The Medici Venus*, then and now in the Tribuna, Roman copy of a Greek original of the 2nd century BC

OTHER OBJECTS
54 South Italian crater, 4th century BC
55 Etruscan helmet
56 *Chimera*, brought here from Palazzo Vecchio in 1717 and much valued as an example of local Etruscan art
57–8 Roman oil lamps, one obscene
59 South Italian situla
60 Egyptian ptahmose, 18th dynasty
61 Greek bronze torso
62 Bust of Julius Caesar
63 Roman silver shield
64 Head of Antinous
65 South Italian crater
66 Etruscan jug
67 Octagonal table with *pietra dura* top made for the Tribuna, designed by Jacopo Ligozzi and Bernardino Poccetti, finished in 1649

George IV (1762–1830)

5

5 George IV (1762–1830)

P ART of the reason why the *Tribuna* failed to please its commissioners was that the King's taste had moved on, even before Zoffany left for Florence. The new favourite was the American artist Benjamin West (1738–1820), whose heroic, neoclassical history paintings and 'moralised' portraits have little place for the high jinks of the conversation piece. One exception to this rule occurs in his 1779 full-length of Queen Charlotte (fig. 72), which includes a group of thirteen royal

children, playing happily behind their mother and in front of the Queen's Lodge, the featureless building on the south lawn of the Castle, where the family lived when in Windsor. This detail is so self-consciously an essay in the conversation piece that it almost looks like a painting within a painting. It was said to have been West who persuaded the King to have his three youngest children painted by another American artist, John Singleton Copley (1738–1815; fig. 73), the only painter of the period who translated the

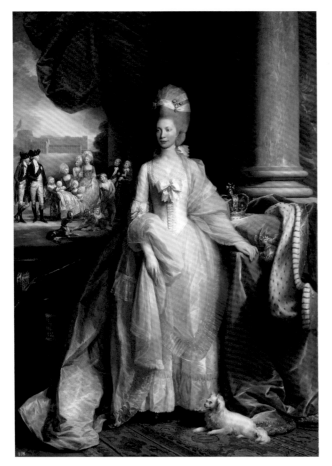

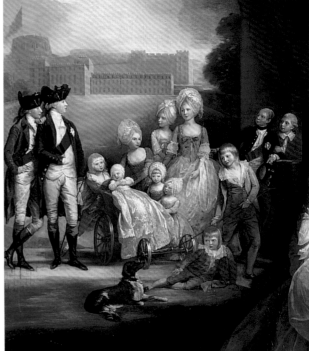

FIG. 72 Benjamin West, *Queen Charlotte*, painted for the King in 1779; oil on canvas (Royal Collection, RCIN 405405)

FIG. 73 John Singleton Copley, *Three Youngest Daughters of George III*, painted for the King in 1785; oil on canvas (Royal Collection, RCIN 401405)

informal, high-spirited disorder of the conversation piece into full-scale portraiture. In this example he takes the idea of children playing horse-and-carriage from Barthelemy du Pan (fig. 44) and Benjamin West (fig. 72) and adds an effect of dazzling light, glossy surfaces and brilliant colour from Zoffany's work. The resultant image is a perfect celebration of the energy and gaiety of the type of natural childhood advocated by Rousseau.

A glimpse of Windsor Castle is visible in the background of Copley's portrait, as it was in West's. The conversation piece had always been associated with the informality of a country seat or suburban palace (see nos. 2, 4, 7, 8–10, 13–14, 22 and figs. 35–7, 44, 55–6), when not depicting an expedition into even wilder terrain (as in no. 17 or fig. 50); during and after the 1760s it became increasingly rustic and Rousseau-inspired. Almost all the

works after this date included here are set in country retirement, in Windsor, the South Downs or the Highlands. The only exception is no. 28, which is set in Hyde Park, at this date lying outside the built-up areas of London.

For the first half of the eighteenth century the post of Ranger of Windsor Great Park stayed within the Churchill family: Sarah, Duchess of Marlborough, Queen Anne's favourite, held the post from 1702 until 1744, when she was briefly succeeded by her favourite grandson, John Spencer, seen in no. 17. Upon Spencer's death in 1746, George II used the opportunity to bring this position into his family, appointing his favourite son, William Augustus, Duke of Cumberland (1721–65), a national hero (or for many, a villain) who had just destroyed the army of the Young Pretender at the Battle of Culloden in April 1746. The Ranger's accommodation which the Duke took over from the Spencer family was a beautiful brick house henceforth known as Cumberland Lodge, built in the 1650s, which appears in Thomas Sandby's watercolour of c.1754 (fig. 74). The presence of the ostrich in Sandby's view reminds us that the Lodge also housed a menagerie. When the Duke died without issue in 1765 the new King,

George III, gave the title, the position as Ranger of the Great Park and Cumberland Lodge to his own brother, Henry Frederick (1745–90; see no. 27). The new Duke of Cumberland proved something of an embarrassment to the King, firstly by conducting an adulterous affair with Lady Grosvenor, resulting in his being sued by her husband in 1770, and then in 1771 by secretly marrying the unsuitable Anne Horton, *née* Luttrell (1743–1808), without royal permission. The couple lived with Elizabeth Luttrell, Anne's sister, a brilliant socialite and notorious gambler – all three appear in Gainsborough's famous portrait (no. 27). Cumberland Lodge became the centre of a fast set that scorned the formal rectitude of the King and Queen. According to the *Memoir* of Lady Louisa Stuart (1757–1851), written in 1827, Elizabeth Luttrell

gathered round her the men, and led the way in ridiculing the King and Queen … a mighty scope for satire was afforded by the Queen's wide mouth and occasionally imperfect English, as well as by the King's trick of saying What? What? his ill-made coats, and general antipathy to the fashion. But the marks

FIG. 74 Thomas Sandby, *The East Front of Cumberland Lodge, c.*1754; watercolour (Royal Collection, RCIN 451431)

FIG. 75 *His Majesty's Cottage, as seen from the Lawn*, published 1823; hand-coloured aquatint (Royal Collection, RCIN 700920)

preferably aimed at were his *virtues*; his freedom from vice as a man; his discouragement of it as a sovereign … his sincere piety and humble reliance upon God.

The King tried to buy out his brother in order to accommodate his own family, but in the event Cumberland Lodge remained in the Duke's possession until his death.

At the time of the Regency in 1811 the Prince of Wales acquired Cumberland Lodge with a view to making it his Windsor home. While work was being carried out he decided to use the Deputy Ranger's Lodge, where Thomas Sandby (1721–98) had lived, as a temporary base. Alterations to this second house began in 1812 and absorbed the Prince's attention, eclipsing Cumberland Lodge completely. The new house, described as a 'cottage', was designed to be a rambling, Gothick, thatched *ferme ornée* (fig. 75). In 1823 John Nash (1752–1835) was replaced by Jeffry Wyatville (1766–1840) as architect and the house became slightly

less rustic, with raised and tiled roof; at this date it also acquired its present name of Royal Lodge. Satirists of the time enjoyed the absurdity of the King playing at being a gardener like Marie Antoinette. Visitors were usually put up at Cumberland Lodge nearby, joining the party at Royal Lodge during the day: one of them wrote in November 1825, 'you cannot imagine anything more beautiful than this *lowly* residence of the Sovereign'. The surviving part of George IV's house provides the setting for Gunn's group portrait (fig. 1), which also shows Wyatville's witty use of the Prince of Wales's heraldic feathers instead of foliage for the Gothic capitals.

The significance of George IV's new home in the present context is connected with his passion for painting, in particular for collecting Old Masters. Around the turn of the century the Prince of Wales, as he then was, began for the first time to collect Dutch and Flemish seventeenth-century paintings. In the last thirty years of his life he

FIG. 76 George Stubbs, *The Milbanke and Melbourne Families*, 1770; oil on canvas (National Gallery, London)

formed one of greatest collections of this type in England, which remains the heart of the Royal Collection's holdings. A very significant proportion of the Netherlandish paintings included here (nos. 1, 4, 6–10; figs. 4, 36, 63 and 92), were bought at this time by George IV, in particular examples of the most precious, technically accomplished masters, Ter Borch, Metsu, De Hooch, Schalcken and Van Mieris. Sometime after he became King in 1820, he decided to demolish his previous home, Carlton House, and move his collection to Buckingham Palace and Windsor Castle, both of which were being substantially rebuilt at the time. A small group of works were separated from the main body and displayed at the Royal Lodge in 1822, including the best animal paintings and scenes of low-life. George IV clearly felt that the Lodge was a place of relaxation where one could enjoy hunting scenes, military reviews and other horse paintings. Included in this group were all the Stubbs horses (including nos. 28–30) and also the

three mews scenes by Melchior de Hondecoeter (nos. 8–10), which he acquired by 1806, among his first Dutch purchases. These paintings, with their strange combination of slightly stiff compositions and wonderfully sleek coats of the animals, seem to have inspired Stubbs's work: in this case he must have seen them in the collection of the Earl of Holderness (see p. 59 above), for they were not acquired by George IV until a decade after Stubbs had painted nos. 28–30. It is usual for a patron's Old Master purchases to influence the contemporary artists in his employ, but the inverse is also possible. It is certainly tempting to suggest that George IV could see the relationship between Stubbs and Melchior de Hondecoeter, and decided for this reason to hang their work together at Royal Lodge. He sent his less important horse paintings, by artists such as Sawrey Gilpin (see no. 26), George Garrard (1760–1826) and Benjamin Marshall (1768–1835), to Cumberland Lodge.

This raises the question of whether horse paintings

should be considered as conversation pieces at all; Melchior de Hondecoeter's scenes (nos. 8–10) would almost certainly not have been so described by his contemporaries. However, in England during the early eighteenth century artists began to adapt the conventions of sporting pictures in order to provide an interesting activity in which a variety of portrait figures could be engaged – in other words, to perform the function of the conversation piece. Wootton's *Warde Family at Squerryes Court* of 1735 (private collection) or his *Beauchamp and Rivers Families and Sir Nevil Hickman* of 1749 (private collection) both show proud owners conversing in gracefully composed groups with friends and family in front of their family seats, in the manner of Arthur Devis. The fact of their being mounted is almost incidental.

Stubbs strove from the start of his career to expand the language of the horse painter, even if it was through his elegant and restful arrangements of mares and foals (see fig. 77), which have many of the characteristics of conversations. His *Milbanke and Melbourne Families* (fig. 76) was exhibited at the Society of Artists 1770 as 'A Conversation', and provides a harmonious relationship between the human figures, their animal companions and their fashion accessories. Conversation pieces in general demonstrate the idea that a gentleman's qualities may be perceived through his taste in clothes, architecture and furnishings. The same principle extends to the stable and the mews: a man of fashion may be recognised by a fine horse and carriage, and his ability to ride and drive them. Even a gentleman's servants, down to the humblest labourer on the estate, reflect upon his benevolent rule, good judgement and fine taste. In *c.*1767 Lord Torrington of Southill Park commissioned Stubbs to paint three group portraits of his servants: two of huntsmen and gamekeepers (both private collection) and one of brick-makers, engaged in loading a cart with no obvious sense of urgency (Philadephia Museum of Art). Clearly these three paintings belong as a group celebrating the work of the estate, with the two serious images supporting a low-life comic scene. This perhaps helps reveal how the three Stubbs images of the Prince of Wales and his household (nos. 28–30) might have been viewed together as a totality.

26 SAWREY GILPIN (1733-1807) with WILLIAM MARLOW (1740-1813)

The Duke of Cumberland Visiting his Stud

Oil on canvas
106 x 140 cm
Painted c.1765 and later, in 1771, exhibited at the Society of Artists
Acquired by Queen Victoria
RCIN 400928
Millar 1969, no. 826

SAWREY Gilpin was the younger brother of the Reverend William Gilpin (1724–1804), the famous advocate of picturesque beauty. Sawrey worked for the Duke of Cumberland and later the Prince of Wales, and was living in Cumberland Lodge at the time of the Duke's death in 1765. The Duke was an enthusiastic horse breeder and a regular at Newmarket racecourse, even in the last years of his life. In the early 1760s Stubbs produced his series of compositions depicting mares and foals, creating more complicated and gracefully spaced designs than had been seen previously in horse painting. One of these (fig. 77), depicting the Duke of Cumberland's stud at Windsor, was exhibited at the Society of Artists in 1765. Gilpin here imitates the poise and harmony of Stubbs's compositions, especially in the group to the right of centre, whether or not it was painted after this date (the year of the Duke's death).

When this painting was exhibited at the Society of Artists in 1771 the landscape was attributed to 'Mr Marlow' (the topographical painter William Marlow) and there is no reason to doubt this source. Marlow must have provided the landscape background, with a view of Windsor Castle from the Long Walk.

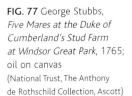

FIG. 77 George Stubbs, *Five Mares at the Duke of Cumberland's Stud Farm at Windsor Great Park*, 1765; oil on canvas (National Trust, The Anthony de Rothschild Collection, Ascott)

27 THOMAS GAINSBOROUGH (1727–88)

Henry, Duke of Cumberland, with Anne, Duchess of Cumberland, and Lady Elizabeth Luttrell

Oil on canvas
163.8 x 124.5 cm, oval
Painted *c*.1785–8
Acquired by George IV
RCIN 400675
Millar 1969, no. 797

GAINSBOROUGH's early work, executed in Ipswich during the decade 1748–59, would fit well with the Merciers and Hogarths in this exhibition. Having trained with Gravelot, he produced small-scale conversation pieces, such as the *Gravenor Family* of *c*.1754 (fig. 78), with a characteristic French elegance and a rococo flourish of the brush. Having turned his back on this way of working as unsuitable for fashionable Bath, where he moved in 1759, or London, where he spent the last fourteen years of his life, Gainsborough seems to have revisited its possibilities in the 1780s. *The Mall* of 1783 (fig. 79) illustrates the same location as no. 18, but instead of treating the scene with a mixture of topography and satire Gainsborough

sees a fashionable parade as a poetic evocation of female beauty, as mythology in modern dress. His inspiration comes from Antoine Watteau, an artist still generally admired in England sixty years after his death. Gainsborough himself owned a set of the *Recueil Jullienne*, a series of prints after Watteau's works (see fig. 38).

In his late work Gainsborough re-interprets Watteau with a loosely woven fabric of long brushstrokes, creating a more veiled, mysterious and poetic type of image. James Northcote said of *The Mall*: 'You would suppose it would be stiff and formal with the straight rows of trees and people sitting on benches – it is all in motion, and in a flutter like a lady's fan. Watteau

FIG. 78 Thomas Gainsborough, *The Gravenor Family: John and Ann Gravenor with their Daughters*, *c*.1754; oil on canvas (Yale Center for British Art, Paul Mellon Collection)

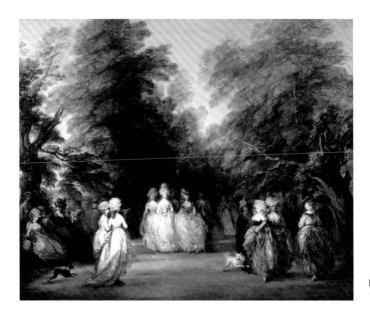

FIG. 79 Thomas Gainsborough, *The Mall*, 1783; oil on canvas (Frick Collection, New York)

is not half so airy' (William Hazlitt, *Mr Northcote's Conversations*, 1829). *The Mall* was said to have been executed for George III, for whom in 1785 he also planned a companion, the 'Richmond Water Walk', depicting another royal park. The *Morning Herald* of 20 October 1785 reported that Gainsborough 'is to be employed, as we hear, for Buckingham House on a companion to his beautiful Watteau-like picture of the Park-scene, the landscape, Richmond water-walk, or Windsor – the figures all portraits'. The King rejected *The Mall* as inadequately topographical; nothing came of its companion beyond a group of figure studies.

This famous portrait group also demonstrates Gainsborough's revival of interest in Watteau. It is unique at this date for its oval format and its figure scale (quarter- as opposed to full-life size). It was commissioned by the sitters but remained in Gainsborough's possession until his death; it only joined the Royal Collection when it was acquired by

George IV when Prince of Wales in 1792. Gainsborough has caught the effect reminiscent of Watteau of towering trees blocking out all but glimpses of sky (see fig. 38) and the way in which sky and trees seem to be frothed up together by the brush. Gainsborough's shadows are darker and the woodland denser, presumably suggesting the grounds of Cumberland Lodge in the Great Park. The colour of Gainsborough's sky is also more intense and dramatic than Watteau's: the atmosphere of the image derives from the fact that the spectrum of the evening, from gold to blue, with greys, pinks and violets between, appears in the sky, even if in snatches, and is echoed in the colour of the leaves.

While the Duke and Duchess take a romantic stroll in the summer evening, they are watched by Elizabeth Luttrell looking wistfully after them, carrying a porte-crayon, with which to record the scene. She has the air of an Echo, fading away with unrequited love for her Narcissus.

28 GEORGE STUBBS (1724–1806)

George IV when Prince of Wales

Oil on canvas
102.5 x 127.6 cm
Signed: *Geo: Stubbs pinx: / 1791*
Exhibited at the Royal Academy 1791
Painted for George IV
RCIN 400142
Millar 1969, no. 1109

THE Prince of Wales is here presented as a man of fashion, riding his magnificent chestnut horse and walking his two dogs. The star of the Garter is the only badge of rank in his costume, which otherwise announces his taste and awareness of the latest fashion. He wears a blue cutaway frock-coat with buff breeches, the 'uniform' of Members of the Whig Opposition led by Charles James Fox (1749–1806). The tall hat, curled and powdered hair, starched white cravat, and soft leather boots were also fashionable with *macaronis*, as dandies of the day were called, who also sought to look as thin as possible (something which the Prince himself found increasingly difficult). Queen Caroline, George IV's estranged wife, later said of her husband: 'I ought to have been the man and he the woman to wear the petticoats … he understands how a shoe should be made or a coat cut … and would make an excellent tailor, or shoemaker or hairdresser but nothing else.'

Though it looks as if the Prince is riding in open countryside this is in fact Hyde Park, looking over the Serpentine towards Apsley House (built for the 2nd Earl Bathurst by Robert Adam in *c.*1772–8) and Westminster Abbey.

In 1793 Thomas Allwood presented a bill to the Prince for £110 16s, for 'Carving & Gilding eight Picture frames of half-length size [40 x 50 in; see p. 105 above] for sundry Pictures painted by Mr Stubbs'. This painting and others in the collection still retain Allwood's frames. The fact that the frames seem to have been made as a set suggests that the paintings were also conceived as a group; however, it is impossible to establish how these eight, or the other paintings of identical format commissioned at this time, were arranged or paired off. It seems to make sense in the present context to hang this portrait as one of a group of three, between images of the Prince's horses and carriage managed by his servants, but there is no direct evidence for this or any other grouping.

29 GEORGE STUBBS (1724–1806)

William Anderson with Two Saddle-Horses

Oil on canvas
102.2 x 127.9 cm
Signed: *Geo: Stubbs p: / 1793*
Painted for George IV
RCIN 400106
Millar 1969, no. 1110

A WELL-STOCKED mews provided a nobleman with a 'string' of horses, like a relay race, for a hunt or ride. A fresh horse is here brought along by the Prince of Wales's Head Groom, ready for when the Prince's current mount tires. We must imagine the Prince himself to be riding a few yards ahead, just outside Stubbs's field of vision.

On 25 September 1780 the great potter Josiah Wedgwood (1730–95) wrote to his friend Thomas Bentley (1730–80), 'I find Mr. S. [Stubbs] repents much his having established this character for himself. I mean that of horse painter, & wishes to be considered as an history, & portrait painter'. The problem was that Stubbs's patrons admired him in his former capacity. When he proposed a design for a Wedgwood ceramic plaque of the Fall of Phaeton (now in the Lady Lever Art Gallery, Port Sunlight), the latter wrote, 'I have objected to this subject as a companion to the frightened horse as that is a piece of natural history, this is a piece of un-natural fiction' (Wedgwood to Bentley, 28 October 1780). Something about Stubbs's close observation, careful outlines and smooth surfaces suggests that he is less able to make the transition to 'un-natural fiction', than his contemporaries, such as Gainsborough: Stubbs has always struck viewers as a natural historian, a matter-of-fact painter.

All three paintings exhibited here illustrate the point. Stubbs had studied the anatomy of the horse with as much science as any veterinary surgeon of the day. His horses are clearly real, even if their names are not as carefully recorded as those of a Derby-winner: they all have the well-knit form of fully understood anatomy as well as glossy coats, created with the kind of paint techniques Ter Borch used for silks. The nervous energy of the galloping, riderless horse in no. 29 allows one to see the layers of muscle and veins, almost as if in Stubbs's cut-away anatomical drawings.

Henry Fuseli (1741–1825) wrote of Stubbs that 'his skill in comparative anatomy never suggested to him the propriety of style in forms'; in other words, his horses did not look *stylised*, like Van Dyck's baroque horses (see fig. 87) or the classical horses of Greek and Roman antiquity. This may be true of Stubbs's scrupulously observed forms, but his arrangement is as stylised as that of any of his contemporaries. The strict profile of the horses here, the way in which they are silhouetted dark on light against the background, their carefully etched outlines; all these things are intended to suggest the low-relief carving of an antique cameo, exactly the effect he sought in his Wedgwood plaques. In such works the object is depicted in low relief; the background is left as a smooth blank surface. Stubbs tries here to convey the same effect through a simplified smooth terrain, evenly light in tone and painted in soft-focus. Stubbs and Wedgwood also collaborated in producing enamel paintings on copper, an experience which perhaps influenced the glossy surface and heightened colour disposed in clear blocks seen in these three works. All these devices result in the measured, calibrated, flat and strangely impersonal character of Stubbs's work.

30 GEORGE STUBBS (1724–1806)

The Prince of Wales's Phaeton

Oil on canvas
102.2 x 128.3 cm
Signed: *Geo: Stubbs pinxit / 1793*
Painted for George IV
RCIN 400994
Millar 1969, no. 1117

THE phaeton was the sports car of its day: a light, open, owner-driven two-horse carriage. The name comes from Phaeton, the son of Apollo, who borrowed and crashed his father's sun-chariot. For a smooth ride even at speed, the phaeton had large wheels and huge steel leaf-springs from which the seat was suspended by means of leather straps, which gave it the nickname 'High-Flyer' (fig. 82). In some examples of the vehicle the two axles were the only rigid elements of the design, connected by another steel leaf-spring to allow the vehicle to flex over bumps, like modern independent suspension. Contemporary illustrations suggest that this fine example of British industrial design was regarded as the pinnacle of fashion or as a symbol of fast living, women drivers being especially singled out for admiration or opprobrium (figs. 80 and 82). When the Prince of Wales overturned his phaeton while driving alone with Mrs Fitzherbert, he presented satirists with an easy target (fig. 81).

The Prince's carriage here is to be drawn by two sleek black horses whose coats and accoutrements match the colours of the carriage and the livery of the groom. The artist explains the harnesses and provides

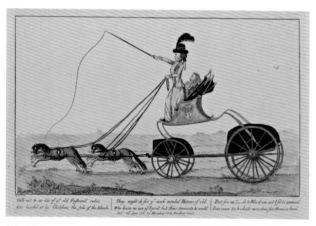

FIG. 80 Anonymous, 'Talk not to me Sir of yr old Fashion'd rules', satirical print published by Hannah Humphrey, 1781; hand-coloured etching (British Museum)

FIG. 81 'The Princes Disastar or a Fall in Fitz', satirical print published by James Aitken, July 1788; hand-coloured etching (British Museum)

a three-quarter view of the carriage without drawing attention to the technical difficulty of either. This is a scene designed to appeal to the discerning eye of a man of fashion, who in this era would have possessed some expertise in horse-flesh and a more general concern that his mews should be efficiently run and his servants well turned-out. Such things matter because they reflect on the owner and master. Contemporaries would have recognised in this painting a reflection upon (even a portrait of) the owner of this equipage – the Prince of Wales. We see here a prince unstuffy enough to drive his own carriage, reducing the trappings of rank to a set of modest silver arms decorating the horses' blinkers. The pomp of a prince is replaced by the elegance of a man of fashion.

The quiet dignity of this scene, supported by the Prince's portly coachman and methodical assistant, is only disrupted by his Spitz dog Fino, leaping up at the horse, which starts back in alarm.

FIG. 82 Nikolaus Wilhelm Heidelhoff, 'Two Ladies, en negligée, taking an airing in a Phaeton', aquatint from Von Heidelhoff's *Gallery of Fashion*, August 1794 (Yale Center for British Art, Paul Mellon Collection)

6

Queen Victoria (1819–1901) and Prince Albert (1819–1861)

6 Queen Victoria (1819–1901) and Prince Albert (1819–1861)

FORTY-FIVE years separate the previous painting (no. 30) and the next one (no. 31), including two reigns (those of George IV, 1820–30, and William IV, 1830–37). During these years George IV acquired his Dutch pictures, thus filling in so many of the gaps in this selection and providing points of departure for future painters. During the same period the formal ceremonial painting graduated from a speculative venture to a regular royal commission. Perhaps the most entrepreneurial creator of ceremonial scenes was Marie

Tussaud (1761–1850), who toured her waxworks from 1803 to 1834, before settling in London in 1835. Immediately after George IV's coronation in 1821 she mounted a tableau of the event, and in 1830 acquired at auction the actual robes worn by the King. Subsequent coronations were similarly re-created, as was the marriage in 1840 of Queen Victoria and Prince Albert.

George IV had employed one of his favourite painters, Sir David Wilkie (1785–1841), to record his carefully stage-managed visit to Scotland in 1822. His *Entrance of*

FIG. 83 Sir David Wilkie, *The First Council of Queen Victoria*, painted for the Queen in 1837–8; oil on canvas (Royal Collection, RCIN 404710)

FIG. 84 Sir George Hayter, *The Coronation of Queen Victoria in 1838*, 1839; oil on canvas. Acquired by the Queen in 1892 (Royal Collection, RCIN 405409)

George IV to Holyroodhouse of 1822–9 (Royal Collection, RCIN 401187) fails to capture the scintillating pageantry of the occasion, preferring to give it a venerable Old Master patina, as if this were a Rubens oil sketch for one of his heroic history cycles. Wilkie's *First Council of Queen Victoria* of 1837–8 (fig. 83) achieves something similar, turning the remarkable composure of a teenage novice queen into a version of the boy Christ teaching among the elders of the Temple. Queen Victoria commissioned this painting but soon came to hate it, in particular for its poor likenesses. No subsequent Victorian painter allowed the subjects' features and costumes to be so completely subsumed into the artistic distribution of light and shadow, though some drew from religious compositional types for their treatment of secular events (see no. 36).

The artist who succeeded Wilkie as Queen Victoria's ceremonial painter was Sir George Hayter (1792–1871), who caught the royal eye through his own speculative ventures. He painted the *Trial of Queen Caroline* of 1820

(National Portrait Gallery) to feed the public's love of scandal as well as spectacle. His *Coronation of Queen Victoria* (fig. 84) was commissioned by the dealers Hodgson and Graves, who displayed it in their gallery in Pall Mall before sending it on tour and commissioning a print to be made. The Queen was actively involved in the creation of this image, as well as agreeing to sit; she finally acquired it in 1892. It was the success of Hayter's coronation picture that led the Queen to commission him to record her marriage in 1840 (fig. 85), for which his fee was 1,500 guineas. Thereafter the Queen made sure that every marriage, christening, state visit, national event, or family gathering of importance was recorded by artists such as Franz Xaver Winterhalter (1805–73), John Phillip (1817–67), William Powell Frith (1819–1909), George Housman Thomas (1824–68) and Laurits Regner Tuxen (1853–1927). This wealth of ceremonial painting commissioned by Queen Victoria was widely disseminated, through touring exhibitions and painted copies, and through the publication of engravings or images

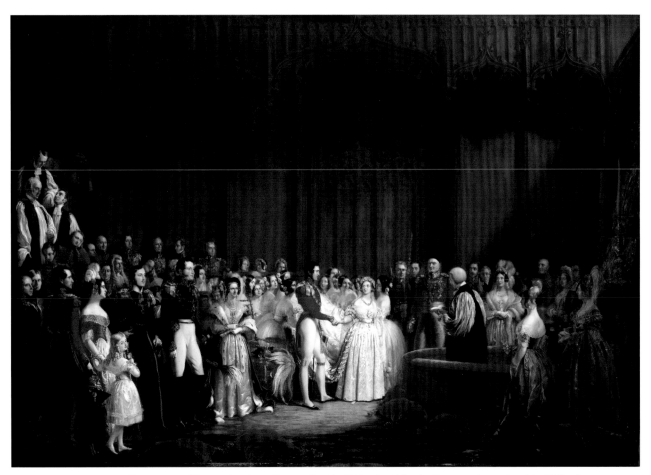

FIG. 85 Sir George Hayter, *The Marriage of Queen Victoria and Prince Albert in 1840*, painted for the Queen and completed in 1842; oil on canvas (Royal Collection, RCIN 407165)

created by new techniques of reproduction such as photo-gravure, complete with keys identifying the sitters. Queen Victoria clearly saw that feeding the public's curiosity had great propaganda potential. She invented the idea that the monarchy should be sustained through magnificent pageantry, shared at one remove by the nation as a whole.

These developments have an interesting impact on the conversation piece. Winterhalter's *The Royal Family in 1846* (fig. 86) was seen by 100,000 people when it was exhibited at St James's Palace in 1847; it was published in an engraving in 1850, and was clearly conceived as an important public image. It contains life-size portraits of the royal pair enthroned, with their children, and as such may be seen as an updated version of Van Dyck's '*Greate Peece*' (Royal Collection, RCIN 405353). The comparison merely serves to show how far Winterhalter has strayed from the model.

The Prince Consort addresses his eldest son, rather than the viewer, seeming by his hand gestures to be telling him to concern himself with his siblings playing on the floor, as if the duties of an elder brother are preparation for those of a king. Princesses Victoria and Alice are already in training for their future roles as mothers. This combination of informal setting, instructive parents and eager children, learning through play, clearly belongs to the tradition of the conversation piece. The nearest precedent for such a public and imposing version of the genre is Knapton's *Family of Frederick, Prince of Wales* (fig. 45), with its similarly empowered mother. The liveliness of the individual elements and the brilliance of colour and texture seem to have been learned from the Zoffanys within the Royal Collection. Winterhalter's *Royal Family in 1846* (fig. 86) was conceived as a public conversation piece with all the trappings of state portraiture:

life-sized figures; dynastic, political or moral message; and public dissemination. Queen Victoria planned others in the same mould: the 'Boat Picture' (no. 36) first conceived in 1850 to show the personal side of the Royal Family, what she called 'the independent life we lead in the dear Highlands'. Later in the reign, Tuxen's *Family of Queen Victoria in 1887* (Royal Collection, RCIN 400500) shows the strength of the dynastic relationships established by 'the Grandmother of Europe' in a composition which resembles a full-scale version of Hogarth's conversations, like his *Assembly at Wanstead House* of 1730–31 (Museum of Fine Arts, Philadelphia). This tradition of the public royal conversation piece connects Knapton's family group (fig. 45) with that of James Gunn (fig. 1) painted exactly two hundred years later.

The evolution of Queen Victoria's conversation pieces also draws attention to something which was perhaps always inherent in the genre: the fact that the patron plays a far more central role in the devising of these images than in most forms of portraiture (let alone other types of painting). Much of the point of a conversation lies in the initial stage-management: the arrangement of people and objects in such a way as to tell a story or convey a message. This part of the process requires no special artistic training and invites the participation of the patron. We can follow this often painful collaboration through the journals of Queen Victoria; we can assume that something similar, though undocumented, may have occurred in the formation of Knapton or Zoffany's royal conversation pieces.

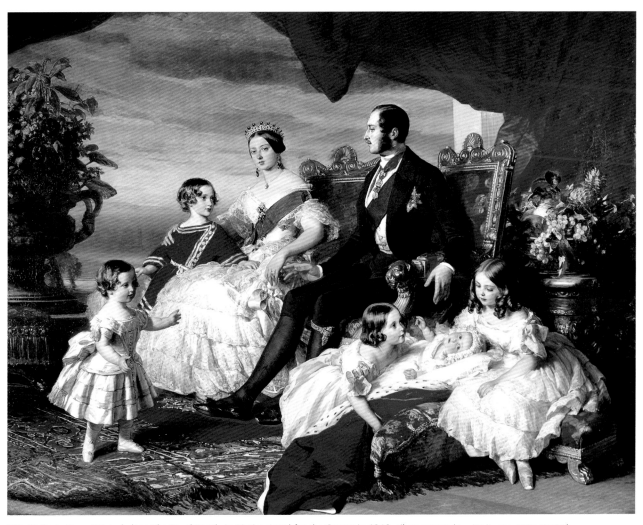

FIG. 86 Franz Xaver Winterhalter, *The Royal Family in 1846*, painted for the Queen in 1846; oil on canvas (Royal Collection, RCIN 405413)

31 SIR FRANCIS GRANT (1803-78)

Queen Victoria Riding Out

Oil on canvas
99.1 x 137.5 cm
Painted for Queen Victoria in 1838–9
Exhibited at the Royal Academy in 1840
RCIN 400749
Millar 1992, no. 270

THE young, recently crowned Queen is here seen riding on her horse Comus, with her dogs Dash and Islay in front, accompanied by her court (from right to left and roughly in order of decreasing prominence): Viscount Melbourne (1779–1848, the Prime Minister), the Marquess of Conyngham (1797–1879, the Lord Chamberlain), Sir George Quintin (Crown Equerry), the Earl of Uxbridge (1797–1869, Lord in Waiting), and the Hon. George Byng, later Earl of Strafford (1806–86, Comptroller of the Household). The procession passes through an imaginary gate in Windsor Great Park (which cannot be identified as Sandpit Gate), with a view of the castle in the far distance against a dawn sky. The Queen clearly enjoyed the creation of this very personal painting, just as she enjoyed riding out with these companions: on 31 July 1839 her journal describes Lord Melbourne sitting on a wooden horse within the artist's studio:

> looking so funny, his white hat on, an umbrella,
> in lieu of a stick in one hand, & holding the reins,
> which were fastened to the steps, in the other …
> it is such a happiness for me to have that dear kind
> friend's face, which I do like & admire so, so like …
> and Uxbridge, George Byng, & old Quintin
> ludicrously like.

The tone of this passage suggests that this painting was intended to be light-hearted and affectionate, even perhaps a private joke amongst the sitters. To read it this way one must imagine how the same image would be understood if the sitters were not recognised, in fact if this were a genre painting: it might then be entitled 'The Heiress' and would be interpreted as depicting a pretty and eligible young lady, in mourning for her

recently deceased father, chaperoned by a guardian and courted by four top-hatted rivals, one of whom has briefly won the favour of a raised veil and sweet smile. The joke depends upon this being a substantially correct reading, except that this heiress has inherited the crown from her recently deceased uncle and her courtiers are seeking royal attention rather than her hand in marriage. The fact that, after her marriage, prints were produced of the image, with Prince Albert as the principal 'suitor', draws attention to the deliberate play on the two meanings of this word.

FIG. 87 Sir Anthony van Dyck, *Charles I on Horseback*, painted for the King *c.*1635–6; oil on canvas. A reduced version of the equestrian portrait in the National Gallery (Royal Collection, RCIN 400571)

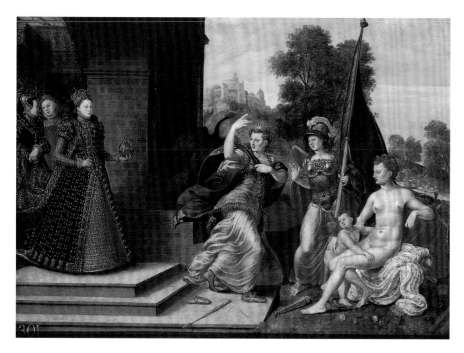

FIG. 88 Attributed to Hans Eworth, *Allegory of Elizabeth I*, probably painted for the Queen, signed and dated 1569; oil on panel (Royal Collection, RCIN 403446)

Sir Francis Grant was a gentleman artist; according to Queen Victoria he had the talent of an amateur and boasted 'of *never* having been to Italy or studied the Old Masters'. It looks here as if he has studied an appropriate Old Master – Van Dyck's equestrian portrait of Charles I, perhaps through the reduced version in the Royal Collection (fig. 87), which has a horse of identical dimensions. This clever resonance is perhaps compounded by an allusion to Hans Eworth's allegory of Queen Elizabeth I sailing regally through a triumphal arch with Windsor Castle in the background (fig. 88). Grant has also learned from Van Dyck and the Flemish school generally the idea of a limited and harmonious colour spectrum, ranging from yellow-buff to grey-blue, the soft tonal transition creating pools of light and shadow. The application of paint is thick and rough, creating an attractive texture rather like the shaggy coat of a dog, reminiscent of Rubens and his Scottish admirer David Wilkie. In a work where no obvious symbol of rank distinguishes the Queen from her friends (for so they seem), it is appropriate that her face is at the exact centre of the composition and that her blue cravat adds a single note of pure colour in an otherwise muted palette.

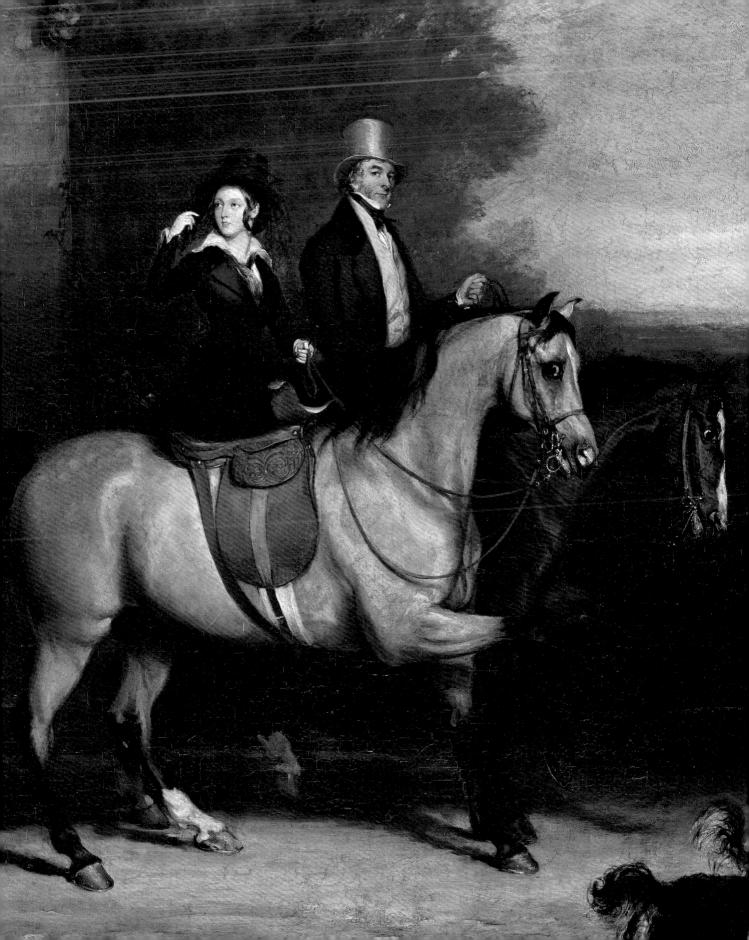

32 SIR EDWIN LANDSEER (1803-73)

Queen Victoria on Horseback

Oil sketch on millboard
52.1 x 43.2 cm
Painted in 1839
Given to Queen Victoria by the artist's family in 1874
RCIN 400200
Millar 1992, no. 394

LANDSEER described Queen Victoria as a 'very *inconvenient* little treasure'; the Queen described the artist in similar terms. Their relationship was close, fruitful and fraught: Landseer was inspired in fits and starts, the Queen enthusiastic but also meddlesome and as concerned with the banality of a likeness as with the brilliance of an artistic idea. The selection of Landseer paintings here illustrates the uncertain outcome of royal commissions. This work is an oil sketch for an ambitious equestrian portrait which failed to materialise after thirty years of trying and as many false starts; no. 33 is a happy accident, surely the work of a few hours, which was acquired as a 'finished sketch'. One of the Highland landscapes (no. 35) is a similarly successful and appreciated moment of inspiration; the other (no. 36) an oil sketch for a grand composition of as painful a gestation as no. 32, though this time resulting in a completed (though by common consent disastrous) work.

Whatever the subsequent fate of the project, this is a near-perfect oil sketch conveying a brilliant compositional idea. Taking his cue from Van Dyck's equestrian portrait (fig. 89), Landseer has shown the Queen riding through a triumphal arch, just indicated by rounding the two upper corners inside the frame, on Leopold, her favourite horse, accompanied by Hector (a deerhound), Dash (a King Charles spaniel, seen in no. 31) and a bloodhound, and followed by a troop of lancers. The Queen is dressed in medieval costume, which chimes with the castle behind – an idealised version of Windsor Castle (as remodelled by Jeffry Wyatville in previous decades). This is a *châtelaine* of romance with her loyal retainers.

The reference to Van Dyck's portrait draws attention to the distinctive pose of mount and rider in Landseer's work, for Leopold, an old, half-blind horse, is shying,

FIG. 89 Sir Anthony van Dyck, *Charles I with M. de St Antoine*, painted for the King in 1633; oil on canvas (Royal Collection, RCIN 405322)

implying equestrian diffidence, giving a graceful curve to its body and demonstrating the Queen's fine side-saddle horsemanship. Like her horse, the Queen looks modestly down. This is not a swaggering king on a charger, but a modest, almost reluctant monarch.

This rapidly executed piece is reminiscent of Rubens's oil sketches. The thinness of the paint, the very light, off-white priming and the extraordinarily summary way in which some of the shapes are blocked also resemble watercolour technique. A close parallel in subject and technique is provided by the flickering watercolour scenes of romanticised history by Richard Parkes Bonington (1802–28), an exact contemporary of Landseer's.

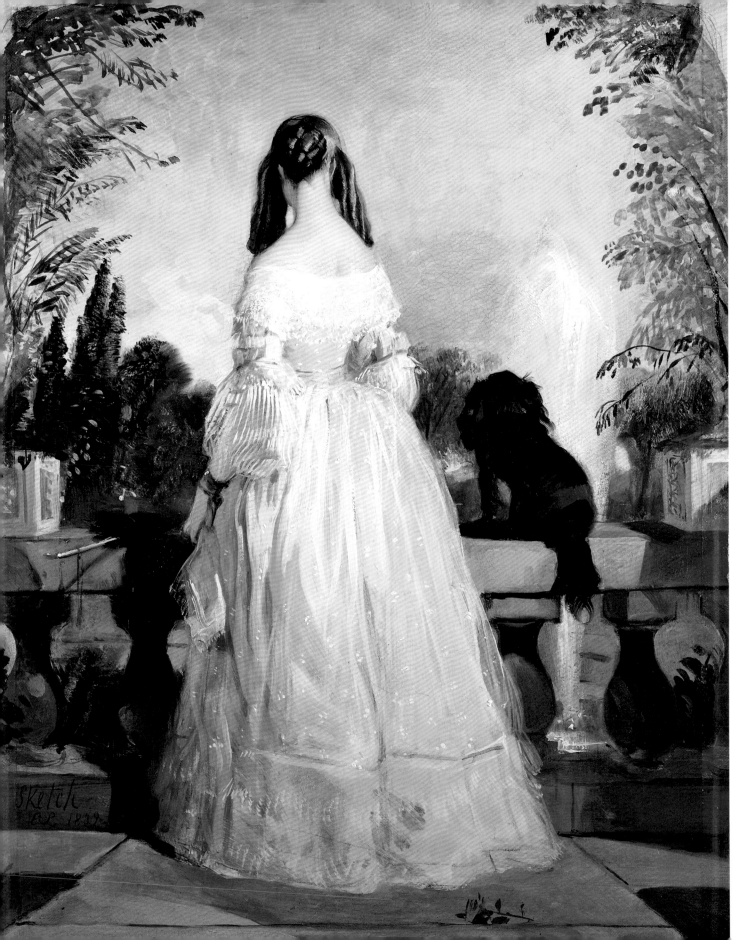

33 SIR EDWIN LANDSEER (1803–73)

Princess Victoire of Saxe-Coburg-Gotha

Oil sketch on canvas
41.9 x 35.2 cm
Signed: *Sketch / EL 1839*
Acquired by Queen Victoria in 1839
RCIN 400521
Millar 1992, no. 409

PRINCESS Victoire (1822–57), 'much-beloved Vecto', was Queen Victoria's first cousin, the daughter of her mother's elder brother, Duke Ferdinand of Saxe-Gotha (1785–1851). It is difficult to categorise this portrait of the Princess: Lord Melbourne called it a 'very odd idea'; Landseer described it as a 'sketch' in the inscription on the canvas. Being a single figure, it should not really qualify as a conversation piece, except that its informal 'snapshot' character and affectionate comedy fit the genre so well.

Sir George Hayter records seeing Landseer sketching the Princess on 29 August 1839 – is it possible that the work was executed without the sitter's knowing? On 10 September 1939 Baroness Lehzen bought Queen Victoria 'a lovely sketch in oils Landseer has done of Victoire's back, as a surprise for me; it is so like, – such a treasure – just the figure of that Angel'.

Landseer's idea begins from the premise that it is possible to recognise a person and tell a surprising amount about them from behind. From her grace of posture, hair and nape of neck we can see that the sitter here is beautiful; we can imagine her to be endowed with sensibility from her abstracted absorption with the beauty of the fountains and formal garden, presumably at Windsor, seen from a terrace. The humour of the image derives from the rhyme made by the shape of the Princess's curls and the ears of the spaniel next to her. There is also an art-historical twist: the figure, complete with dress and hair-design, is an exact quotation from Vermeer's *Music Lesson* (fig. 90), a painting that was hanging in Windsor at this time and attributed to Frans van Mieris. Landseer has seized upon the most striking oddity of Vermeer's painting – the fact that the principal female figure turns her back to us – and has made it even odder.

FIG. 90 Johannes Vermeer, *The Music Lesson*, c.1665; oil on canvas. Acquired by George III in 1760 as by Frans van Mieris
(Royal Collection, RCIN 405346)

34 SIR EDWIN LANDSEER (1803–73)

Windsor Castle in Modern Times; Queen Victoria, Prince Albert and Victoria, Princess Royal

Oil on canvas
113 x 143.8 cm
Inscribed on the back as having been painted between 1840 and 1843
Painted for Queen Victoria
RCIN 406903
Millar 1992, no. 396

LANDSEER had his first interview to discuss this picture two months after the royal couple's marriage on 13 April 1840; at this stage the painting seems to have been planned as a happy sequel to no. 31, which was exhibited in that year: it is of almost identical dimensions and originally hung with it as a pair (see fig. 91). After various false starts the Queen was able to report on 2 October 1845 that the 'Game Picture (begun in 1840!), with us 2, Vicky [the Princess Royal] & the dear dogs is at last hung up in our sitting-room here [Windsor], & is very beautiful picture, & altogether very cheerful & pleasing'. Landseer was paid a very handsome 800 guineas for the piece.

We must imagine that Prince Albert, Ranger of the Great Park, has spent the day shooting and returns laden with booty – kingfisher, jay, mallard, woodcock, pheasant and ptarmigan – which he proudly, if not very probably, spreads out upon the drawing room carpet. He sits in outdoor clothing, with muddy boots, bag and powder pouch, patting his favourite dog, Eos, while Dandy Dinmont, Islay and Cairnach fuss around. The Queen welcomes her husband home by presenting him with a nosegay; their daughter plays with a dead kingfisher – a 'Halcyon', symbol of peace.

The scene is set in the White Drawing Room at Windsor, decorated with the Morel and Seddon furniture commissioned by George IV, and with a view of the East Terrace, upon which Queen Victoria's mother, the Duchess of Kent, is seen enjoying a circuit in a bath chair.

FIG. 91 Joseph Nash, *The Queen's Sitting Room in the Victoria Tower, c.*1850; watercolour
(Royal Collection, RCIN 919788)

FIG. 92 Gerard Ter Borch, *The Letter, c.*1665; oil on panel.
Acquired by George IV in 1814 (Royal Collection, RCIN 405532)

Some liberties have been taken with the scene: the light of the setting sun does not quite seem to strike at the right angle and the windows seem to be entirely without glass.

Like so many paintings included here, this one is conceived as a tribute to an Old Master within the Royal Collection: Ter Borch's *The Letter* of *c.*1665 (fig. 92), which was acquired by George IV and which at this date hung in the Picture Gallery at Buckingham Palace. Landseer's visual quotation is followed through with a version of the 'Ter Borch silk' at least as silvery and shiny as Zoffany's (see no. 20). It was at this date that Dutch painting seemed particularly to epitomise domestic harmony (see p. 21 above); whether Ter Borch's ladies are engaged in an intrigue or a virtuous correspondence, Landseer clearly felt that the reference gave the right flavour to his image of marital felicity.

35 SIR EDWIN LANDSEER (1803–73)

Queen Victoria at Loch Laggan

Oil on panel
34.1 x 49.5 cm
Inscribed: *Queen Victoria with Princess Royal and the Prince of Wales at Loch Laggan Septr 1847 (Edwin Landseer Xmas 1847)*
Painted for Queen Victoria.
RCIN 403119
Millar 1992, no. 401

DURING Queen Victoria's first visit to the Highlands of Scotland, from 21 August to 17 September 1847, she stayed at Ardverikie, a house borrowed from the Duke of Abercorn. She wanted Landseer to create a memento of this holiday to give to Prince Albert for Christmas. She wrote to Prince Albert's secretary, George Anson, suggesting

> a Cabinet Picture *in size*, representing a dead Stag, with a back ground taken from the Scenery close here – the Lake with some of the most *known* Hills – a Highlander should be near the deer, & perhaps the Prince of Wales in his kilt, & herself *might* be represented looking at it; but he might paint them in, without any attempt at likeness as the figures should be only 6 or 7 inches in height & the whole Picture about 19 inches by *13 in*: It need not be an elaborate picture, but the Queen anxiously wishes to have it for *Xmas Eve*, & though he may now make *only* a *dead deer* with a Gilly near it & the Loch & hills behind, so as to ensure its completion or make more indication in the distance of the Queen. The Picture itself might also *be* smaller than 19 inches by 13. Mr Anson should make Mr. Landseer *understand* that that she is *very anxious* to have this, & that she would be content with *as little* as possible, if she can only *get it* … Perhaps Lord Abercorn might *help* in *getting* Landseer to do this Picture, & to sketch it when he (L.) comes here. But great secrecy must be observed.

> (Letter of 4 September 1847)

The Queen sounds very anxious, but in this case Landseer delivered a finished work for Christmas 1847, for which he was paid £200.

This painting operates at two levels. At one level a ghillie, bearing the stag shot by Prince Albert, has failed to recognise the simply dressed lady out sketching with her children until he is upon them. He bows awkwardly, accompanied by his equally confused deerhound, with cap in hand and feet placed in parallel, a means of designated plebeian posture since the time of Hogarth. The Queen responds with a gracious bow, so solemn that it resembles a prayer; the Prince of Wales points with pride to his father's booty. At another level the scene is dominated by its landscape background, depicting the end of Loch Laggan looking towards the East Binnein and painted with a freshness and brilliance quite new within the genre of conversation. Even the Queen adopts a humble posture before the majesty and beauty of God's creation, which she appreciates in her capacity as an artist and as a Christian.

In 1838 Frank Howard, an artistic theorist, published a book called *Colour as a means of Art*, which distinguished between two factions, the *Bianchi* and the *Neri*. The former seek to reproduce the brilliance of light through heightened colour; the latter tone everything down to a harmonious, Old Masterly brown. It is obvious from comparing the works in this section, in particular Grant's sombre *Queen Riding Out* (no. 31) and this, the most luminous of landscapes, that Howard was indeed describing real alternatives.

36 SIR EDWIN LANDSEER (1803–73)

Queen Victoria Landing at Loch Muick

Oil on canvas
42.9 x 76.5 cm
Inscribed on the back: *Original Sketch for the Large Picture / Sir. E. Landseer. 1850.*
Painted for Queen Victoria
RCIN 403221
Millar 1992, no. 402

ROYAL Sports on Hill and Loch, otherwise known as 'The Boat Picture' or the 'Balmoral misfortune', was a project that occupied Landseer and Queen Victoria for twenty years and resulted in a disappointing finished work, recorded in W.H. Simmons's print of 1874 (fig. 93). As in previous examples, the optimistic early stages of this process produced some much more satisfying sketches. Queen Victoria acquired this one in 1870, when she despaired of seeing the finished painting; it was, she said, 'valuable to her as a remembrance of happy times'.

The episode depicted was described by the Queen in her journal of 17 September 1850:

The lake [Muick] was like a mirror, & the extreme calmness, with the bright sunshine, hazy blue tints on the fine bold outlines of hills coming down in to our sweet loch quite enchanted Landseer. We landed at the usual landing place, where there was a haul of fish.

This stage of Landseer's development of the design was described two days later (19 September 1850):

the picture is intended to represent me as meeting Albert, who has been stalking, whilst I have been fishing, and the whole is quite consonant with the truth. The solitude, the sport, and the Highlanders in the water &c. will be, as Landseer says, a beautiful historical exemplification of peaceful times, & of the independent life we lead in the dear Highlands. It is quite a new conception, and I think the manner in which he has composed it will be singularly dignified, poetical, & totally novel, for no other Queen has ever enjoyed, what I am fortunate enough to enjoy in our peaceful happy life here. It will tell a great deal, & it is beautiful.

It is to be thus: I, stepping out of the boat at Loch Muick, Albert, in his Highland dress, assisting me out, & I am looking at a stag which he is supposed to have just killed. Bertie is on the dear pony with McDonald (whom Landseer much admires) standing behind, with rifles and plaids on his shoulder.

FIG. 93 W.H. Simmons after Sir Edwin Landseer, *Royal Sports on Hill and Loch*, print published 1 January 1874 (Royal Collection, RCIN 630538)

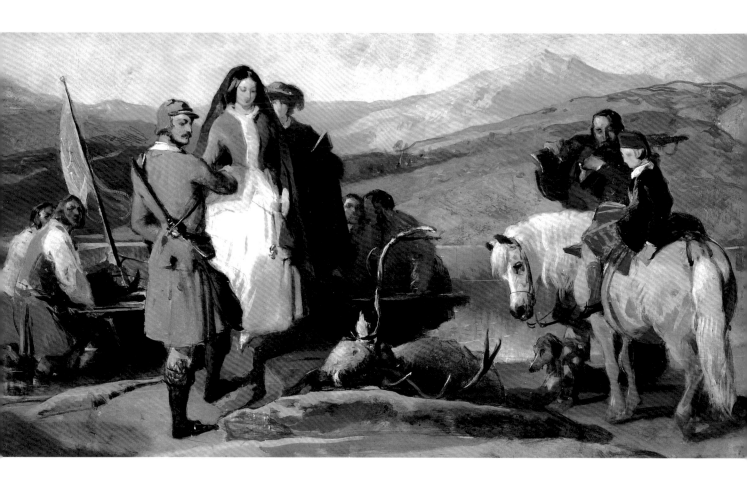

Landseer studied with the idealistic history painter Benjamin Robert Haydon (1786–1846), and is said to have painted the donkey in his *Christ's Entry into Jerusalem* (1814–20; St Mary's Seminary, Norwood, Ohio), an ambitious religious scene in which portraits of famous men – Newton, Voltaire, Hazlitt, Keats and Wordsworth – respond in different ways to the sight of their Redeemer. Landseer clearly recalled this eccentric idea when he decided in this composition to reinvent the Renaissance altarpiece with portraits. Landseer's model is the *sacra conversazione* of Raphael or Correggio, where

a Madonna is flanked symmetrically by groups of saints holding their attributes. In this case Prince Albert is a St George, his hat like a helmet, his kilt like Roman armour and with a stag instead of a dragon. The huge and noble figure of McDonald, whom Landseer likened to a Giorgione, next to the young prince, makes a group reminiscent of St Christopher carrying the Christ Child. The Queen advances towards the red-carpeted central space (accompanied by Lady Jocelyn with sketching equipment), in order to play the part of the Madonna, but her eyes are turned down with characteristic modesty.

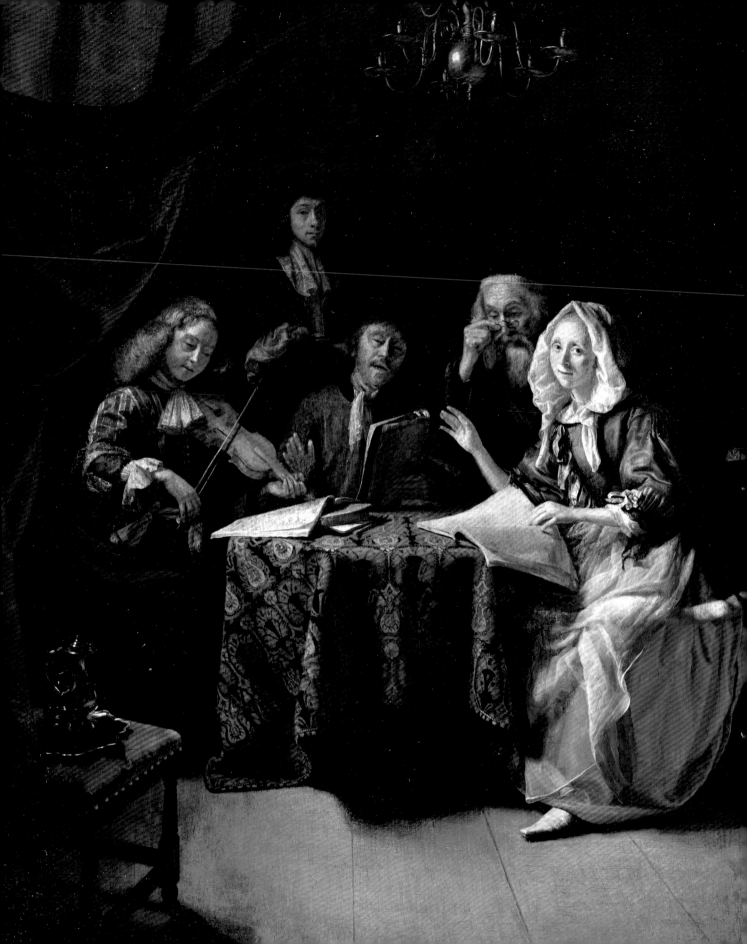

Further Reading

ROYAL COLLECTION CATALOGUES

O. Millar, *The Tudor, Stuart and Early Georgian Pictures in the Collection of Her Majesty The Queen*, London, 1963
— *The Later Georgian Pictures in the Collection of Her Majesty The Queen*, London, 1969
— *The Victorian Pictures in the Collection of Her Majesty The Queen*, Cambridge, 1992
C. White, *The Dutch Pictures in the Collection of Her Majesty The Queen*, Cambridge, 1982
— *The Later Flemish Pictures in the Collection of Her Majesty The Queen*, London, 2007

SOURCE MATERIAL

Joseph Addison, Richard Steele et al., *The Spectator*, 1711–14, reprinted in 4 vols., ed. G. Smith, London, 1907
Johan van Beverwijck, *Van De Wtnementheyt des Vrouwelicken Geslachts* (*On the Excellence of the Female Sex*), Dordrecht, 1643
Fanny Burney, *Diaries and Letters*: *The Early Journals and letters of Fanny Burney*, ed. L.E. Troide, Oxford, 1990 *Diary and Letters of Madame D'Arblay 1778–1840*, ed. C. Barrett and A. Dobson, 6 vols., London, 1904–5
Margaret Cavendish, *Natures Pictures drawn by Fancies Pencil to the Life*, London, 1656
William Cavendish, *Méthode et invention nouvelle de dresser les chevaux*, Antwerp, 1658
Joseph Farington, *The Diaries of Joseph Farington*, eds. K. Garlick, A. Macintyre and K. Care, 16 vols., New Haven and London, 1978–84

Owen Felltham, *A Brief Character of the Low-Countries under the States: Being Three weeks observations of the vices and vertues of the inhabitants*, London, 1952
Frederick the Great, *Memoirs of the House of Brandenburg, From the Earliest Accounts to the Death of Frederick I, King of Prussia, By the Hand of a Master*, London, 1751
Pierre-Jean Grosley, *A Tour to London*, London, 1772
William Hazlitt, 'Mr Northcote's Conversations', in *The Complete Works*, ed. P.P. Howe, vol. XI, London and Toronto, 1932
John, Lord Hervey, *Some Materials towards Memoirs of the Reign of King George II*, 3 vols., ed. R. Sedgwick, London, 1931
Arnold Houbraken, *De groote Schouburgh der Nederlantsche Konstschilders en Schilderessen* (*The Great Theatre of Netherlandish Painters and Paintresses*), 3 vols., Amsterdam, 1718–21
Lucy Hutchinson, *Memoirs of the Life of Colonel Hutchinson*, London, New York and Toronto, 1973
Jean-Bernard Le Blanc, *Letters on the English and French Nations*, 2 vols., London, 1747
Count Lorenzo Magalotti, *Travels of Cosmo the Third Grand Duke of Tuscany Through England during the Reign of King Charles II 1669*, ed. J. Mawman, London, 1821
Duchess of Northumberland, *The Diaries of a Duchess. Extracts from the Diaries of the first Duchess of Northumberland (1716–1776)*, ed. J. Greig, London, 1926
Mrs Papendiek, *Court and Private Life in the Time of Queen Charlotte: Being the Journals of Mrs. Papendiek, Assistant-Keeper of the Wardrobe and Reader to her Majesty*, ed. Mrs V.D. Broughton, 2 vols., London, 1887
César de Saussure, *Letters from London, 1725–1730*, trans. Paul Scott, London, 2007

James Renat Scott, *Memorials of the Family of Scott, of Scots-Hall, in the County of Kent*, London, 1876

Lady Louisa Stuart, *Memoir*, 1827, published in the introduction of *The Letters and Journals of Lady Mary Coke*, 4 vols., Bath, 1970

Josiah Tucker, *Instructions for Travellers*, London, 1757

George Vertue, 'Notebooks', *Walpole Society*, 18 (1929–30), 20 (1931–2), 22 (1933–4), 24 (1935–6), 26 (1937–8) and 30 (1948–50)

Horace Walpole, *Anecdotes of Painting in England*, 4 vols., 1762–71

Horace Walpole's Correspondence, eds. W.S. Lewis, W.H. Smith and G.L. Lam, 48 vols., London and New Haven, 1947–83

STUDIES AND EXHIBITION CATALOGUES

B. van Beneden and N. de Poorter (eds.), *Royalist Refugees: William and Margaret Cavendish in the Rubens House, 1648–1660*, exh. cat., Rubenshuis, Antwerp, 2006

J. Brewer, *The Pleasures of the Imagination: English Culture in the Eighteenth Century*, London, 1997

C. Campbell Orr (ed.), *Queenship in Britain 1660–1837*, Manchester and New York, 2002

M. De-la-Noy, *The King Who Never Was: The Story of Frederick, Prince of Wales*, London, 1996

E.G. D'Oench, *The Conversation Piece: Arthur Devis and his Contemporaries*, exh. cat., Yale Center for British Art, New Haven, 1980

R. Edwards, *Early Conversation Pieces from the Middle Ages to about 1730*, London, 1954

E. Einberg, *Hogarth: The Painter*, exh. cat., Tate, London, 1997

— *Manners and Morals: Hogarth and British Painting 1700–1760*, exh. cat., Tate, London, 1987

B. Haak, *The Golden Age: Dutch Painters of the Seventeenth Century*, New York, 1984

R. Harris, *The Conversation Piece in Georgian England*, exh. cat., Kenwood House, London, 1965

O. Hedley, *Queen Charlotte*, London, 1975

C. Hibbert, *George III: A Personal History*, London, 1998

H. Hoock, *The King's Artists: The Royal Academy of Arts and the Politics of British Culture 1760–1840*, Oxford, 2003

J. Huizinga, *Dutch Civilization in the 17th Century*, London and New York, 1968

J. Ingamells and R. Raines, 'A Catalogue of the Paintings, Drawings and Etchings of Philip Mercier', *Walpole Society*, 46, 1976–8, pp. 1–70

G. Jackson-Stops (ed.), *The Treasure Houses of Britain: Five Hundred Years of Private Patronage and Art Collecting*, National Gallery of Art, Washington, DC, 1985

C. Lerche, *Painted Politeness: Private und öffentliche Selbstdarstelling im Conversation Piece des Johann Zoffany*, Weimar, 2006

C. Lloyd, *The Quest for Albion: Monarchy and the Patronage of British Painting*, exh. cat., Royal Collection, 1998

J. Marsden (ed.), *The Wisdom of George III*, London, 2004

M.R. Michel, 'Watteau and England', *The Rococo in England: A Symposium*, ed. C. Hind, London, 1986, pp. 46–59

O. Millar, *Zoffany and his Tribuna*, London, 1966

R. Paulson, *Hogarth*, 3 vols., New Brunswick, 1993

L. Picard, *Restoration London*, London, 1997

— *Dr. Johnson's London*, London, 2000

M. Praz, *Conversation Pieces: A Survey of the Informal Group Portrait in Europe and America*, London, 1971

J.L. Price, *Culture and Society in the Dutch Republic during the 17th Century*, London, 1974

R. Raines and J. Ingamells, *Philip Mercier, 1689–1760*, exh. cat., City Art Gallery, York, and Kenwood House, London, 1969

K. Retford, *The Art of Domestic Life; Family Portraiture in Eighteenth-Century England*, New Haven and London, 2006

A. Ribeiro, *The Gallery of Fashion*, London, 2000

— *Dress in Eighteenth-Century Europe, 1715–1789*, New Haven and London, 2002

— *Fashion and Fiction: Dress in Art and Literature in Stuart England*, New Haven and London, 2005

W.W. Robinson, 'Family portraits of the Golden Age', *Apollo*, 110, no. 214, December 1979, pp. 490–97

K. Rorschach, *Frederick, Prince of Wales (1707–1751) as a Patron of the Visual Arts: Princely Patriotism and Political Propaganda*, dissertation, Yale University, 1985

F. Russell, 'The Hanging and Display of Pictures, 1700–1850', in G. Jackson-Stops et al., *The Fashioning and Functioning of the English Country House*, Washington, DC, 1989, pp. 133–53

C. Saumarez Smith, *Eighteenth-Century Decoration: Design and the Domestic Interior in England*, London, 1993

S. Schama, 'The Domestication of Majesty: Royal Family Portraiture 1500–1850', in R.I. Rotberg and T.K. Rabb, *Art and History: Images and their Meaning*, Cambridge, 1986, pp. 155–83

— *The Embarrassment of Riches: An Interpretation of Dutch Culture in the Golden Age*, London, 1987

D. Shawe-Taylor, *The Georgians: Eighteenth-Century Portraiture and Society*, London, 1990

S. Sitwell, *Conversation Pieces; a Survey of English Domestic Portraits and their Painters*, London, 1936

D.R. Smith, *Masks of Wedlock: Seventeenth-Century Dutch Marital Portraiture*, Epping, 1982

D. Solkin, *Painting for Money: The Visual Arts and the Public Sphere in Eighteenth-Century England*, New Haven and London, 2001

K. Staniland, *In Royal Fashion: The Clothes of Princess Charlotte of Wales and Queen Victoria 1796–1901*, London, 2001

L. Stone, *The Family, Sex and Marriage in England 1500–1800*, London, 1977

P.C. Sutton (ed.), *Masters of Seventeenth-Century Dutch Genre Painting*, exh. cat., Philadelphia Museum of Art, 1984

J. Todd, *Sensibility: An Introduction*, London, 1986

M. Vidal *Watteau's Painted Conversations: Art Literature and Talk in 17th and 18th Century France*, New Haven, 1992

F. Vivian, *A Life of Frederick, Prince of Wales, 1707–1751; A Connoisseur of the Arts*, ed. R. White, Lewiston, Queenston, Lampeter, 2006

M. Webster, *Johan Zoffany, 1733–1810*, exh. cat., National Portrait Gallery, London, 1976

S. West, 'The Public Nature of Private Life: The Conversation Piece and the Fragmented Family', *British Journal for Eighteenth-Century Studies*, 18, 1995, pp. 152–71

W.T. Whitley, *Artists and Their Friends in England 1700–99*, 2 vols., London and Boston, 1928

M.E. Wieseman, 'The Art of "Conversatie": Genre Portraiture in the Southern Netherlands in the Seventeenth Century', in P.C. Sutton, *The Age of Rubens*, Boston, 1993

Picture Credits

All works reproduced in this book are in the Royal
Collection unless indicated otherwise. Royal Collection
Enterprises are grateful for permission to reproduce
the following:

Ascott, The Anthony de Rothschild Collection
(The National Trust), fig. 77
Ashmolean Museum, University of Oxford, figs. 19, 20
© bpk, Stiftung Preussische Schlösser und Gärten
Berlin-Brandenburg, Jörg P. Anders, fig. 34
© bpk, Gemäldegalerie der Akademie der bildenden
Künste, Vienna, fig. 22
© bpk, Bayerische Staatsgemäldesammlungen,
Alte Pinakothek, Munich, fig. 51
© The Bridgeman Art Library, fig. 65
© The British Library Board, All Rights Reserved,
1509/1009, 2008, fig. 29
© The Trustees of the British Museum, figs. 5, 12, 64, 80, 81
© The Cleveland Museum of Art, Gift of the Hanna Fund
1951.355, fig. 28
Photograph © 1995 The Detroit Institute of Arts, Founders
Society Purchase, Eleanor Clay Ford Fund, General
Membership Fund, Endowment Income Fund and
Special Activities Fund, fig. 60

By Permission of the Trustees of Dulwich Picture Gallery,
fig. 37
Frans Hals Museum, Haarlem, fig. 26
© The Frick Collection, New York, fig. 79
The J. Paul Getty Museum, Los Angeles, fig. 3
Royal Picture Gallery Mauritshuis, The Hague, fig. 21
The Metropolitan Museum of Art, Gwynne Andrews Fund,
1952 (52.63.2). Image © The Metropolitan Museum
of Art, fig. 71
© Museum of London, fig. 7
© The National Gallery, London, fig. 76
© National Portrait Gallery, London, figs. 1, 48
© Museo Nacional del Prado, Madrid, fig. 35
© Royal Academy of Arts, London, fig. 66
Private collection, figs. 33, 40
Rijksprentenkabinet, Rijksmuseum, Amsterdam, fig. 6
Soprintendenza Speciale per il Polo Museale Fiorentino,
Gabinetto Fotografico, figs. 68, 69
© Tate, London 2008, figs. 42, 55, 56
© The Utrecht Archives, figs. 30, 31
© National Museums, Liverpool, Walker Art Gallery, fig. 57
City of Westminster Archives Centre, fig. 52
© Yale Center for British Art, Paul Mellon Collection,
figs. 78, 82

Index